IMAGES
of America

INDIANA'S LINCOLNLAND

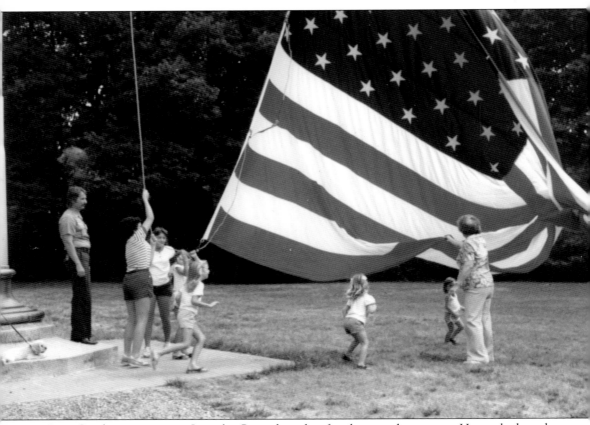

Jerry Sanders grew up in Lincoln City where his family owned a tavern. He worked at the Lincoln Boyhood National Memorial for 25 years. In this photograph, Sanders helps a group of youngsters raise the American flag on the state's largest flagpole. The girl with a ponytail is Julie Hevron. The Hevron family, which includes Romines, Gentrys, Turnhams, and Woods (all of whom intersected with young Abe Lincoln), settled in the area in the early 1800s, years before the Lincolns moved here, and their history is intertwined with the history of Lincoln City and the Lincoln family. From left to right are Jerry Sanders, Shelly Havron, Julie Hevron, Rhea Hemenway, Mary Smith, Adrienne Woods, Kara Hemenway, and Florence Smith. The woman holding the dog leash is Marge Heron. (Courtesy of Hevron family collection.)

On the cover: When Abraham Lincoln lived in southern Indiana, the area where his family settled was called Little Pigeon Creek. At one time, the local post office was called Kercheval, probably for Sam Kercheval, who owned land in the area. After Lincoln's assassination, the railroad company purchased land and changed the name of the area to Lincoln City, bringing people to the area where Lincoln's mother, Nancy Hanks Lincoln, was buried and the site of his family farmstead. It did not hurt the tourism trade that, while much of the county was dry, alcohol was legal in Lincoln City. This 14-acre lake was used by railroad companies to provide water for their steam engines. The lake, like much of Lincoln City, now lives only in remembrance, but Lincoln's legacy in southern Indiana lives on. (Courtesy of O. V. Brown collection.)

IMAGES
of America

INDIANA'S LINCOLNLAND

Mike Capps and Jane Ammeson

ARCADIA
PUBLISHING

Published by Arcadia Publishing
Charleston SC, Chicago IL, Portsmouth NH, San Francisco CA

Printed in the United States of America

Library of Congress Catalog Card Number: 2007942670

For all general information contact Arcadia Publishing at:
Telephone 843-853-2070
Fax 843-853-0044
E-mail sales@arcadiapublishing.com
For customer service and orders:
Toll-Free 1-888-313-2665

Visit us on the Internet at www.arcadiapublishing.com

*To my family, including my daughter Nia, who has frequently
wandered the roads of Lincoln with me. And to my husband and son,
Charles and Evan, who have supported us while we did so.*
—Jane Ammeson

CONTENTS

Acknowledgments 6

Foreword 7

Introduction 8

1. The Lincolns in Indiana 9

2. Wisps of History 13

3. On the River 25

4. The Civil War 29

5. Lincoln's People and Places 37

6. Lincoln City 47

7. Lincoln Land 61

8. Commemorating Lincoln 71

ACKNOWLEDGMENTS

The story of Abraham Lincoln in Indiana would be lost to time, just some old records in dusty tomes and courthouses and mentions in biographies, if it were not for dedicated historians who live where Lincoln once resided. O. V. Brown is one such historian. A resident of Dale, which is just a few miles from the Pigeon Creek area (encompassing towns called Dale, Lincoln City, and Gentryville) where the Lincolns lived, Brown traveled the countryside, taking photographs of the houses that Lincoln visited and the spots where important parts of Lincoln's life had occurred, and collected photographs and artifacts of Lincoln's time here. Many of these are gone now, and if Brown had not recorded the David Turnham house where Lincoln read law books or the Huffman Mill where he took corn to be ground, those images would be lost forever. His great-great-nephew Daryl Lovell continued Brown's dedication to Lincoln history, working with the photographs and preserving them for the future. Holiday World and Splashin' Safari are the caretakers of much of Brown's Lincoln memorabilia, keeping it intact and available for public viewing. There are other Lincoln aficionados who dedicate time and effort to Spencer County's Lincoln history. Those include Steve Sisley and the members of the Spencer County Historical Society. Jerry Sanders was chief of operations at the Lincoln Boyhood National Memorial when he retired from park service after 25 years. He grew up in Lincoln City where his parents owned June's Place, a popular tavern. The name comes from his father's first name—Junious. The tavern was torn down to make way for the park. Joe Hevron and his nephew Jim Hevron also are part of the Lincoln story and participate in the preservation of Lincoln lore. The Hevron family traces its roots in this area back to the early 1800s. They were here before the Lincoln family and still are today. All these people and more work to ensure that Lincoln is still among us here in southern Indiana.

I want to thank my southern Indiana "family" who make each trip so much fun: Paula Werne and her son James, Pat Koch, Will Koch, Joe Hevron, James Hevron, Daryl Lovell, and Jerry Sanders, just to name a few.

—Jane Ammeson

FOREWORD

The history of Spencer County is dominated by a towering figure, the nation's 16th president, Abraham Lincoln, who spent his formative boyhood years (from age seven to age 21) living in what is now called Lincoln City, then referred to as the "Little Pigeon Creek Community." To a large extent, Indiana's role in the development of Lincoln, the president, the emancipator, and the man who saved the Union, is forgotten outside of this region. My father, William Koch, recognized the value of Lincoln, the importance of preserving his history, and his legacy here in Spencer long ago. He worked to create the Lincoln Boyhood National Memorial and he and my mother, Pat, attended the bill-signing ceremony with Pres. John F. Kennedy. William was a founder of the Lincoln Heritage Trail. He was also instrumental in developing a plan to save "Young Abe Lincoln" in 1988, the second year of its production. He believed in the importance of preserving and promoting our Lincoln heritage.

In recent months and years, I have come to very deeply appreciate the footprints that Lincoln left here in Spencer County, but my father did the same many years ago. As I write this in February 2008, I am the chair of the Lincoln Boyhood Drama Association, which is working to put a new show on the stage at the Lincoln State Park Amphitheatre. Somehow, I think that he would approve of what we are working to do.

Ultimately, the history of Lincoln City is the history of Lincoln and the growth of legends and myths concerning him following his assassination on Good Friday in 1865. Lincoln is the most written about man in the history of the world, with the sole exception of Jesus of Nazareth. Lincoln was a man of contrasts and contradictions. He was a man who deeply desired to leave a lasting impression on his fellow men, and he chose to do this through politics. Lincoln was a master politician, but he was also something that many politicians in his day (and ours) were not—a profoundly ethical man. Lincoln's actions were determined by his internal sense of right and wrong—a sense that never failed him.

Lincoln towers over us. He dominates the history of our country, Spencer County, and Lincoln City. Let us not only idolize this man for what he did during his five years in office, but let us also commit and recommit ourselves to live our lives and to steer our government, as he did, with a clear ethical and moral sense.

—Will Koch, president of Holiday World and Splashin' Safari.

INTRODUCTION

Before photography and before Abraham Lincoln became known, he lived in southern Indiana, moving here in 1816 when he was seven and residing in the area now known as Spencer County until he was 21. If a child is the father of the man, then Indiana played a great part in the man Lincoln became. He returned only once, in 1844, after moving away, when he was campaigning for Henry Clay. But upon walking into the room where his old friends were, he recognized them immediately, and even in 1860 when he had become one of the most famous men in America, he wrote longingly to his old friend David Turnham whom he had not seen in 16 years about their friendship, their lives, and his time back here. Descendents of the Turnham family remain in southern Indiana and so do many other families whose lives intersected with Lincoln years before. There are still vestiges of places that he visited. One can wander the rolling hills and winding country roads and pass fields and woods where Lincoln once roamed. His sister Sarah, who died in childbirth, is buried in the Little Pigeon Cemetery on land once owned by the Romine family, whose descendants still live here. His mother, Nancy Hanks Lincoln, who died of milk sickness, is buried in the Lincoln Boyhood National Memorial. Before her death, she had nursed a neighbor, Nancy Brooner, who also died of the sickness. The Brooners still have family here, and Brooner Printing is a thriving business in Dale, a town just down the road from the Lincoln farm. Towns such as Gentryville, Lincoln City, and Dale, are connected because they were all part of or near Little Pigeon Creek. There are so many other connections to Lincoln here, but they are not large monuments or substantial buildings. They are wisps of history that are, in some ways, more compelling because they are so ethereal. They are pieces of the past preserved in more abstract ways, such as wandering through the Dale Cemetery and seeing the gravestone of David Turnham or the Civil War veterans whose lives were impacted by Lincoln's dedication to freeing the slaves. They are in the names of the people who live here, whose ancestors were part of Lincoln's life. They are small things, but in some ways, they are larger than monuments dedicated to Lincoln because they are real in the way that the history of everyday people is real. Lincoln said about this area, "There I Grew Up." In many ways, here he still is.

—Jane Ammeson

One

THE LINCOLNS IN
INDIANA

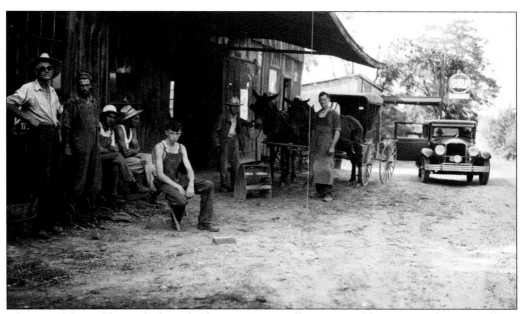

The site of the Baldwin Blacksmith Shop in Gentryville is pictured here. According to William Thayer in *From Pioneer Home to the White House: the Life of Abraham Lincoln* (1882), "John Baldwin, the blacksmith came into the neighborhood when Abraham was about ten years old." Joe Hevron was a boy in Lincoln City in the mid-1970s and the village still had a blacksmith, a man named Sutton. "He was a blacksmith extraordinaire," says Hevron, who has lived in Lincoln City all his life. (Courtesy of O. V. Brown collection.)

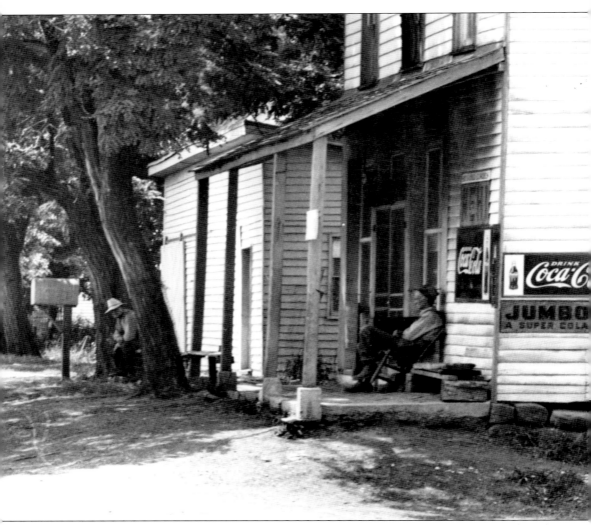

Though this photograph was taken long after the time when the Lincoln family lived in the area, country stores were the meeting places not only for those buying goods but also for those congregating to talk about the events of their community and the world beyond. According to the book *The Life of Lincoln* by William Herndon, "The centre of wit and wisdom in the village of Gentryville was at the store. This place was in charge of one Jones who soon after embarking in business seemed to take quite a fancy to Abe. He took the only newspaper—sent from Louisville—and at his place of business gathered Abe, Dennis Hanks, Baldwin the blacksmith, and other kindred spirits to discuss such topics as are the exclusive property of the store lounger." Dennis Hanks describes John Baldwin, according to *Lincoln's Youth: the Indiana Years* by Louis A. Warren, as "the famous storytelling blacksmith." (Courtesy of O. V. Brown collection.)

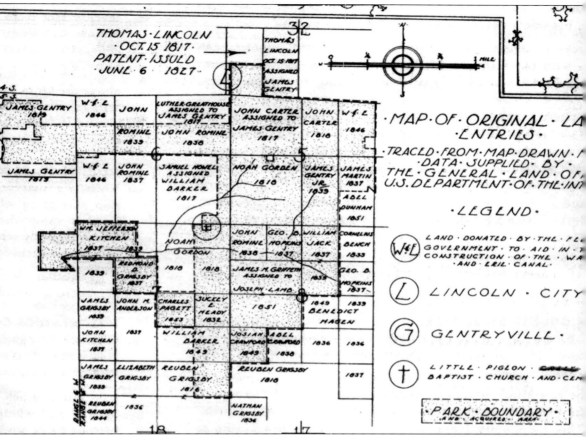

A map of the original land entries dated June 6, 1827, shows where many of the families, including the Lincolns, lived at the time. Many of the names on this map, including John Romine, Noah Goden, James Gentry, and Reuben Grigsby, will appear at least once in this book. Lincoln's roots still remain in southwestern Indiana not only in the remnants of where he once lived and worked but also in the people whose forebears worked with and were friends with the future president and whose families still live here now.

11

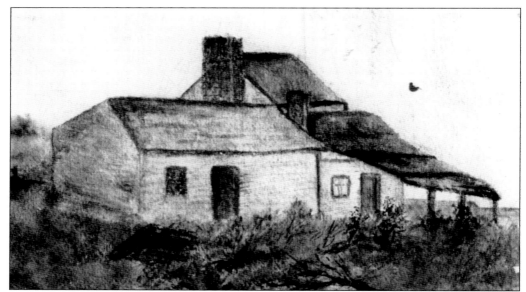

The caption on this drawing reads, "Noah Gorden House." The Gorden's Mill, now part of the Lincoln State Park, was powered by horses rather than water. It was here that Abraham Lincoln was kicked by a horse. "Get up," he was saying when the horse kicked him in the forehead and knocked him unconscious. Lincoln lay unconscious the whole night, and when he came to the following morning, his first words were "you old hussy," finishing the sentence he had started the day before. (Courtesy of O. V. Brown collection.)

"Our family at one point in time owned as much as 60% of what is now the park," says Jim Hevron. The Romine-Hevron farm remained in the family for four generations. From left to right, this photograph shows Samuel Howell, the grandfather of Hevron's wife Barbara Michel; William Baker; and John Romine. According to James Hevron, Abraham Lincoln walked past this house many times and worked on the farm. This was the closest house to the Little Pigeon Creek Baptist Church. The first owners were the neighbors of the Lincolns while they lived there. This area is now where the Lincoln Amphitheater in the Lincoln State Park stands. (Courtesy of O. V. Brown collection.)

Two

WISPS OF HISTORY

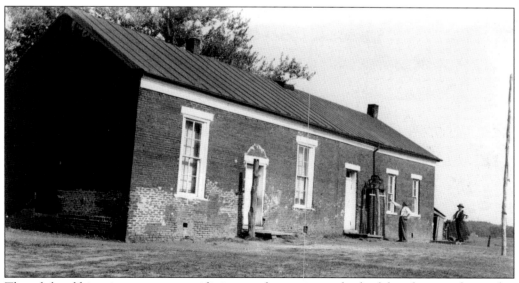

Though local historians are not sure if it is true, the caption on back of this photograph says this is the old Jones home northwest of Gentryville. This was the first Jones home, a two-room log cabin that was later expanded and bricked. The Jones Store and present Jones home was build on the north side of the road. Col. William C. Jones played an important part in Lincoln's early life. He sent Lincoln on a trip downriver to New Orleans where the future president saw slaves being traded. It was something Lincoln never forgot. (Courtesy of the James Hevron family.)

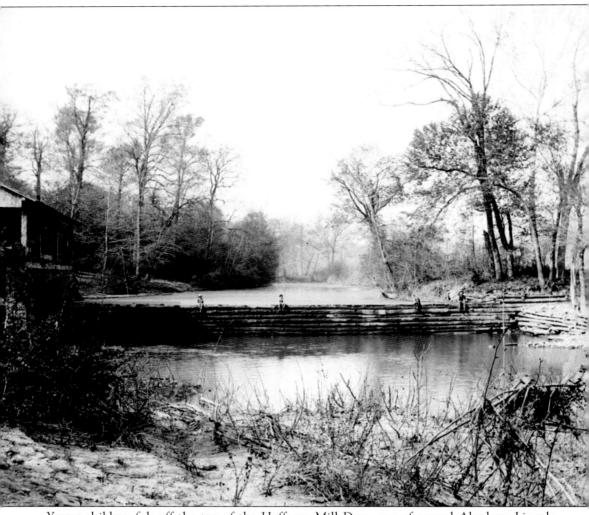

Young children fish off the top of the Huffman Mill Dam, one of several Abraham Lincoln visited. Lincoln journeyed to Princeton, Indiana. He rode "across the country on a gray mare, with a bunch of wool which his mother had sent along to be carded at the mill there." When Lincoln was on his way to his inauguration, he was introduced at Lafayette to a man whose last name was Stockwell, to whom he told the following incident: "When I was a boy about fifteen years of age, I took some wool to Princeton to be carded. As I entered the village I was stuck with a quaint sign on the corner of the public square. It stood out in bold relief, Robert Stockwell merchant. It was the first time in my life I had seen gold lettering on a sign and hence I was strongly impressed. I have never forgotten it." Lincoln then asked Stockwell if he might be related to Robert Stockwell, to which he replied, "I am the man." This information, from *Lincoln Lore*, No. 119 and the *Evansville Journal*, July 11, 1890, was provided by Jerry Sanders. (Courtesy of O. V. Brown collection.)

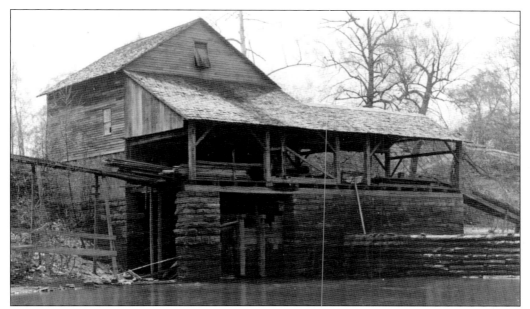

According to *Lincoln's Youth* by Louis Warren, "One of the ways young Abraham Lincoln was able to see what was happening in the surrounding county was by going on the periodic treks that had to be made to the nearest gristmill. Going to the mill was an essential part of pioneer life." Lincoln frequently made the 16-mile journey from Little Pigeon Creek to the Huffman Mill. (Courtesy of O. V. Brown collection.)

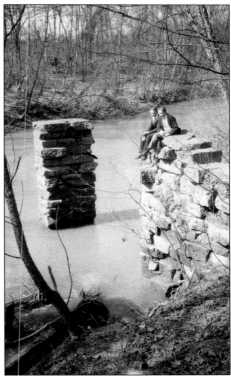

George and Nancy McDaniel Huffman settled on the Spencer County side of the Anderson River in 1810. After hearing about the scalping of Atha Meeks in western Spencer County the following year, they returned to Breckinridge County in Kentucky around 1815 or 1816. Later coming back to Indiana, they built a water-powered mill just upstream from the bridge on the Spencer County side. The third water mill was torn down around 1910. These are the remnants of that mill. (Courtesy of O. V. Brown collection.)

Today the road to where the Huffman Mill was located on the Anderson River is a beautiful drive through rolling hills dotted with farms, and there is a covered bridge near the site. But in Lincoln's time, this section of Indiana was much wilder. Abraham Lincoln would later say, "It was a wild region, with many bears and other wild animals still in the woods." (Courtesy of O. V. Brown collection.)

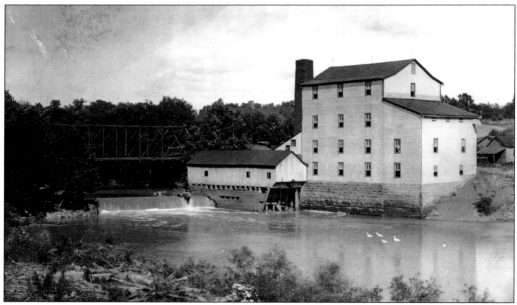

Lincoln is said to have also traveled to the Enlow Mill in Jasper about 17 miles from his home. Like the Lincolns, the Enlow family came from Kentucky, though they continued further north to what is now Jasper, though for a while the city was known as Enlow Hills. Supposedly the Enlows had been neighbors of the Lincolns in Kentucky and Mrs. Enlow was said to have been the midwife at Lincoln's birth. (Courtesy of O. V. Brown collection.)

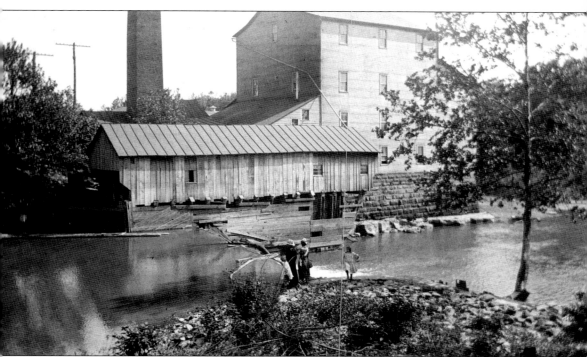

Originally known as the Evans Mill, built between 1813 and 1817 by Revolutionary War veteran Col. Andrew Evans, the Enlows bought the mill in 1820. Thomas and Abe Lincoln traveled here, and since the trip was so long, they reportedly spent the night with the Enlows. The original mill was destroyed in 1870. The mill shown in this photograph dates back to 1865 and was so weakened by a 1964 flood that it was torn down. (Courtesy of O. V. Brown collection.)

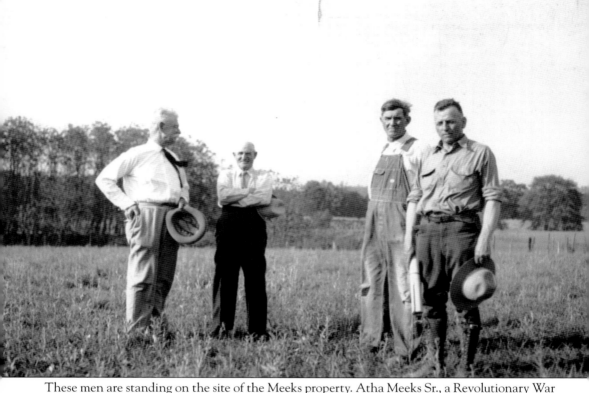

These men are standing on the site of the Meeks property. Atha Meeks Sr., a Revolutionary War veteran, settled on the banks of Little Pigeon Creek sometime between 1805 and 1810. In spring of 1811 or 1812, Shawnee Indians led by Set-te-tah attacked the Meeks, shooting and attempting to scalp Atha Meeks Jr. Big Bones, a member of the raiding party, shot Atha Sr. as he rushed outside to help his son. Atha Jr. was able to fend off the other Shawnees, giving his brother William time to shoot Big Bones. The remaining Shawnees fled. A posse captured the Native Americans, and they were taken to justice of the peace Uriah Lamar. Spencer County historian Steve Sisley recounts, "Believing that one of the men wouldn't approve of killing Set-te-tah, they sent him out to a well to get water but he returned before the killing was accomplished so one of the men spilled the water and they sent him out again. When he returned Set-te-tah was dead." The body of Big Bones was found in a tree, and folklore says that the Meeks family used his skull as a drinking vessel. (Courtesy of O. V. Brown collection.)

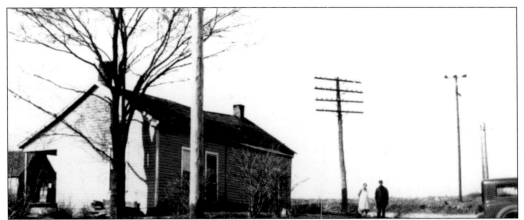

Abraham Lincoln read law in the log home of Constable David Turnham around 1824. Turnham was 16 at the time, and Lincoln had just turned 10 the month before. Turnham supplied the following description of Lincoln: "Lincoln had a strong mind. I was older than he was by six years and further advanced,—but he soon outstripped me. We'd but few books at that time and our opportunities were poor." The home shown in the photograph was where Turnham lived after 1835. (Courtesy of O. V. Brown collection.)

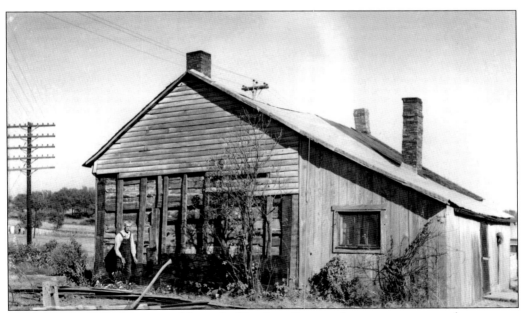

The Turnham house was moved from the Turnham farm, and an attempt was made to restore it. However termite damage was so extensive it could not be saved. Barbara Michel, the great-great-granddaughter of Turnham, married James Hevron and still lives in southern Indiana. Turnham told William Herndon, Lincoln's law partner, "I have a cupboard in my house now which Mr. Thomas Lincoln made for me about 1821 or '22." That cupboard now is in the Evansville Museum. (Courtesy of O. V. Brown collection.)

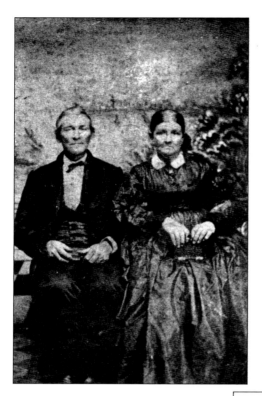

David and Matilda Turnham are pictured in their later years. Abraham Lincoln spent time with David in part because of their love of the law and books. When Lincoln and Turnham were growing up they lived in the area now known as Lincoln City. The Lincolns' farm was about two miles south of Dale, Indiana, writes Daryl Lovell in his book, *Dale, Indiana 1843–1993*. David was appointed constable and loaned Lincoln the first law book he ever saw, called *The Revised Statutes to Indiana*. Lincoln frequently returned to David's home to study and ask questions about the book. (Courtesy of O. V. Brown collection.)

In one of his letters to David, Lincoln wrote: "I well remember when you and I last met, after a separation of fourteen years, at the cross-road voting place, in the fall of 1844. It is now sixteen years more and we are both no longer young men. I suppose you are a grandfather; and I, though married much later in life, have a son nearly grown." (Courtesy of O. V. Brown collection.)

Orian Brown marked the spot with an X where the Romine-Gentry Store in Gentryville once stood. Lincoln was known to have spent time in this county store. There are still Romines and Genrtys in the area. (Courtesy of O. V. Brown collection.)

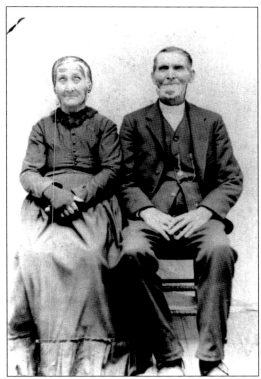

Rev. Allen Brooner and his wife are pictured here. Brooner was a friend of Lincoln's whose home was located near the Lincoln home. Brooner's wife was a friend of Nancy Hanks Lincoln, and it was Nancy who nursed her when she was dying of milk sickness. Within a few days, Nancy also died of the ailment, and they were buried side by side. The Brooners still live in the area, and members of the family own Brooner's Printing, located in Dale. (Courtesy of O. V. Brown collection.)

"When the Lincolns were getting ready to leave," Allen Brooner told William Herndon in 1865 when the historian was collecting information about Abraham Lincoln's time in Indiana, "Abraham and his stepbrother, John Johnston, came over to our house to swap a horse for a yoke of oxen. 'Abe' was always a quiet fellow. John did all the talking, and seemed to be the smarter of the two. If any one had been asked that day which would make the greatest success in life, I think the answer would have been John Johnston." This is a photograph of the Henry Brooner house, just north of Dale in Dubois County. (Courtesy of O. V. Brown collection.)

Abe Lincoln's friend, Henry Brooner recalled that in 1829, "Abraham Lincoln came to my house where I now live and left an article of agreement for me to keep." The article related to John Johnson, Lincoln's step-brother who worked at the distillery. "It is true that Lincoln did work the latter part of one winter in a small still house, up at the head of a plow." The quote is from the *Collected Works of Abraham Lincoln*. All the information was provided by historian Jerry Sanders. (Courtesy of O. V. Brown collection.)

According to Spencer County historian Steve Sisley, Lincoln made barrels for Reuben Grigsby, who had a springhouse and still between Gentryville and where the Lincoln State Park is now located. Grigsby's son Aaron married Abraham Lincoln's sister Sarah, who died in childbirth less than two years after their marriage. Sarah attended school with her brother, and Aaron's brother Nathan told historian William Herndon, "Sally was a quick minded young woman. She was more industrious than Abe, in my opinion. I can hear her good-humored laugh now. Like her brother, she could greet you kindly and put you at ease. She was really an intelligent woman." The photograph caption, written by Brown read, "Sarah Lincoln died here." Brown, who lived in nearby Dale, traveled the countryside recording spots with a known historical connection to Abraham. (Courtesy of O. V. Brown collection.)

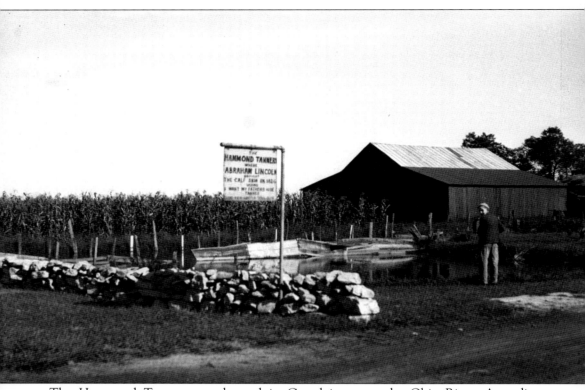

The Hammond Tannery was located in Grandview near the Ohio River. According to Spencer County historian Steve Sisley, it is well documented that Abraham Lincoln took calf hides to the tannery. "I knew one of the Hammonds," says Sisley. "He told me he once fell into one of the tanning pits and ended up getting his hide tanned twice." (Courtesy of O. V. Brown collection.)

Three

ON THE RIVER

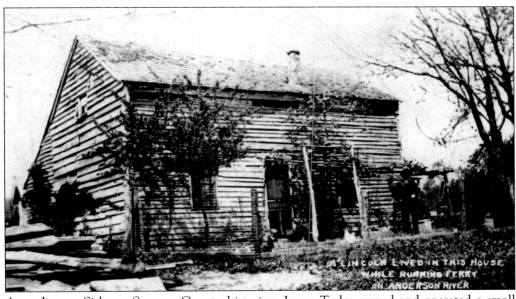

According to Sisley, a Spencer County historian, James Taylor owned and operated a small ferry that crossed the Anderson River. Lincoln lived in the Taylor home, shown above, while he worked for the family. There was a bell on the riverbank, and whenever someone wanted a ferry ride, they rang it. Lincoln was one of the people who ferried travelers across the river. For $6 a month he also plowed split rails and slaughtered hogs. It was the roughest work a man cold do, he later said. But it also opened up a new world of people traveling down the Ohio River. (Courtesy of O. V. Brown collection.)

In 1826, Abraham Lincoln worked here at the farm of James Taylor, earning the first money that belonged to him and not his father. He worked as a ferryman at the mouth of the Anderson River where it flowed into the Ohio River. This information is from historian Jerry Sanders. (Courtesy of O. V. Brown collection.)

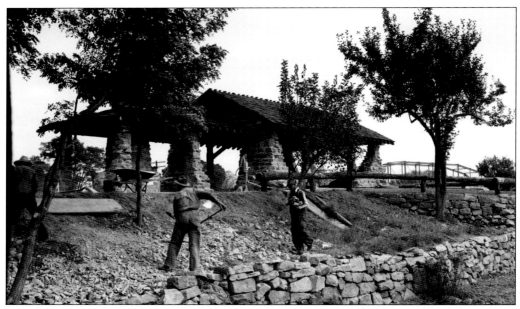

Lincoln built a scow while staying at the Taylor home. After taking two well-heeled men to a steamboat on the Ohio River, he was rewarded with two silver half dollars. "I could scarcely credit," he said, "that I, poor boy, had earned a dollar in less than a day." According to Steve Sisley, as Lincoln was paddling his boat back to the Indiana shoreline, he accidentally dropped one of the coins into the water. He recalled years later the anguish of seeing such a large sum disappear. This photograph, taken in 1939, shows men building the Lincoln Ferry Park. (Courtesy of O. V. Brown collection.)

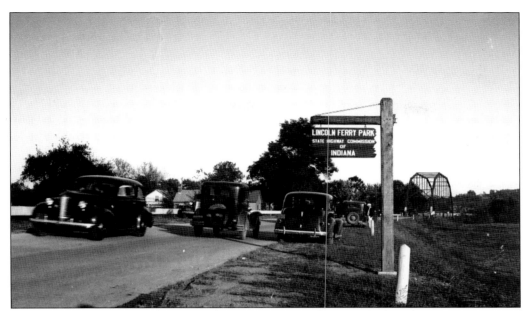

Green B. Taylor, the son of James Taylor, was interviewed at age 82 about his reminiscences of Lincoln. According to an 1895 article in *McClure* magazine, Green "remembers Mr. Lincoln perfectly, and wrote our Indiana correspondent that it was true that his father hired Abraham Lincoln for one year, at six dollars a month, and that he was 'well pleased with the boy.'" (Courtesy of O. V. Brown collection.)

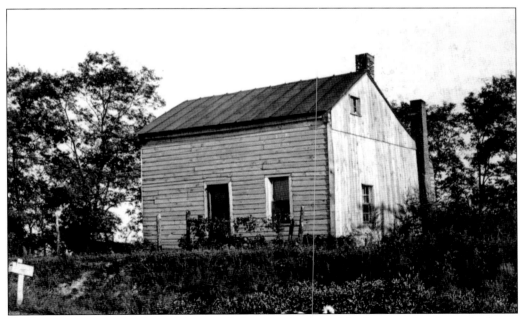

"A. Lincoln was in this house" is one of the notations on this photograph taken of a home in Grandview, a small town on the Ohio River in Spencer County. Daryl Lovell was able to read the barely discernable writing indicating that Thomas Lincoln helped build the house. (Courtesy of O. V. Brown collection.)

Judge Squire Pate's home was located in Hawesville, Kentucky, and it was here that Abraham Lincoln, aged either 16 or 17, was taken for trial in 1827 after his arrest for transporting several gentlemen halfway across the Ohio River to a steamboat. The Dill Brothers had exclusive rights to ferry passengers back and forth from Indiana to Kentucky, and they objected when Lincoln stole their customers. Lincoln, not yet a lawyer, argued in front of Pate that he had only taken the men to the middle, not across the river. Across, he said, meant from one side to another. The judge agreed, and Lincoln won his first case. (Courtesy of O. V. Brown collection.)

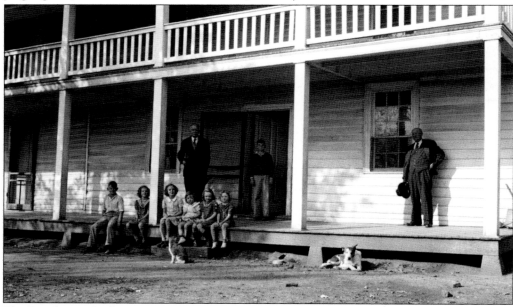

The Pate house, built in 1822, is now a museum open to visitors. According to Spencer County historian Steve Sisley, while in the home, Lincoln noticed Pate's books and made several trips to the home to read them. (Courtesy of O. V. Brown collection.)

Four

THE CIVIL WAR

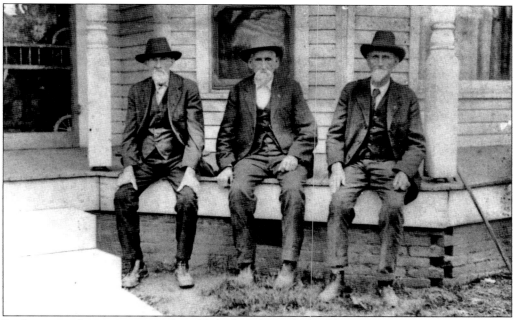

In the original newspaper article published in the *Dale Weekly Reporter*, brothers John, Elijah, James, and William Whitten are shown. In this photograph, only Elijah, James, and William are featured, as the newspaper had inserted John's photograph. The brothers were all over 80 years old when this picture was taken. Each had served in the Civil War. James was the great-great-grandfather of Daryl Lovell. Lovell tells the story of how James was hit by a cannonball, and his brother William stopped to help. His commanding officers ordered him to keep going. He disobeyed and took his brother to the doctor. Within a few years of this photograph being taken, all the brothers would be dead. (Courtesy of O. V. Brown collection.)

The oldest of the Whitten brothers, John, who was 86 in this photograph, moved to Evansville while his other brothers remained here. Two of the brothers married Winkler sisters. A 1925 newspaper article says that two of the brothers were Republicans and two were Democrats. (Courtesy of O. V. Brown collection.)

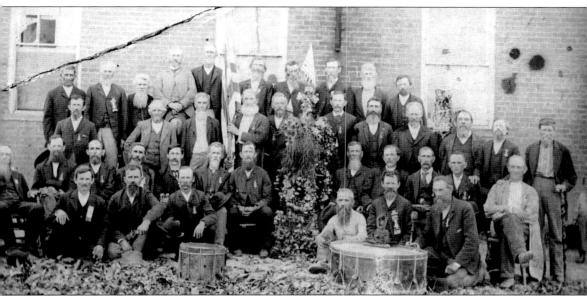

This undated photograph shows a gathering of the veterans of the Grand Army of the Republic (GAR). The soldiers would come to Lincoln City to visit the grave of Nancy Hanks Lincoln. According to Jim Havron, they would arrive for three days and would number up to 100. According to information supplied by Daryl Lovell, "though not all these soldiers were from the 42nd Indiana Volunteer Regiment, that unit was organized at Evansville, Indiana in October, 1861. It fought at Murfreesboro and Stone River; then at Chickamauga, Lookout Mountain, and Mission Ridge. After re-enlistment in January 1864, the regiment joined Sherman near Chattanooga, took part in the campaign before Atlanta, pursued Hood into Alabama, and ended the war pursuing Johnston through North Carolina." (Courtesy of Joe A. Hevron.)

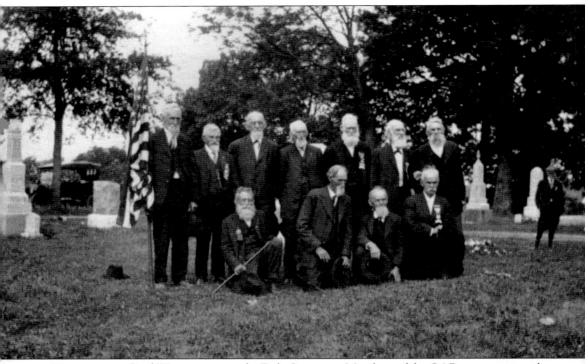

Here are some Civil War veterans at the Dale Cemetery. Members of the GAR came to pay tribute to Abraham Lincoln's mother at her grave site in nearby Lincoln City. Because of local option laws, thirsty men from Dale and other area communities rode the train to the very wet Lincoln City. The visiting vets enjoyed stopping there too. (Courtesy of O. V. Brown collection.)

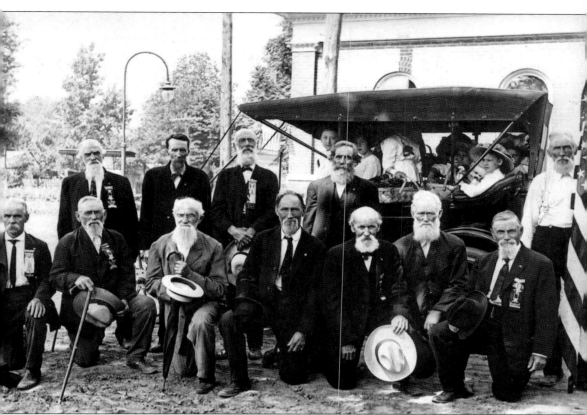

This photograph, taken on May 30, 1911, shows Civil War veterans at the corner of Main and Medcalf Streets in Dale before their march to the cemetery. They are standing in front of the Dale State Bank (now Brooner Printing). Pictured from left to right in front are Alexander Mills, William Wood, Michael Heichelbech, Elijah Whitten, Wesley Brown, Ed Stone, and John Schaaf. The flower girls seen sitting in the car marched to the graves where they scattered flowers. James Whitten is the man in the white shirt and matching beard holding the American flag at right. Note the carbide gas lamp at left. Dale was home to a carbide gas company and the town marshal lit these lamps each evening and extinguished them in the morning. This information was provided by Daryl Lovell, coauthor of *Dale, Indiana 1843–1993*. (Courtesy of O. V. Brown collection.)

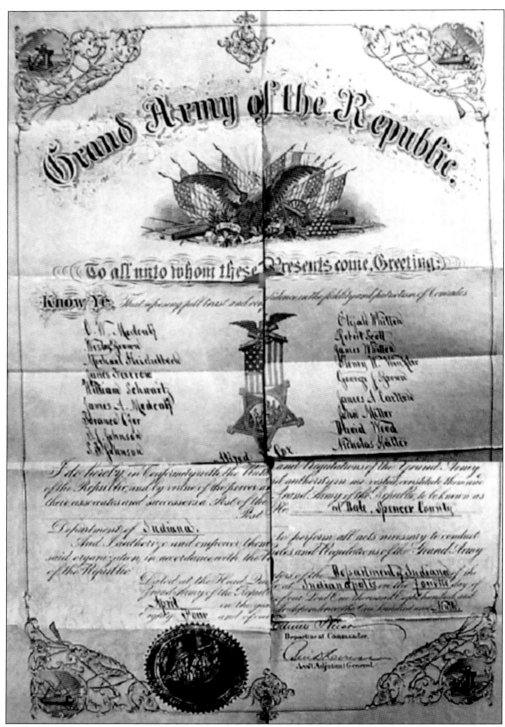

The original charter for the GAR in Dale lists members from the Whitten and Medcalf families, among others from Dale, Indiana. (Courtesy of O. V. Brown collection.)

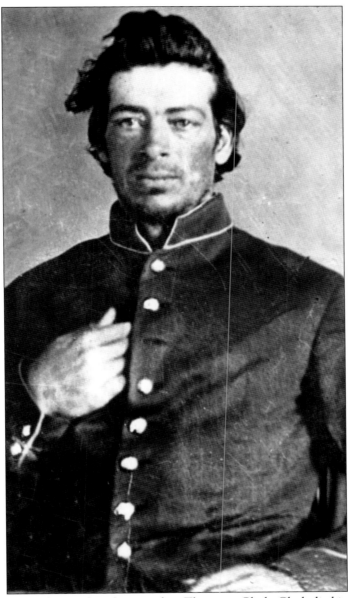

The rather dashing soldier in this photograph is Thornton Clark. Clark died in Andersonville, the notorious Confederate prisoner of war facility, in 1864. A document in the Indiana Historical Society describes Clark as a phonetic speller of words such as "rebble," "attact," "shugar," "ridgement." Besides being a skilled carpenter, Clark was a deeply religious man who frequently wrote his wife, Nancy, asking her to make sure the children attended Sunday school and attributing thunderstorms to the wrath of the Lord against the company commander. He was frequently sick and missed the battle of Murfreesboro on that account. He was continually hopeful that the war would soon end. After his death at 38, Nancy received a widow's pension on which she supported their four children. She never remarried and died in 1918 at age 85. Thornton is the great-great-great-grandfather of Daryl Lovell who provided photographs and information for this book. (Courtesy of O. V. Brown collection.)

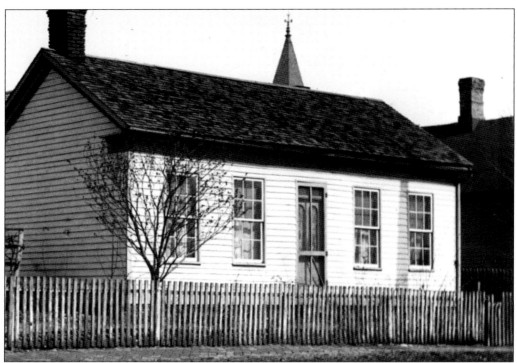

Thornton Clark built this charming house in Dale before serving in the Civil War. It remained in the Clark-Brown family until the 1960s when it was torn down. "My Uncle Paul Brown had his dentist office here," recalls Daryl Lovell. (Courtesy of O. V. Brown collection.)

Taken prior to 1918 in one of the original structures of the Lincoln State Park, this image, recaptured from a glass negative by Lovell, shows many generations of the Brown family. In the second row, second from the right, is Nancy, whose husband, Thornton, died at Andersonville Prison in 1864. Lovell's great-grandmother Florence Brown is the little girl on the right. Lovell's great-great-grandfather Albert Frederick Brown is the man standing in the first row on the far right. (Courtesy of O. V. Brown collection.)

Five

LINCOLN'S PEOPLE AND PLACES

So much of the history of Abraham Lincoln's years in Indiana would have been lost if not for Orian (O. V.) Brown (1889–1966), who had a passion for preserving the places that Lincoln visited and the families of the people whose relatives had crossed paths with the 16th president. Brown, who lived in Dale near the Lincoln farm, is shown here as a young boy. The Brown family tree includes Clarks and Lovells. (Courtesy of O. V. Brown collection.)

O. V. Brown worked for the Brown Brothers, a family-owned lumber business that is still operating in Dale. Brown traveled the winding roads of southern Indiana with his camera, capturing the essence of Abraham Lincoln's time here. So much of what he photographed, including the Huffman Mill and the Turnham and Brooner homes, are gone now. Many of his photographs as well as his extensive collection of Lincoln memorabilia are on display at Holiday World in nearby Santa Claus, Indiana. (Courtesy of O. V. Brown collection.)

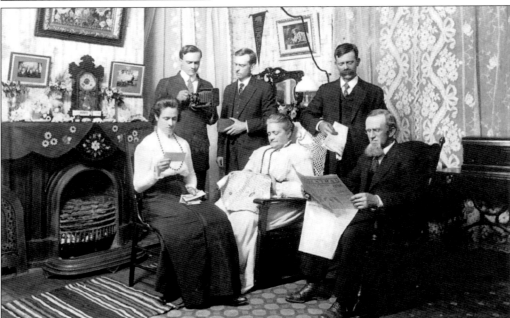

Brown is holding a camera in the family photograph taken in the early 1900s at their home in Dale. He became recognized as an authority on Lincoln, and Carl Sandburg, the great poet, even visited him. Brown recognized that it was important to preserve Lincoln sites that were rapidly disappearing. (Courtesy of O. V. Brown collection.)

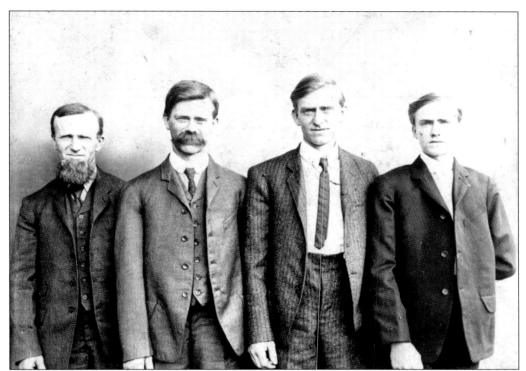

From left to right, Albert Brown is pictured with his three sons, Frank T., Albert J., and O. V. (Courtesy of O. V. Brown collection.)

In his book, *Dale, Indiana 1843–1993*, Daryl Lovell and Ellen Winkler Rexing write, "When in 1868, Albert F. Brown started a carpenter's shop in Dale, little did he think that this little business place would some day be the present Brown Bros. One of Mr. Brown's first jobs was to help build the Anderson tobacco factory." (Courtesy of O. V. Brown collection.)

Albert Brown's father, Frederick Brown, who came from Morges, Switzerland, was a millwright and built a sawmill and a gristmill southeast of Huntingburg. Thornton Clark, a grandfather of the Browns, conducted a furniture factory in Dale making chairs, bedsteads, and other furniture. Clark operated his little factory before the Civil War just a block west of the present location. Brown Brothers literally helped build Dale. It erected three of the tobacco warehouses, two schoolhouses, three churches, several small businesses, and many residences. (Courtesy of O. V. Brown collection.)

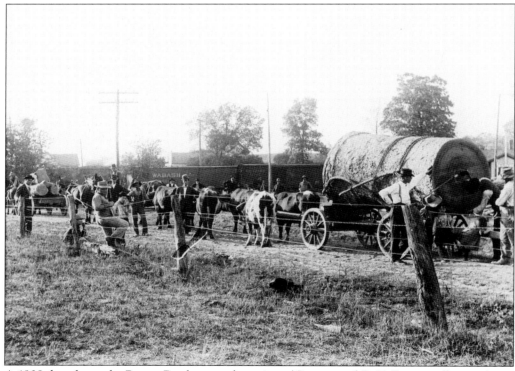

A 1908 shot shows the Brown Brothers at a busy time. (Courtesy of O. V. Brown collection.)

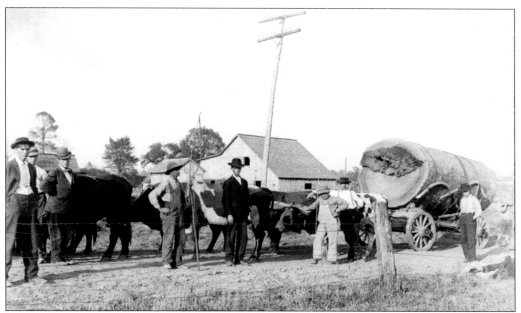

Brown Brothers was not the only sawmill in Dale in the late 1800s. According to Daryl Lovell, "In 1894, there was a saw mill located at the depot with that mill reporting they were handling eight or ten wagons of logs daily and employed 25 men." (Courtesy of O. V. Brown collection.)

"In 1895, Albert F. Brown built a section of the present building," writes Daryl Lovell, who coauthored *Dale, Indiana 1843–1993* with Ellen Winkler Rexing. "He installed a 4-horse power engine and they ground plow points and did other sundry small jobs. The first circle saw for log sawing was put in the mill in 1900. A. F. Brown's sons, F. T. Brown, A. J. Brown and O. V. Brown, joined the business and the business became known as Brown Bros. Lumber Co." (Courtesy of O. V. Brown collection.)

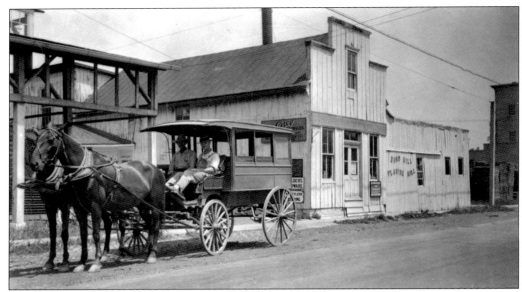

The Browns were granted a patent by the federal government in 1922 on a log-loading device. By 1932, Brown Brothers was one of the best equipped sawmills and planing mills in this section of the state. At that time, it employed 20 men. (Courtesy of O. V. Brown collection.)

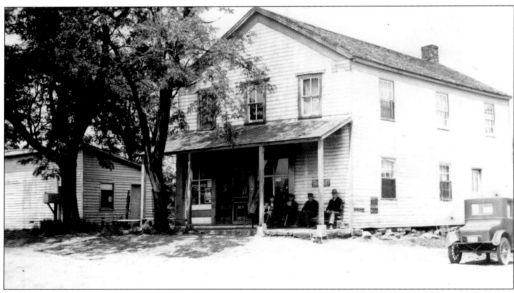

Even after Lincoln's time, country stores continued to be a big part of Southern Indiana life. Abraham Lincoln clerked at a store in Gentryville, though this store, also in Gentryville, was long after his time. Once when Lincoln was clerking, he shortchanged a customer by 3¢. When the store closed, Lincoln walked two miles to return the money. This 1935 photograph shows the Harris-Hopkins Store. The third person from the right is James Romine Hevron, and the Model T Ford parked to the right is his car. This is thought to be the earlier Romine-Gentry Store. (Courtesy of Sandra Hemingway.)

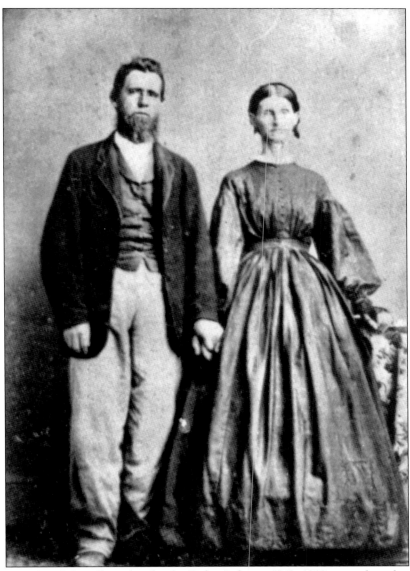

According to Daryl Lovell in his book, *Dale, Indiana 1843–1993*, coauthored with Ellen Winkler Rexing, Lincoln's friend David Turnham was a constable for Squire William Wood's court. "William Wood influenced Lincoln almost as much as David Turnham," Lovell quotes S. Grant Johnson as saying. "Squire Wood was the brother of Dale's first name-sake, Elizabeth Jones. Lincoln attended all the trials that Squire Wood presided over. Wood also received the newspapers of that time. But it was said that no one paid much attention to the papers till neighbors gathered in to hear Abe read them. Abe was the best reader in the community and would often hold the paper up in front of him and read articles that were not there. Mr. Wood was an abolitionist. And it was in Mr. Wood's cellar where Abe saw the shivering and scared slaves huddled while waiting to continue their journey on the Underground Railroad. Abe played with Wood's children and called the Squire Uncle Lincoln later referred to Wood as his 'devoted friend and mentor.'" This is a photograph of the squire's daughter Margaret with her husband, James Hammond. (Courtesy of O. V. Brown collection.)

This is the John Turnham, son of David, store interior. According to Daryl Lovell in his book, *Dale, Indiana 1843–1993*, coauthored with Ellen Winkler Rexing, Abraham Lincoln was 16 years old when David Turnham's first child was born. "Soon after the birth of the little girl, Lincoln walked through deep snow to see his friend's daughter. Lincoln and Turnham talked about a name. Abe said he loved his mother's name and so it was agreed to name the baby after Abe's mother, Nancy. In later years Nancy Turnham married Thomas Medcalf. There is a Medcalf Street in Dale, and photographs from the early 1900s show several Medcalf family members. (Courtesy of O. V. Brown collection.)

John Jones Turnham and Melissa Baker Turnham are pictured here. "When Thomas Lincoln and family moved from their home, where Lincoln City is now located, to Illinois, they went through what would become the town of Elizabeth now Dale, passing the home of David Turnham in the south part of town," writes Brown in his book *Dale, Indiana 1843–1993*, coauthored with Ellen Winkler Rexing. (Courtesy of O. V. Brown collection.)

Here is John later in life. "I would like to visit the old home and old friends of my boyhood," Lincoln wrote in October 1860 to David. "But I fear the chance for doing so soon is not very good." (Courtesy of O. V. Brown collection.)

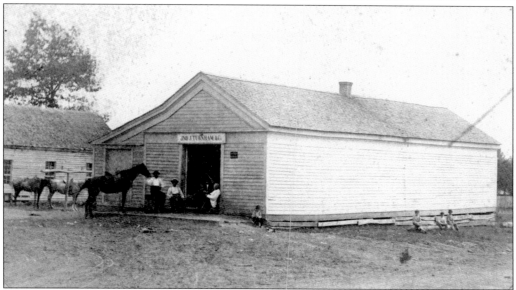

Seen here is the exterior of the Turnham Store. Turnham was visited by William Herndon, who was Lincoln's law partner when he lived in Illinois. Herndon came to Elizabeth (now Dale) on September 15, 1865, to talk to people who had known Lincoln in his youth and eventually wrote the book *The Life of Lincoln.* Turnham recalled Lincoln's dress, "Buckskin for pants—wore coonskin caps—sometimes fox, skin and sometimes possum skin caps. Buckskin was a common dress at that time." (Courtesy of O. V. Brown collection.)

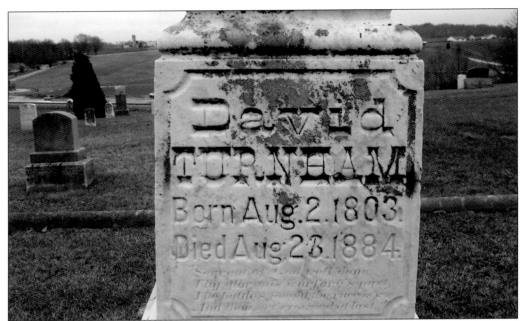

"Although quick witted and ready with an answer," David Turnham said about his friend years later, "he began to exhibit deep thoughtfulness and was so often lost in studied reflection we could not help noticing the strange sensitiveness, especially in the presence of men and women, and although cheerful enough in the presence of boys, he did not appear to seek our company as earnestly as before." Turnham is buried in the Dale Cemetery. (Courtesy of O. V. Brown collection.)

The Bockstahler School was a small country school located just about a mile southeast of Dale. Sarah and Abe Lincoln did not attend school often, as they had too many chores.

Six

LINCOLN CITY

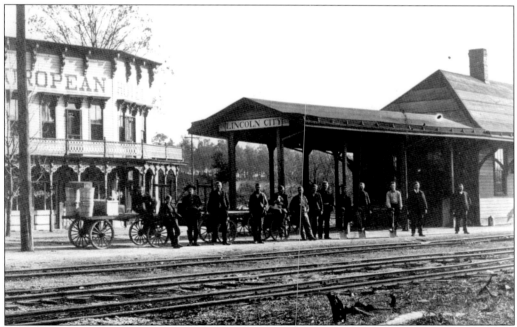

According to the Hevron family cookbook *Our Lincoln Heritage: Recipes and Reflections*, which contains information around 200 years of Hevron family history in southern Indiana, Lincoln City is one of the many little towns and big cities connected by railroad which opened the country to travel during the late 19th century. The town was platted on April 23, 1872, and some say the post office, which had been called Kercheval (named after ancestors Ken Kercheval, star of television show *Dallas*,) was changed to Lincoln City on April 1, 1892. (Courtesy of the Hevron family.)

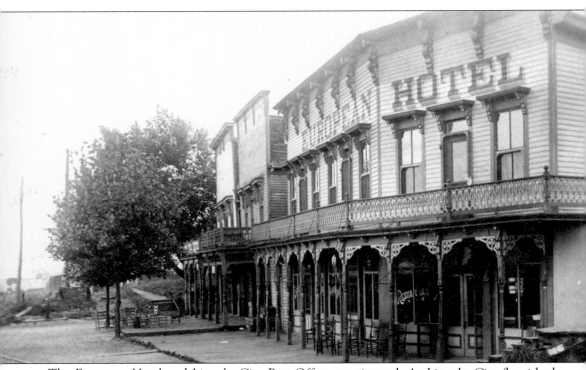

The European Hotel and Lincoln City Post Office are pictured. As Lincoln City flourished, hotels such as this one were built to accommodate both travelers who were passing through and those who wanted to visit the land where Abraham Lincoln had lived. Every year, the GAR held a reunion here and many of the Civil War veterans arrived in Lincoln City by train. The European Hotel opened between 1895 and 1900 and was known locally as Mrs. Egbert's Hotel. It burned down Easter Sunday of 1916. According to Jim Hevron, shortly after the noon train departed, travelers on the depot's porch noticed a fire on the roof of the post office. Within five minutes, all four buildings, including the hotel, were engulfed in flames and soon 17 buildings, including Rhode's Livery Barn (which was full of hay), were burning. With the strong wind and the hay, the fire raged out of control. (Courtesy of James Hevron.)

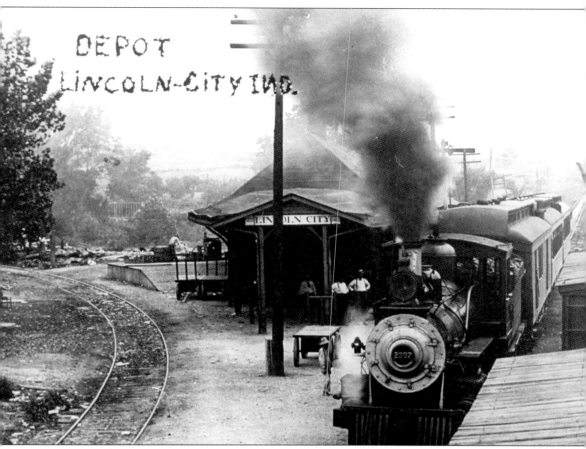

The story of the area that became Lincoln City is also the story of many families who still live here, including the Romine-Hevron-Gentry families who owned vast tracks of property in Lincoln City and Gentryville. "Our ancestors deeded the church and cemetery where Sarah Lincoln and her child are buried," says Jim Hevron. James and Elizabeth Gentry came to the Little Pigeon Creek area in the early 1800s, as did Christopher and Margaret Romine. When Abraham Lincoln lived in this area, it was known as Little Pigeon Creek. (Courtesy of James Hevron.)

The Tom and Lizzie Lipsey store in Lincoln City is seen here in the 1940s. Through the years the store was owned by many people starting with A. J. Rhodes, prior to 1900 according to information provided by Jim Hevron. (Courtesy of Sandra Hemenway.)

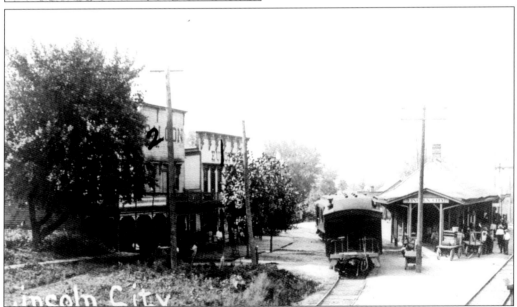

The caption on this photograph says that it was taken before the fire, probably the one in 1911, which destroyed many of the commercial buildings in Lincoln City. Back then, most buildings were made of wood and frequently towns and cities were hard hit by fires. Several fires roared through Lincoln City in the early part of the 1900s, destroying the commercial area. (Courtesy of O. V. Brown collection.)

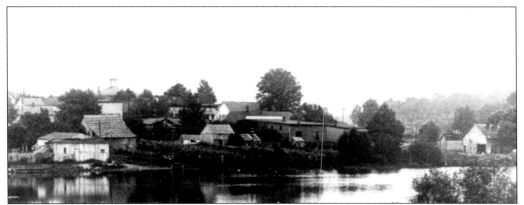

A 14-acre lake created for steam engines, it gradually filled in after the advent of diesel engines. Now woodland, Joe Hevron recalls, "When we were kids we could put our skates and skate all the way down the ditch to the pond." Jim Hevron points out that the cupola from the Lincoln City School is in the background. The lake was also used for swimming, fishing, and boating. (Courtesy of Hevron family collection.)

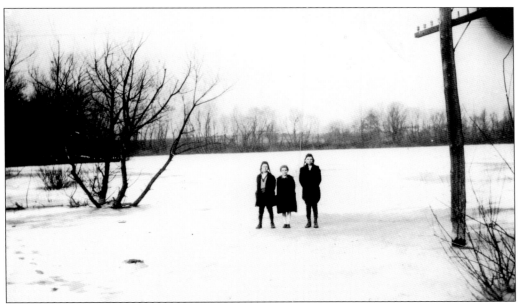

This photograph of the frozen Southern Railroad Pond was taken in January 1936. The children, from left to right, are Joe Woods, Florence Woods, and George Woods. According to historian Clayton Spurlock, the 17.3-mile trip from Lincoln City south to Rockport had eight stops, and a round-trip ticket cost $1.25. "Those of us who grew up here will always remember the trains and the hustle and bustle around this depot," he says in his film about Lincoln City. At the end of the 19th century, Lincoln City was one of the largest railroad centers in southern Indiana. (Courtesy of Sandra Hemenway.)

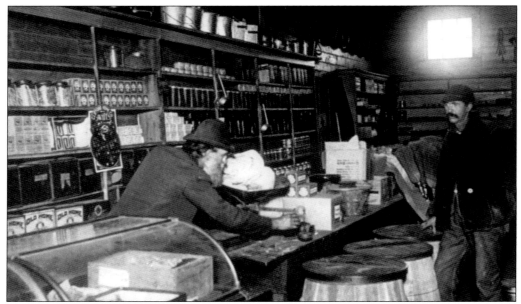

The interior of the William Van Winkle store is pictured. The gentleman weighing the material on the scale is Van Winkle. He operated a barbershop and post office in the building. The Van Winkle Country Store was one of many in Lincoln City. Around 1900, according to Jim Hevron, there were four in the small town. During the 1921 fire, all the mail from the post office was moved here and saved. (Courtesy of Ray Van Winkle.)

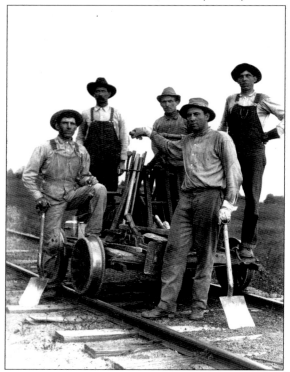

The Southern Railroad section gang, based in Lincoln City, are pictured here. From left to right are Edward Crooks, foreman John Staten, Charles Oskins, Earl Anderson, and Rollie Staten. The handcar was used for transportation. (Courtesy of James and Barbara Hevron.)

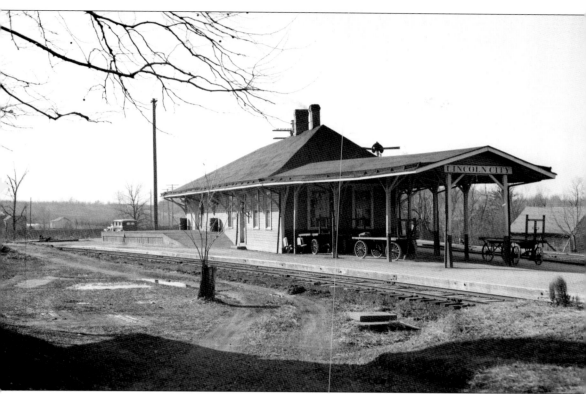

According to local historian Clayton Spurlock, at one time, a train left the Lincoln City depot every 30 minutes. Many families that lived in Lincoln City had relatives who worked for the railroad, including the Hevrons, whose family's roots trace all the way back to the early 1800s. Ancestors of the Hevron family, who included the Lipseys and Statens, owned stores in Lincoln City. Much of the commerce of the city was dependent upon the railroad, and for a time, the city flourished. This is one of three depots built in Lincoln City and this photograph, with the car in the background, shows how transportation was changing. By the 1950s, cars and highways eclipsed the railroads. (Courtesy of O. V. Brown collection.)

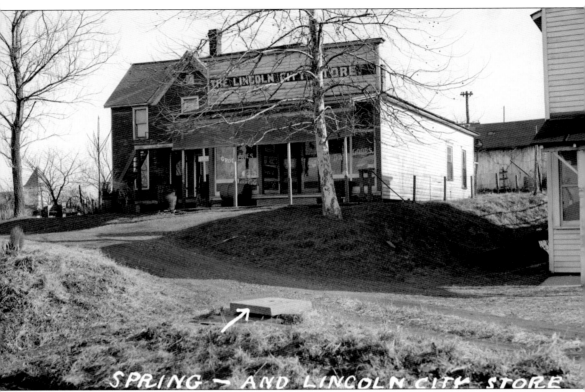

SPRING — AND LINCOLN CITY STORE

The Lincoln City store was near where Joe Hevron grew up. "We called it the Staten store as it was owned by John and Clara Staten who later sold it to John and Nan Hile," he recalls. "Reverend Fleener lived in the house next door. In the background is the Lincoln City Evangelical United Brethren Church. We drank water of the well right in front using a well bucket. The well is now in surrounded by a fence in the Lincoln Boyhood National Memorial." (Courtesy of O. V. Brown collection.)

June's Place was owned by the parents of Jeny Sanders, who worked at the Lincoln Boyhood National Memorial for 25 years and was chief of operations there. Shown in this photograph is Jeny's father Junious. (Courtesy of Jerry Sanders.)

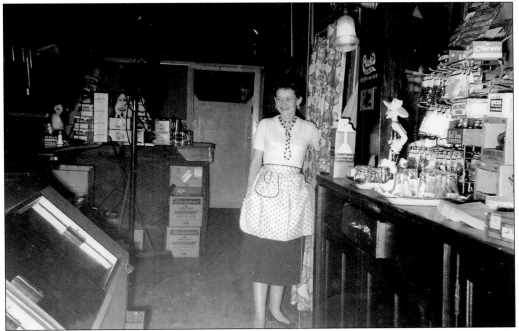

June's Place operated for 19 years before being sold to the federal government as part of the land acquisitions process that consolidated the current boundaries of Lincoln Boyhood National Memorial. This photograph shows Florence Sanders. (Courtesy of Jeny Sanders.)

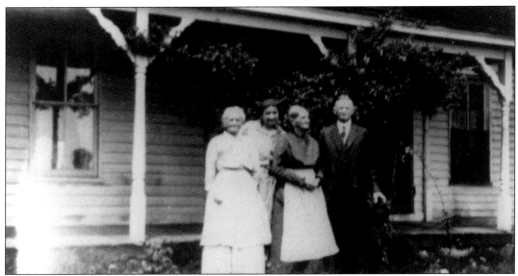

Members of the Gentry and Romine families are pictured in front of their homestead. Each of these families can trace their heritage back to the days when the Lincolns lived in southern Indiana on land not far from the Lincoln homestead. The old roadway that Abraham Lincoln walked, which ran within 150 feet of this house, can still be seen. From left to right are Eliza Romine Hevron, her daughter Bertha Hevron, and Charlotte Romine Stockings. The man is unidentified. (Courtesy of Hevron family collection.)

Built in 1930, the United Brethren Church, according to Lincoln City resident Joe Hevron, and then the Evangelical United Brethren Church, was on the grounds of the original Thomas Lincoln farm. Allen Brooner, Lincoln's friend, preached in front of the original congregation on October 5, 1857. (Courtesy of O. V. Brown collection.)

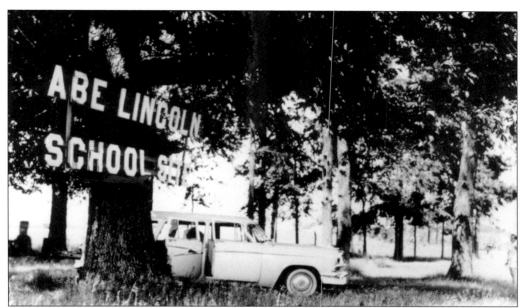

When Helen Hevron and her brother John Woods attended grade school in Lincoln City, there was more than one class in a schoolroom. When Hevron was asked during a health lesson what she had eaten for breakfast that morning, she answered pancakes. Her brother, in the back of the class, added that she had eaten nine of them, and she saucily replied, "They were small ones." (Courtesy of O. V. Brown collection.)

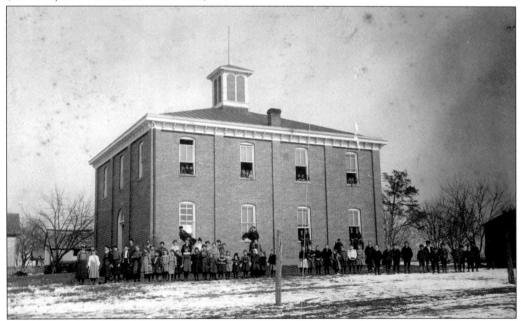

O. V. Brown's notation on the photograph reads, "Lincoln City School on Lincoln Farm." Information provided by Daryl Lovell indicates that the school stood on the same site as the present Lincoln cabin at the Lincoln Boyhood National Memorial and about 100 feet from where the cabin stood when the Lincolns lived here. (Courtesy of O. V. Brown collection.)

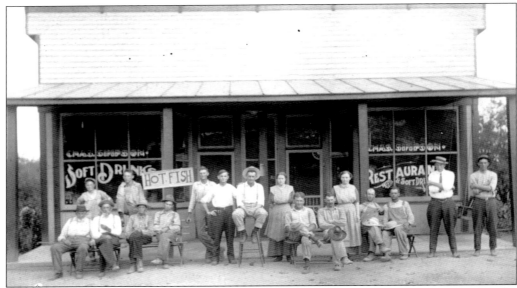

Shirley Skelton sits on a stool at the Charlie Simpson Restaurant in Lincoln City. Others in the photograph include Charlie, Maggie Simpson, and Carrie Skelton. Jim Hevron and his sister Beverly remembered being welcomed into the Skelton's family home anytime of the day or night. (Courtesy of Doris Murray Schulte.)

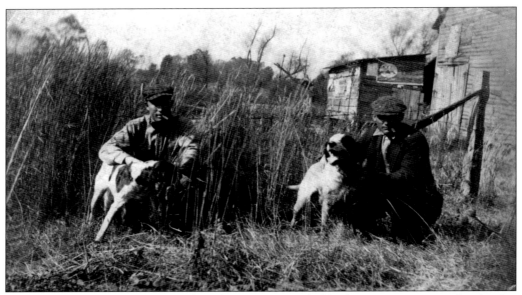

Roy "Uncle Hopper" Hopkins and Nick Hevron once held a hunting contest to decide who had the best bird dog according to Hevron family lore. "After the hunt, both pair returned and emptied their hunting coats. One pair had 74 quail and the other pair 72." Hunting and trapping was a way of life for the men and the boys in Lincoln City and it was not just for support. The hides were sold for extra money and the game served at the family table. (Courtesy of Hevron family collection.)

Bill Hevron and Nelson Klingensmith are seen sitting on a coal pile. "Sgt. Nelson Klingensmith is missing in action," read the newspaper headline about the Lincoln City native missing in action over Germany during World War II. Klingensmith was a member of the crew of a Flying Fortress. His parents feared the worst and were surprised one day when they read about a prisoner of war who was a cartoonist. It was their son. He returned home after the war and still lives in the area. (Courtesy of James and Barbara Hevron.)

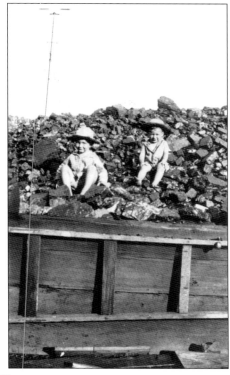

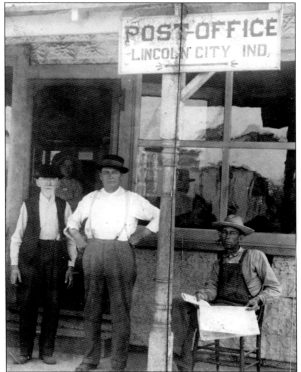

The William T. Van Winkle store sat just east of the Cannelton Branch Railroad tracks west of the Lincoln cabin site. The Lincoln City Post Office was also housed in this building. The men in the picture are, from left to right, Samuel "Pa" Bench; John Collier, the postmaster from 1897 to 1914; and Willie Bench. This was one of four stores that operated in Lincoln City at the time. The post office remained in the building until 1944. There was also a barber shop and Joe Hevron, a long-time Lincoln City resident, got his hair cut there. (Courtesy of Hevron family collection.)

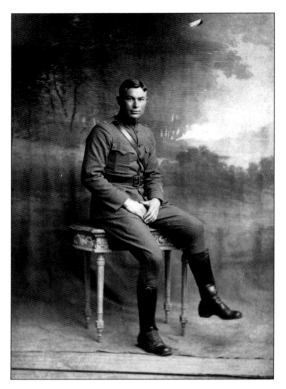

Roy C. Hopkins was born on October 12, 1893, and raised on the Ferguson-Hopkins farm in Lincoln City. The north part of this farm had been the farm of Tom Lincoln and Roy's grandmother. Ferguson's home sat about 500 feet from the Lincoln cabin site. Hopkins went to work as a brakeman for the Southern Railway on February 5, 1913, then was drafted into the U.S. Army on September 17, 1917, and was discharged on June 26, 1919, as a second lieutenant. Hopkins was promoted to conductor in 1937. He worked for the railway for 47 years. This photograph was taken in France after he graduated from officer training school. (Courtesy of James and Barbara Hevron.)

Bill Hevron is seen here standing in front of the Lincoln City train depot. He later moved to Michigan and became a sportscaster, and then worked for NBC. (Courtesy of Joe Hevron.)

Seven

LINCOLN LAND

Like the Huffman Bridge located near the old Huffman Mill that was frequented by Abraham Lincoln, most covered bridges in Indiana were built between 1856 and 1922. Approximately 1,500 bridges still exist in the U.S. and about 90 of them are in Indiana. The Huffman Bridge was built in 1864 by William T. Washer of nearby Troy at a cost of $5,700. It is still standing today on County Road 1490 North, and has been repaired and painted since this photograph was taken in the mid-1990s. (Courtesy of O. V. Brown collection.)

The development of Lincoln Boyhood National Memorial was part of the push to preserve Abraham Lincoln's heritage. William Koch, owner of Santa Claus Land, about five miles east of the park, was instrumental in the late 1950s and early 1960s in turning this land into the first national park in Indiana. (Courtesy of O. V. Brown collection.)

Mid-town — Dale, Indiana — 1 Block E. Jct. Ind. 68 &
U. S. 231, on U. S. 460 — Greyhound Station 1 Block

Abe Trails Turotel

RESTAURANT - CAR SERVICE 100 YDS. - NEWSPAPER - RADIO
MAPS - CAR PORT AT DOOR
MINUTES ONLY FROM ALL POINTS OF INTEREST
LINCOLN COLLECTION ADJACENT
CATERING TO COMFORT AND CONVENIENCE OF TOURISTS
TO INDIANA LINCOLN LAND

Sleep better at

O.UR V.ERY B.EST ROWN'S

(over)

O. V. Brown not only recorded Lincoln sites, he also ran what was known as a "turotel," or overnight accommodations for travelers. While the term never caught on, Brown's Abe Trails Turotel in Dale was the perfect stop for those wandering the Lincoln Heritage Trail. (Courtesy of O. V. Brown collection.)

Charles Rice is pictured on his motorized bike in front of O. V. Brown's Abe Trails Turotel. Besides Brown, William Koch was also a proponent of preserving Lincoln's Indiana heritage. Koch built nearby Santa Claus Land into the powerhouse Holiday World and Splashin' Safari, a theme park that attracts about one million visitors during the four months each year it is open. He also traveled to Washington, D.C., and even Japan to spread the word of Lincoln having lived in Indiana. (Courtesy of O. V. Brown collection.)

O. V. Brown was considered one of the foremost Abraham Lincoln historians in this part of the country. "His house was filled to the rafters with his Abe Lincoln collection," said Grace Marshall Brown, who was married to Brown's nephew and was the editor of the *Dale News* at one time. "We used to say that he probably had a rock that Abe stubbed his toe on. Somebody would say 'Here comes Orie with Windell's customers kicking and screaming to show off his Lincoln collection.'" (Courtesy of O. V. Brown collection.)

Photographed at their cabin near the Dale train depot on December 25, 1921, from left to right, are (first row) Ralph Schroer, Ketchen Morlen, Guy Musgrave, Owen Barr, Clarence Schaaf (holding a flag), Wallace Wilkie (holding a flag), Ora Niehaus, Herschel Morlen, Wallace Whitten, Ford Scott, and Charles Barr; (second row) Ervin Hile, Frank Brooner, Paul Brown, O. V. (scoutmaster), Walter Wilkie, Emanuel Kitchen, and John Snyder. Whitten was the grandson of Civil War veteran James Whitten and the grandfather of Daryl Lovell, who lives in Dale. (Courtesy of O. V. Brown collection.)

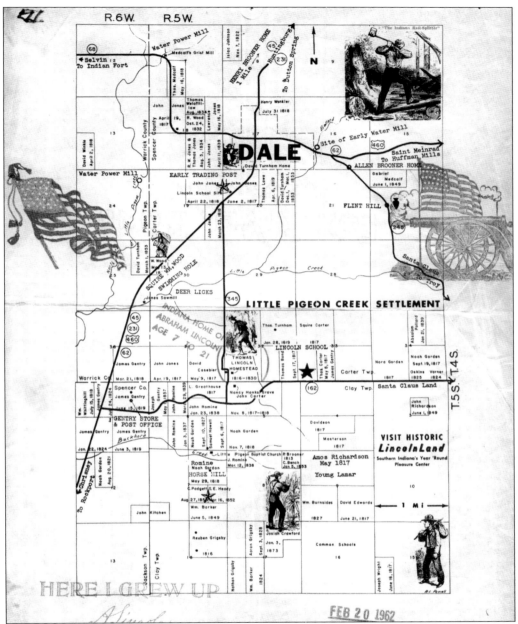

A tourist map, stamped "Here I grew up," which was Lincoln's description of southern Indiana in a reminiscence he wrote about his Indiana days, offers a guide to visitors of historic Lincoln land. "The fact that most tourist guides invariably showed a picture of the grave of Nancy Hanks Lincoln and ignored Lincoln's boyhood was a source of unending frustration to him," said Grace Brown in a speech about her husband's uncle, O. V. "He designed and paid to have printed thousands of maps pinpointing the Thomas Lincoln farm, the school site where Abe received his only formal education; Little Pigeon Creek Cemetery where his sister was buried and countless other little-known facts and sent them to presidents, governors, mayors and tourist organizations." (Courtesy of O. V. Brown collection.)

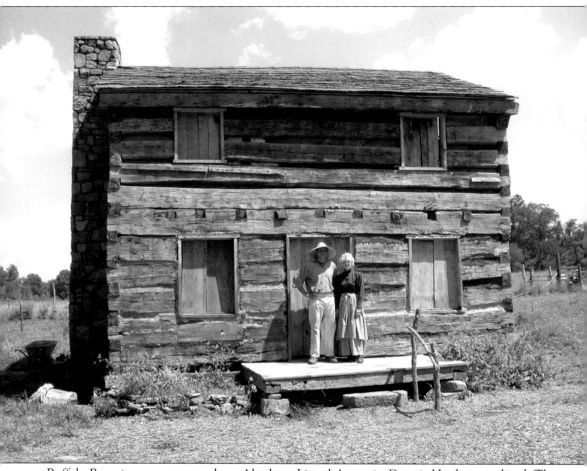

Buffalo Run sits on property where Abraham Lincoln's cousin Dennis Hanks once lived. The theme of this property is commemorative of the Buffalo Trace, which once ran through Spencer County near Buffaloville. The legend of the cabin is that young adult Lincoln was returning from a trip to the Huffman Mill in 1830. He stopped to let his oxen take a drink about eight miles from his home. The story claims that the yoke of the oxen broke and fell into the water, making it impossible for Lincoln to finish the trip. Lincoln was forced to spend the night in order for a new yoke to be fashioned the next morning. It is believed that the two-story cabin could have been an inn. Owned by Mike and Kathy Crews, Buffalo Run sells buffalo burgers and ice cream, and the land out back has buffalo and ostriches. (Courtesy of Legendary Places.)

Dale school pupils identified are Allen Brooner, Earl Michel, Ernest Woods, Victor Wertman, Bill Rice, Grand Michel, Bill Winkler, Charles Medcalf, Junior Woods, Catherine Richardson, Malee Medcalf, D. W. Medcalf, Ralph Woods, Uls Woods, Kenneth Rice, Lloyd Woods, Ralph Giepenstroh, Kenneth Michel, June Medcalf, Kathryn Medcalf, Jeanette Medcalf, Joe Rice, Louette Rice, Florence Winkler, Emman Jayne Jennings, Nelson Klingensmith, Eldo Griepenstroh, Ida Dale Avery, Betty Jo Heichelbech, Kathryn Mae Gentry, Nadine Medcalf, Madeline Richardson, Joan Richardson, Betty Flo Whitten (Daryl Lovell's aunt), Bill Hevron, Ella Mae Jennings, Wanda Medcalf, and Lorain Jones. These pupils were the descendants of people who were friends and neighbors of the Lincoln family in Spencer County. (Courtesy of O. V. Brown collection.)

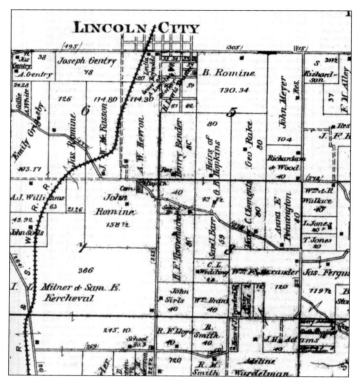

According to the 1885 *History of Warrick, Spencer, and Perry Counties, Indiana,* by Goodspeed Brothers and Company, at one time, the area where Lincoln City is now located was known as Kercheval, which was also the name of the post office. According to Clayton Spurlock, the Kerchevals were large landowners in the area, but in 1881, William Bender successfully petitioned to have the name changed to Lincoln City. Ken Kercheval, star of the television show *Dallas,* traces his ancestry to this part of the state. This map is from the *1879 Historical Atlas of Spence County* by D. J. Lake and Company. (Courtesy of O. V. Brown collection.)

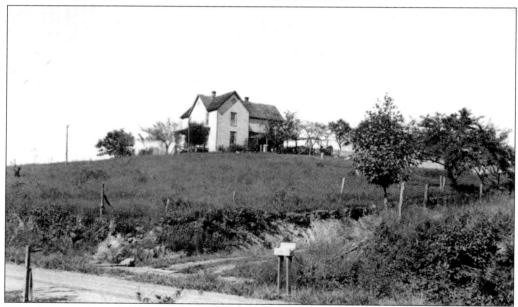

This photograph reads "Hannaniah Lincoln in Huff Township." Hannailegh is a Lincoln family name and the house might have belonged to a cousin, as Thomas Lincoln had several living in the area. It is one of the intangibles encountered when tracing Abraham Lincoln's past in southern Indiana. Local historian Jerry Sanders surmises that this house sits on property belonging to that branch of the family. (Courtesy of O. V. Brown collection.)

The split rail fence along the Lincoln Heritage Trail is pictured in the early 1900s. (Courtesy of O. V. Brown collection.)

This sign advertising Lincoln and the park stood on Highway 231 at the north edge of Gentryville. The big *R* tells people to turn right. This photograph is from around 1940. (Courtesy of Joe Hevron.)

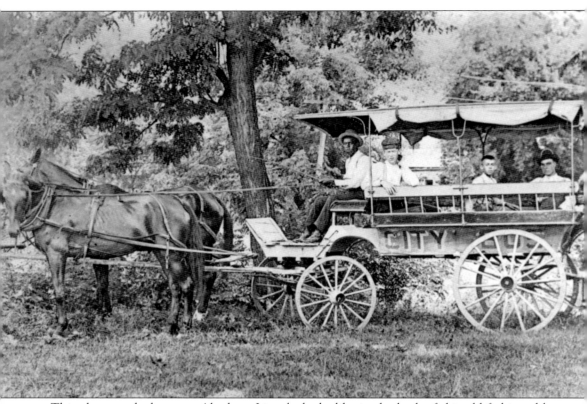

This photograph shows an Abraham Lincoln look-alike in the back of this old fashioned bus that operated out of Rockport, a river town and the county seat of Spencer County. Speculation is that it might be one of Lincoln's cousins who lived in the area. Lincoln came back to southern Indiana in 1844 to campaign for Henry Clay. He ran into several of his old friends at the Richardson school, though they did not recognize him at first. As noted by Daryl Lovell, Richard Jones, the son of Elizabeth Jones, later recalled, "Lincoln grasped the hand of each, slapped him on the back and cried, 'Here's David Turnham, Here's Thomas Medcalf, here's William Wood, here's James Blair.'" The original of this photograph, provided by Lovell, belonged to the late Ruth Taylor of Dale.

Eight

COMMEMORATING LINCOLN

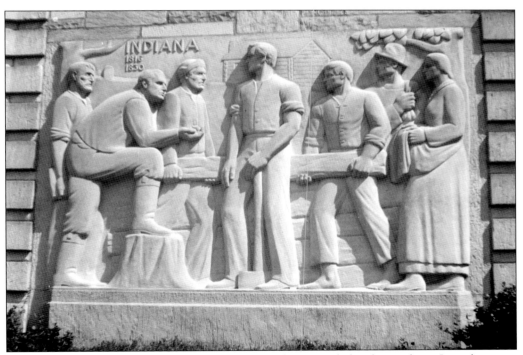

Lincoln Boyhood National Memorial preserves the site of the farm where Lincoln spent 14 formative years of his life, from age seven to age 21. He and his family moved to Indiana in 1816 and stayed until 1830, when they moved to Illinois. Lincoln Boyhood National Memorial is also significant because it represents that period when the creation of memorial edifices and landscapes was an important expression of the nation's respect and reverence for Lincoln.

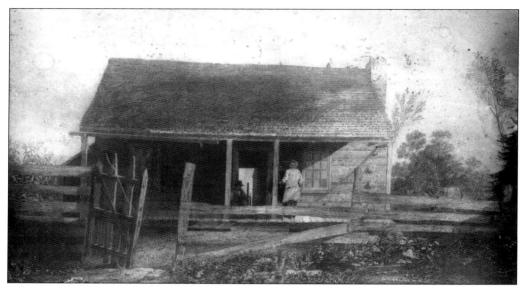

Following the departure of the Lincolns for Illinois in 1830, the farm that Thomas Lincoln had built was sold several times and divided up. Others occupied the cabin he started in 1829, and the location of Nancy Hanks Lincoln's grave was virtually forgotten. But following Abraham Lincoln's death, interest in his Indiana home site was revived. This engraving is said to be based on a photograph taken in 1860. (Courtesy of Lincoln Boyhood National Memorial Historic Photograph Collection.)

In April 1865, some residents of the nearby town of Elizabeth, later to be known as Dale, went to the Lincoln farm area and posed for pictures in front of what was reputed to be the 1829 cabin. In September of the same year, Lincoln's Springfield law partner, William Herndon, visited the farm site and talked with local residents as he gathered information for his biography of the late president. (Courtesy of Lincoln Boyhood National Memorial Historic Photograph Collection.)

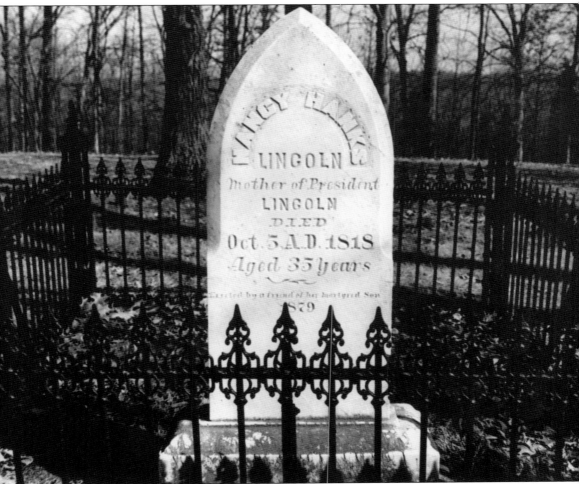

Presumably during the Lincoln family's residence in Indiana, there was some kind of marker on Nancy's grave, but for many years after they left, the site was unmarked. By 1865, it was reported that vegetation had overgrown the area almost completely. An 1879 newspaper article reporting the neglect of Nancy Hanks Lincoln's grave site prompted Peter E. Studebaker, second vice president of the Studebaker Carriage Company, to contact Rockport postmaster L. S. Gilkey with instructions to buy the best tombstone available for $50 and place it anonymously on the site. Another $50, solicited from the area residents, paid for an iron fence around the grave. (Courtesy of Lincoln Boyhood National Memorial Historic Photograph Collection.)

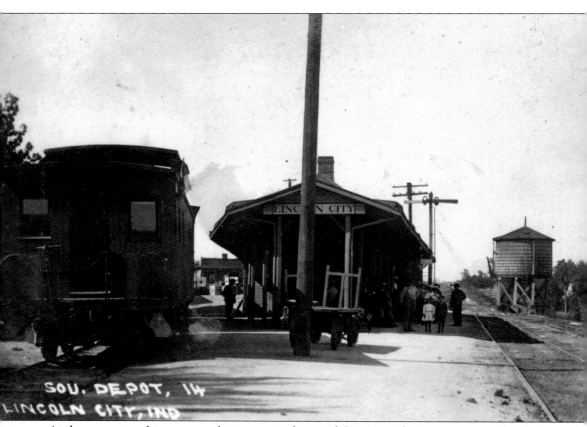

SOU. DEPOT, 14
LINCOLN CITY, IND

At the same time this stone was being acquired, several Cincinnati businessmen were developing Lincoln City. This community, built because of the railroad, was to have a great impact on the Abraham Lincoln boyhood home site. A local resident convinced the developers to donate the half acre surrounding the grave site to Spencer County. The Southern Railroad depot is pictured in this postcard postmarked 1909. (Courtesy of Lincoln Boyhood National Memorial Historic Photograph Collection.)

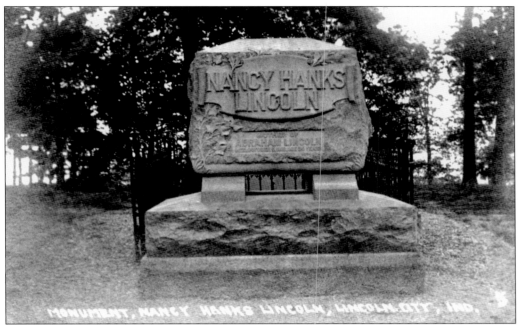

In 1902, following the completion of an elaborate monument at Pres. Abraham Lincoln's grave in Springfield, Illinois, J. S. Culver resculpted a discarded stone from the original monument and vault as a monument to Nancy Hanks Lincoln. Gov. Winfield T. Durbin, president of the memorial association, accepted the massive stone and placed it in front of the Studebaker marker. The Culver stone was dedicated in a graveside ceremony on October 1, 1902. (Courtesy of Lincoln Boyhood National Memorial Historic Photograph Collection.)

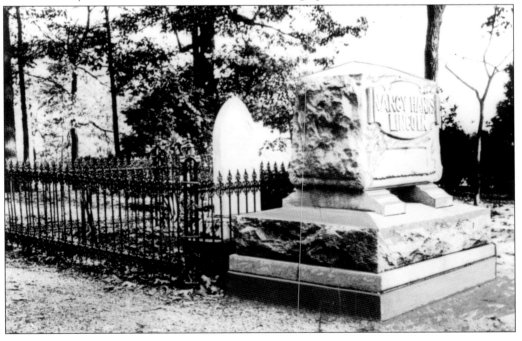

In 1907, the state legislature created a commission to maintain the site and appropriated $5,000 for the erection of an ornamental iron fence around a 16-acre park. In 1909, dead trees were cleared, the fence and an elaborate entrance gate were erected, and a road was built to the grave site. The entryway featured life-size lions at the highway entrance with eagles perched on columns closer to the grave site. (Courtesy of Lincoln Boyhood National Memorial Historic Photograph Collection.)

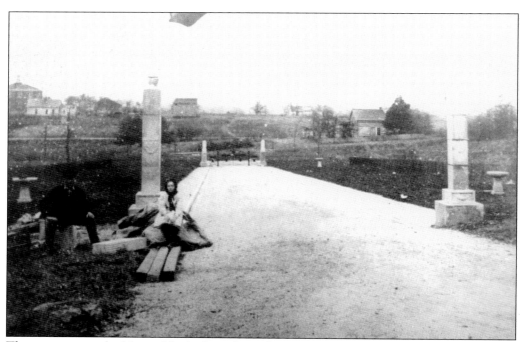

The entrance to the Nancy Hanks Lincoln Park in 1920 is shown, looking north away from the grave site. The structures in the background are part of Lincoln City. The two-story brick building at the upper left is the schoolhouse that sat very near where the cabin site memorial was erected. (Courtesy of Lincoln Boyhood National Memorial Historic Photograph Collection.)

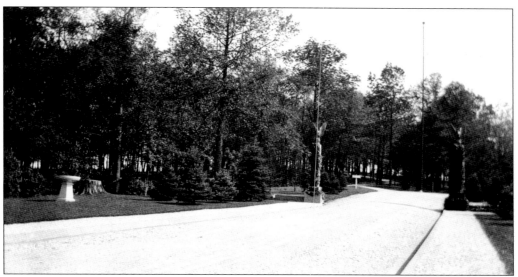

Here is an early view of the park, looking southeast, showing the columns with eagles. Vehicles could be driven up the road where they circled around the fenced-in grave site of Nancy Hanks Lincoln. (Courtesy of Lincoln Boyhood National Memorial Historic Photograph Collection.)

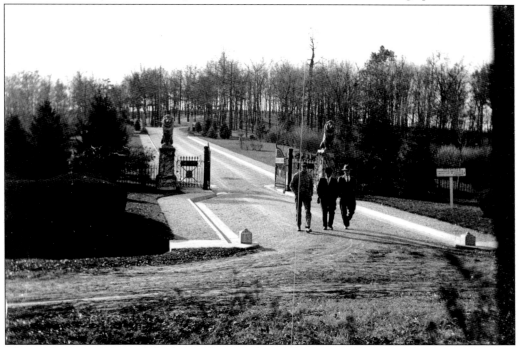

This early view of the park looks southwest. The roadway in the foreground was Highway 162. After the state park was created, the highway was relocated to the south of the hill and the orientation of the park was changed. The road approaching the grave was removed, as were the iron gates, the lions, and the eagles. Vehicle access to the grave site was prohibited because it was considered inappropriate for them to be driving over the other unmarked grave sites on the hill. (Courtesy of Lincoln Boyhood National Memorial Historic Photograph Collection.)

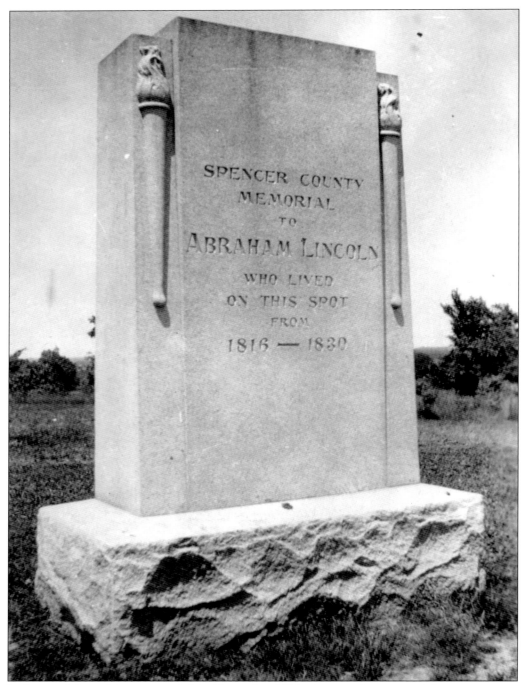

Indiana celebrated its centennial in December 1916. Among the centennial programs was a movement to identify locations important to the state's history. In 1917, Spencer County's centennial commission requested the assistance of older residents of the county in determining the exact location of Thomas Lincoln's cabin. A marker was erected on the site on April 28, 1917. (Courtesy of Lincoln Boyhood National Memorial Historic Photograph Collection.)

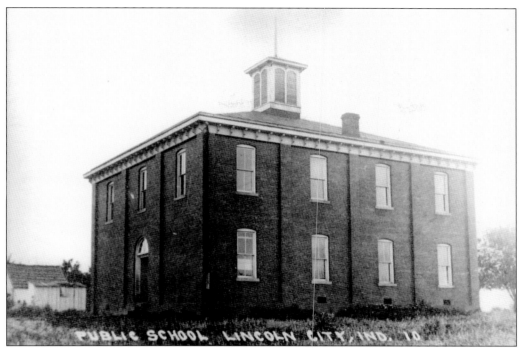

The Lincoln City schoolhouse is pictured in the late 1920s. The schoolhouse and all the surrounding buildings were removed after the state acquired the property and began developing the park. (Courtesy of Jim Hevron.)

Another view of the cabin site area was taken in 1927. The building just left of center was the outhouse for the school. (Courtesy of Lincoln Boyhood National Memorial Historic Photograph Collection.)

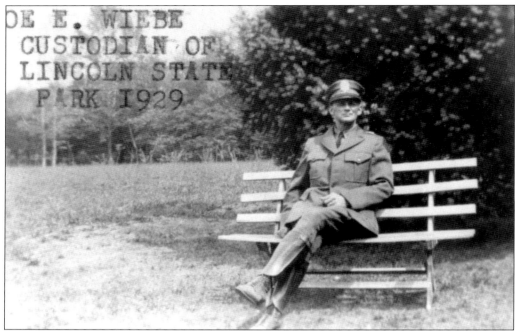

In 1929, Joe Wiebe was appointed custodian of the park. That same year, the Indiana Department of Conservation acquired the 30 acre tract of land to the north of the Nancy Hanks Lincoln grave site that included the site of the Lincoln cabin. The land was purchased by Frank C. Ball of Muncie and donated to the state. The state immediately began removing the buildings and streets in the area and worked with the state highway department to relocate Highway 162 to the south of the grave site. Wiebe served as custodian until 1933. (Courtesy of Lincoln Boyhood National Memorial Historic Photograph Collection.)

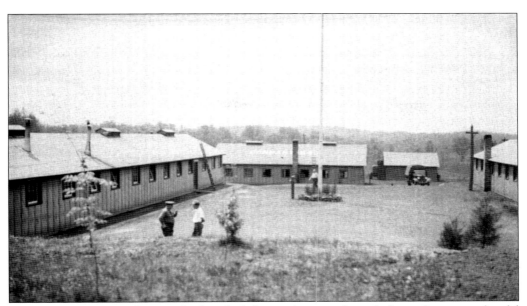

In 1933, Congress passed "an act for the relief of unemployment through the performance of useful work and for other purposes." This legislation led to the creation of the Civilian Conservation Corps (CCC). In July 1933, CCC camp 1543 was established in Lincoln State Park. (Courtesy of O. V. Brown collection.)

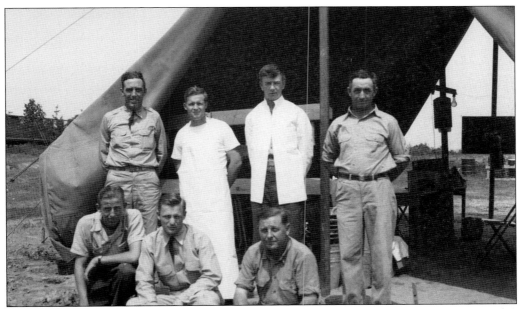

Unlike other CCC camps that were composed of primarily young, unemployed men, camp 1543 was made up of unemployed World War I veterans. (Courtesy of Lincoln Boyhood National Memorial Historic Photograph Collection.)

By 1934, the camp's facilities included a recreation hall, barracks, a mess hall, an administration building, and a bathhouse. (Courtesy of Lincoln Boyhood National Memorial Historic Photograph Collection.)

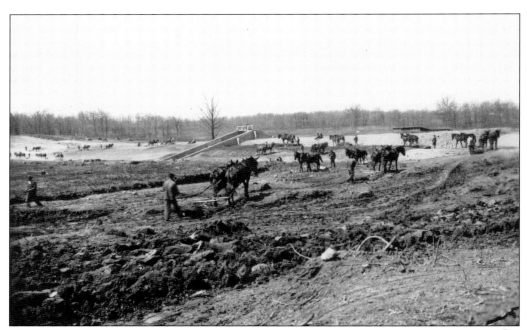

The major project of the camp was to construct a complete water system for the grounds. The 30-acre lake in Lincoln State Park was built to irrigate the grass and shrubs in the allee and courtyard of the memorial. Pipes were laid from the lake to the memorial grounds. (Courtesy of Jim Hevron.)

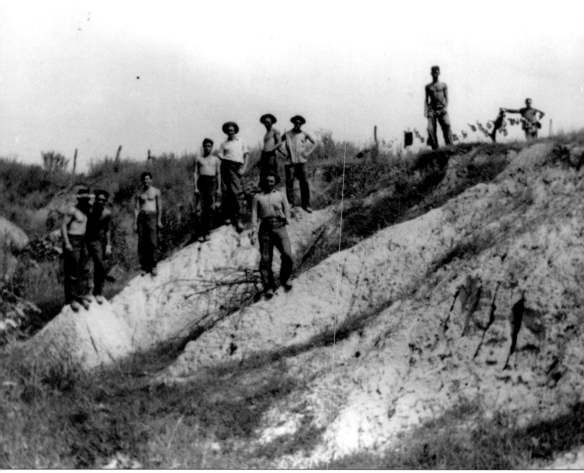

The technical crew of the camp consisted of a camp superintendent, three civil engineers, a landscape architect, three construction foreman, a mechanic, and a blacksmith. The purpose of the camp was to develop the park and memorial grounds. The remaining work was landscaping, reforestation, and erosion control. (Courtesy of Lincoln Boyhood National Memorial Historic Photograph Collection.)

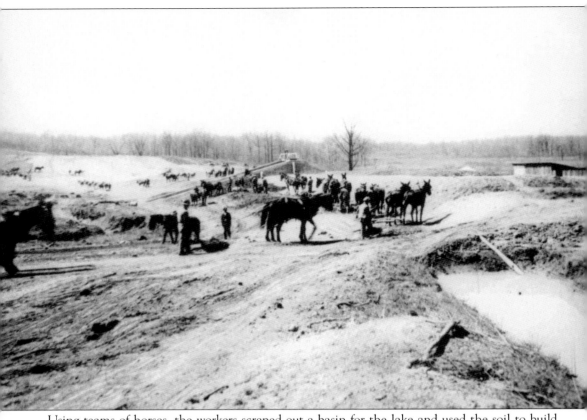

Using teams of horses, the workers scraped out a basin for the lake and used the soil to build the dam. When finished, the lake created by the dam contained 43 million gallons of water. (Courtesy of O. V. Brown collection.)

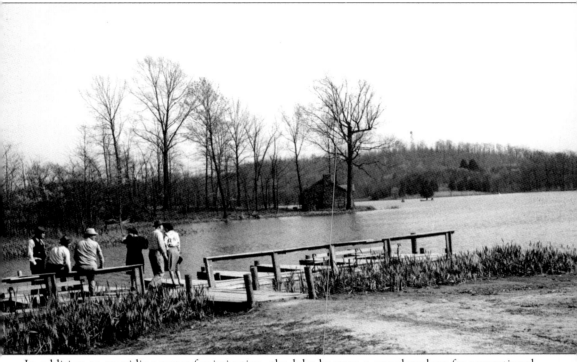

In addition to providing water for irrigation, the lake became a popular place for recreational activities. In 1936, the lake was heavily stocked with game fish. In the distance to the right of the boathouse, the fire tower can be seen. (Courtesy of O. V. Brown collection.)

Other work included the construction of a road to the Little Pigeon Church area and the construction of a ranger's cabin, which is now the boathouse. (Courtesy of Lincoln Boyhood National Memorial Historic Photograph Collection.)

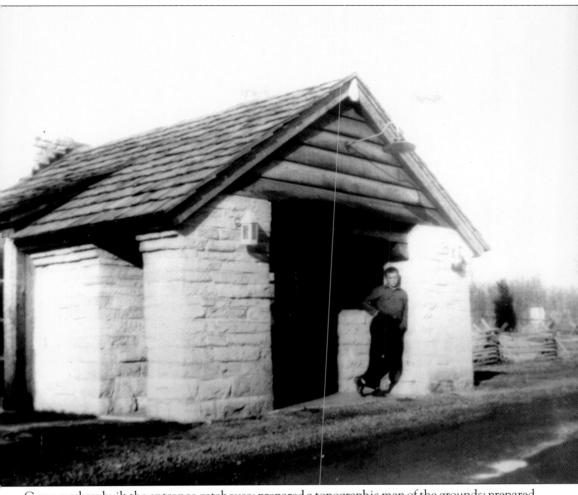

Camp workers built the entrance gatehouse; prepared a topographic map of the grounds; prepared trails, foot bridges, and fire trails; and planted 125,000 native hardwood trees. (Courtesy of Lincoln Boyhood National Memorial Historic Photograph Collection.)

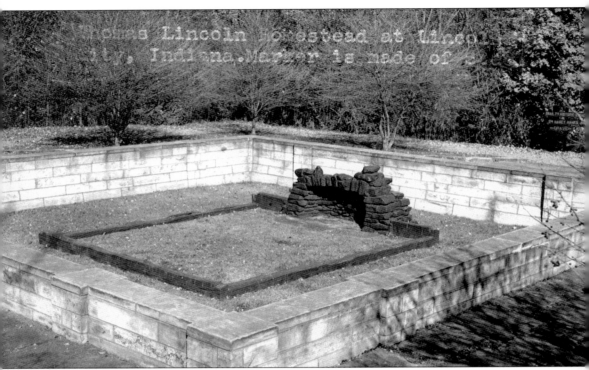

Thomas Lincoln Homestead at Linco... ...ty, Indiana. Marker is made of ...

Placement of the bronze cabin site memorial was one of the more notable achievements in the effort to memorialize the Lincoln site. Desirous of marking the site in an appropriate manner, the Indiana Lincoln Union accepted the proposal of architect Thomas Hibben, who suggested defining the cabin foundation with bronze sill logs and hearthstones to be set on the exact locations and on the same grade level as the original Lincoln cabin. In Hibben's words, "The log sill is chosen as appropriate to mark the outline of the cabin; the hearth and fireplace are chosen because they have been, since time immemorial, the altar of the home, the center around which all life moved. The entire conception is cast in bronze in order that it may be durable and that it may not in any way seem a reconstruction of the original cabin. The entire purpose of the design is intended to be a symbol of the hearth and home of the Lincoln family." (Courtesy of O. V. Brown collection.)

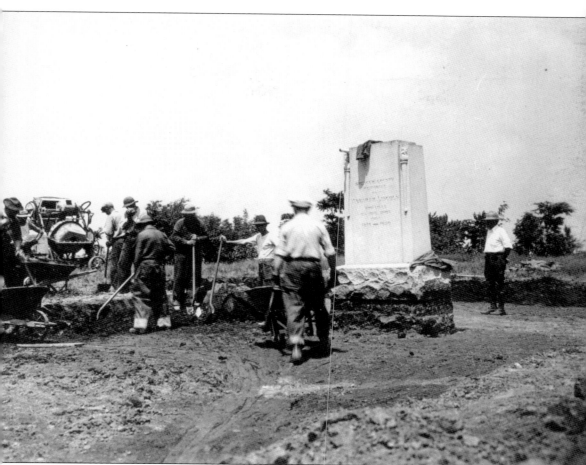

In order to construct the cabin site memorial, the 1917 marker needed to be relocated. It became a part of a trail of 12 stones that was developed to connect the cabin site memorial with the grave site of Nancy Hanks Lincoln. (Courtesy of Lincoln Boyhood National Memorial Historic Photograph Collection.)

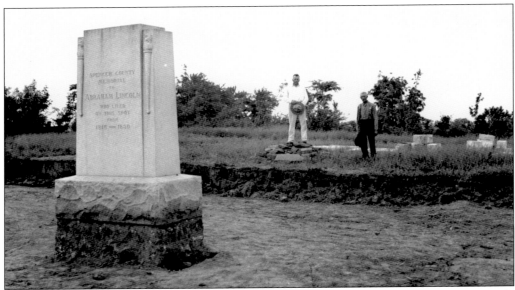

The decision by the Indiana Lincoln Union to place the bronze casting on the original grade level of the cabin led to the removal of a substantial amount of dirt, as evidenced by these photographs. (Courtesy of O. V. Brown collection.)

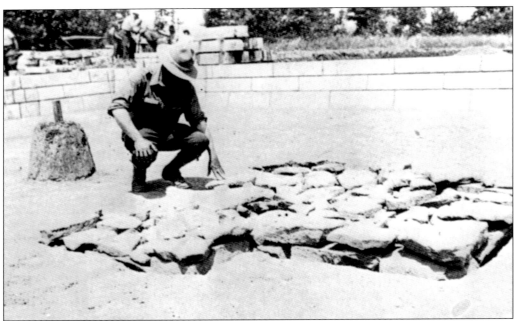

During the excavation directed by Horace Weber, the crew discovered what have become known as the Lincoln cabin hearthstones, which were situated in a T configuration and comprised three layers of stones measuring roughly 18 inches square and five to six inches deep. Pictures of the stones and articles on the discovery appeared in numerous newspapers in the summer of 1934. Construction of a surrounding stone wall is taking place in the background. (Courtesy of Lincoln Boyhood National Memorial Historic Photograph Collection.)

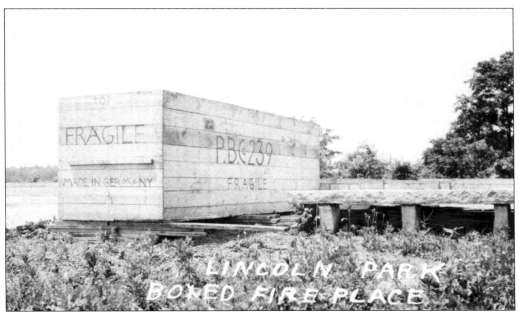

The casting was made by the International Art Foundries in Munich, Germany, and shipped to the site in a wooden box. (Courtesy of Lincoln Boyhood National Memorial Historic Photograph Collection.)

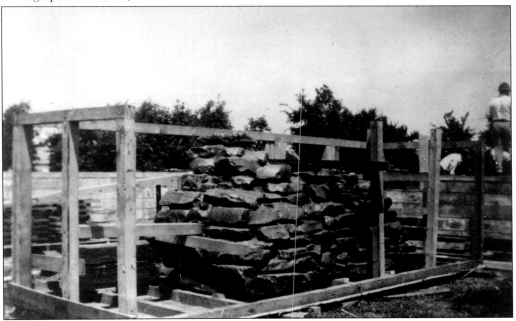

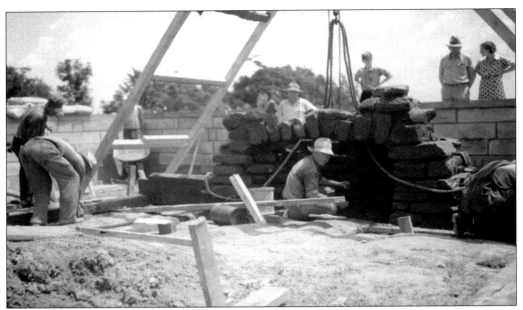

Thomas Hibben personally selected typical worn sill logs, reconstructed a typical pioneer fireplace, and supervised the taking of plaster casts, which were then shipped to Germany for use in casting the bronze. Placement of the casting and the construction of the surrounding stone wall were accomplished by CCC workers. (Courtesy of O. V. Brown collection.)

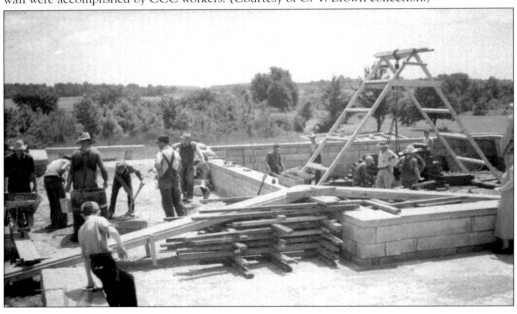

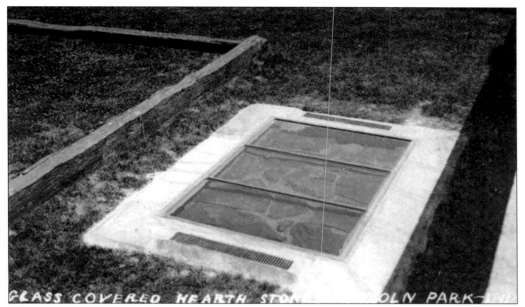

GLASS COVERED HEARTH STONE ... OLN PARK IND

Following completion of the cabin site memorial, several of the original hearthstones that had been found were placed inside a concrete bronze and glass case. The stones proved to be of great interest to park visitors. (Courtesy of O. V. Brown collection.)

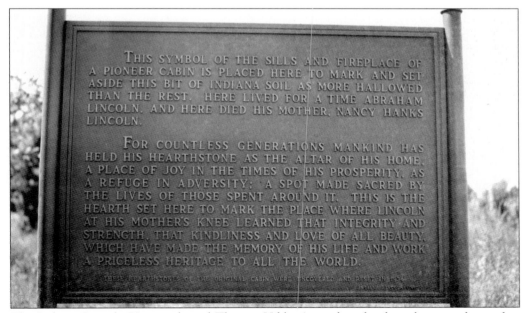

THIS SYMBOL OF THE SILLS AND FIREPLACE OF A PIONEER CABIN IS PLACED HERE TO MARK AND SET ASIDE THIS BIT OF INDIANA SOIL AS MORE HALLOWED THAN THE REST. HERE LIVED FOR A TIME ABRAHAM LINCOLN, AND HERE DIED HIS MOTHER, NANCY HANKS LINCOLN.

FOR COUNTLESS GENERATIONS MANKIND HAS HELD HIS HEARTHSTONE AS THE ALTAR OF HIS HOME, A PLACE OF JOY IN THE TIMES OF HIS PROSPERITY, AS A REFUGE IN ADVERSITY; A SPOT MADE SACRED BY THE LIVES OF THOSE SPENT AROUND IT. THIS IS THE HEARTH SET HERE TO MARK THE PLACE WHERE LINCOLN AT HIS MOTHER'S KNEE LEARNED THAT INTEGRITY AND STRENGTH, THAT KINDLINESS AND LOVE OF ALL BEAUTY, WHICH HAVE MADE THE MEMORY OF HIS LIFE AND WORK A PRICELESS HERITAGE TO ALL THE WORLD.

The Indiana Lincoln Union adopted Thomas Hibben's wording for the cabin site plaque that was erected on the site. (Courtesy of O. V. Brown collection.)

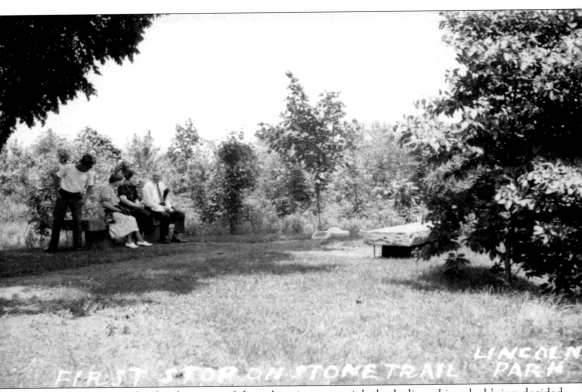

FIRST STOP ON STONE TRAIL LINCOLN PARK

In addition to the development of the cabin site memorial, the Indiana Lincoln Union decided to develop a trail of historic stones leading from the cabin site to the grave. Along this trail were rest stations with stones collected from the various important places associated with Abraham Lincoln's life. Bronze plaques told the story of the rise of Lincoln from his birth to his death. (Courtesy of O. V. Brown collection.)

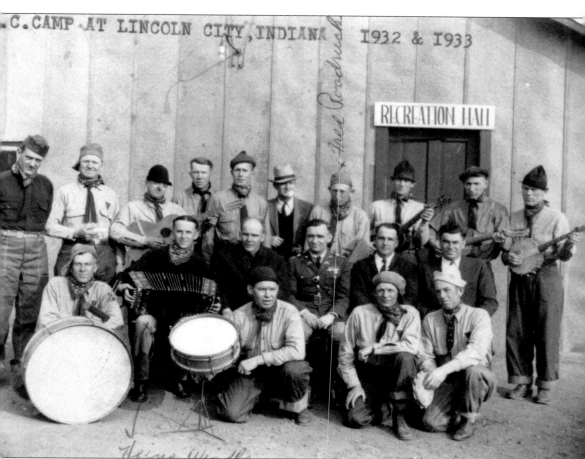

In addition to providing much needed work relief, the CCC camp also became an integral part of the surrounding community. The recreation hall was used for weekly concerts and dances that were attended by neighbors as well as the camp workers. The men were also invited to attend night school classes at the Lincoln City School. (Courtesy of Lincoln Boyhood National Memorial Historic Photograph Collection.)

In spite of its successes, camp 1543 was closed in June 1934. Though its existence was brief, its impact on Lincoln Boyhood National Memorial was substantial. (Courtesy of Lincoln Boyhood National Memorial Historic Photograph Collection.)

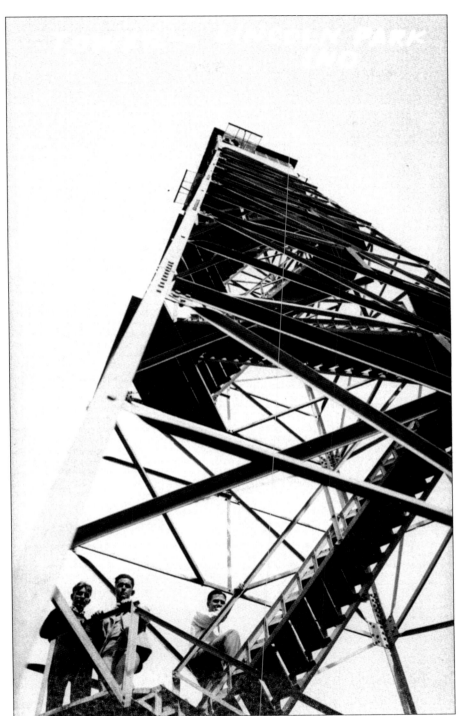

In 1935, a steel fire tower was built south of the lake. An attendant was on duty there during fire season, and a telephone line was constructed to connect it with the system of fire towers erected by the state forestry division. (Courtesy of O. V. Brown collection.)

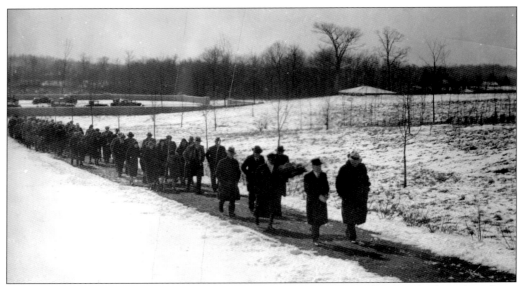

Ceremonies to honor Abraham Lincoln and his mother, Nancy Hanks Lincoln, have long been a tradition at the site. In the late 19th and early 20th centuries, these consisted of reunions by veterans of the GAR. Beginning in the 1920s, the Boonville Press Club began sponsoring annual programs. Initially held at the pavilion that was built near the grave site in 1909, the ceremony was later moved to the memorial building. Regardless of the location, though, an integral part of every program has always been a walk, or pilgrimage, to the grave site on the hill. In the photograph above, attendees are seen making this pilgrimage in spite of the wintry weather. Indiana governor Paul McNutt is pictured in the photograph below. (Courtesy of Lincoln Boyhood National Memorial Historic Photograph Collection.)

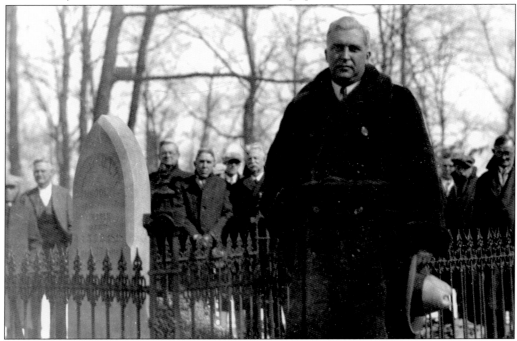

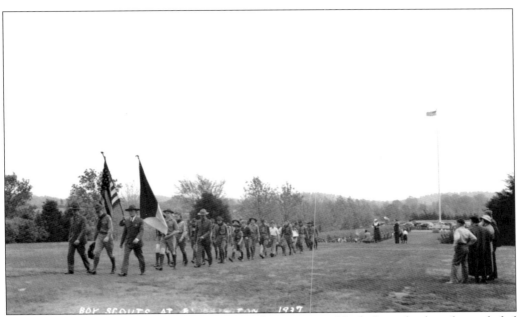

In 1939, Boy Scouts held a special ceremony to honor Nancy Hanks Lincoln that also included a pilgrimage from the newly completed plaza to the grave site and the cabin site memorial. (Courtesy of O. V. Brown collection.)

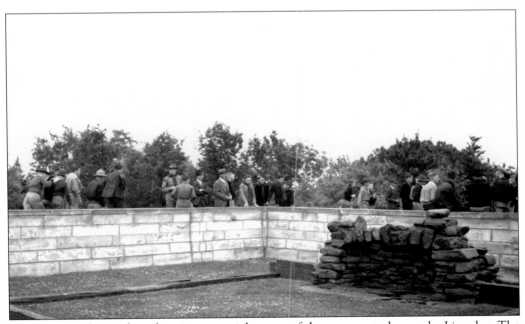

Boy Scouts gather at the cabin site memorial as part of the program to honor the Lincolns. The tradition of Scout programs in the park is a longstanding one. On several occasions over the years they have gathered in the park to pay homage to Lincoln's Indiana years.

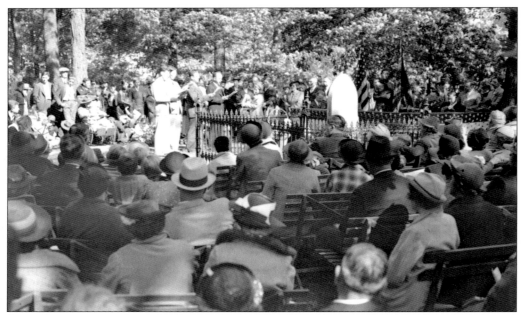

Special music was performed at Lincoln's grave site.

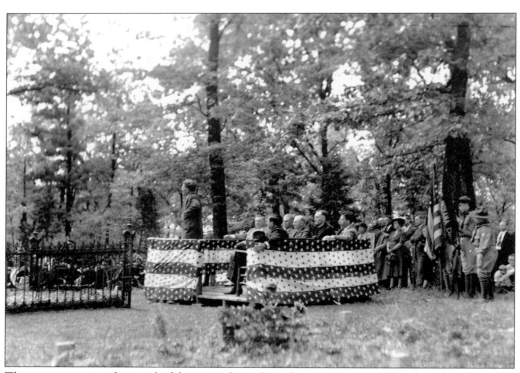

The occasion was also marked by special speakers during a ceremony at the grave site. The Boy Scouts have long had a history of such ceremonies at the park. (Courtesy of O. V. Brown collection.)

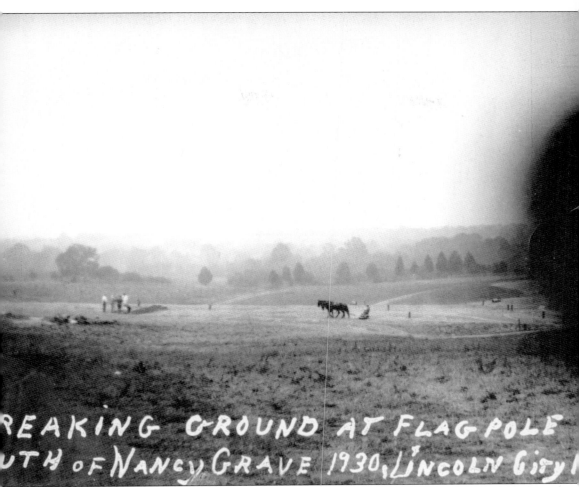

REAKING GROUND AT FLAGPOLE
UTH OF NANCY GRAVE 1930, LINCOLN City I

To further develop the new state park, Frederick Law Olmsted Jr. was hired by the Indiana Lincoln Union to prepare a landscape design. He wanted to create a formal memorial landscape with an allee that extended from a plaza to the south of the grave site up toward the wooded knoll where Nancy Hanks Lincoln was buried. (Courtesy of Lincoln Boyhood National Memorial Historic Photograph Collection.)

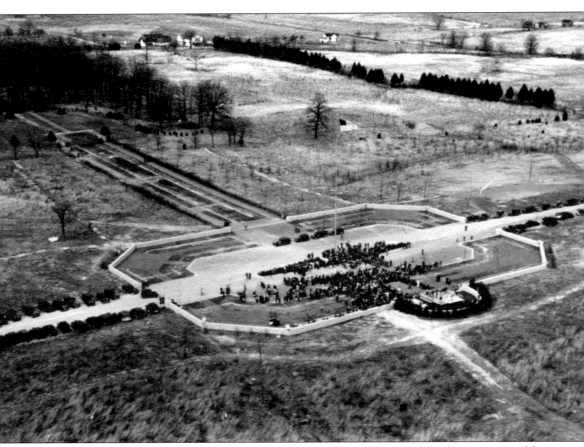

Implementation of Olmsted's design resulted in the formal memorial landscape pictured here, with a formal allee extending between the grave site in the trees at the upper left to a walled plaza to the south. A towering 120-foot-tall flagpole was placed in an island in the center of the plaza and was formally dedicated on July 12, 1931. The relocated Highway 162 passed through the center of the plaza. (Courtesy of Lincoln Boyhood National Memorial Historic Photograph Collection.)

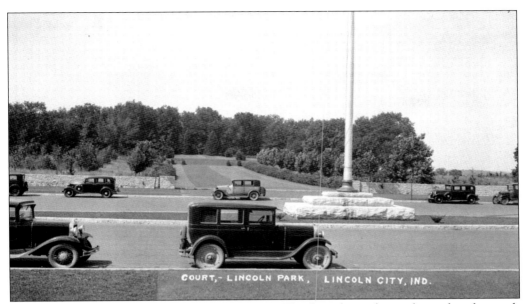

COURT,- LINCOLN PARK, LINCOLN CITY, IND.

Here is a view looking north toward the grave site. The flagpole was later relocated to the north to sit on the hilltop closer to the grave.

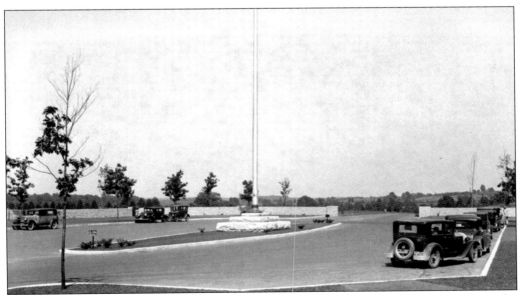

Relocation of the Highway 162 was a key element in the development that took place in the 1930s. By 1937, when these photographs were taken, visitors to the site could park in the plaza and approach the grave site by way of gravel paths on either side of the allee. (Courtesy of O. V. Brown collection.)

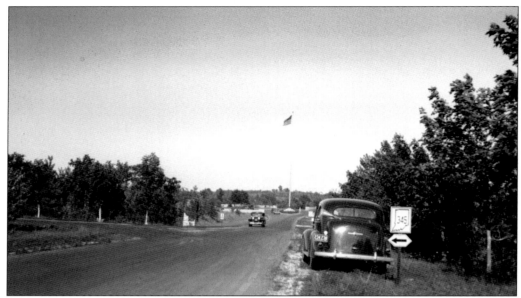

Frederick Law Olmsted Jr., in describing his vision for the approach to the site said, "I am inclined to believe that there is one, and only one, large and conspicuous object, idealistic in significance, that could be used as the dominant object in . . . an entrance composition. . . . That object is a great flagpole bearing the American flag." This view is looking east toward the plaza. (Courtesy of O. V. Brown collection.)

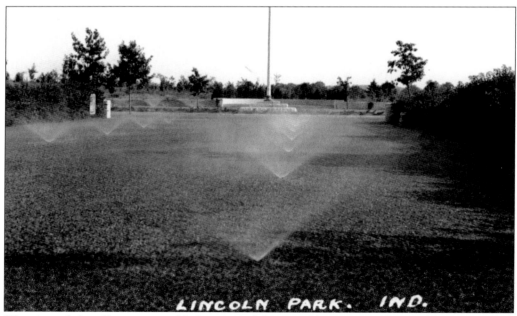

Watering of the allee was possible because of the sprinkling system that had been installed. The lake, built by the CCC, provided the water that was pumped into the system. (Courtesy of O. V. Brown collection.)

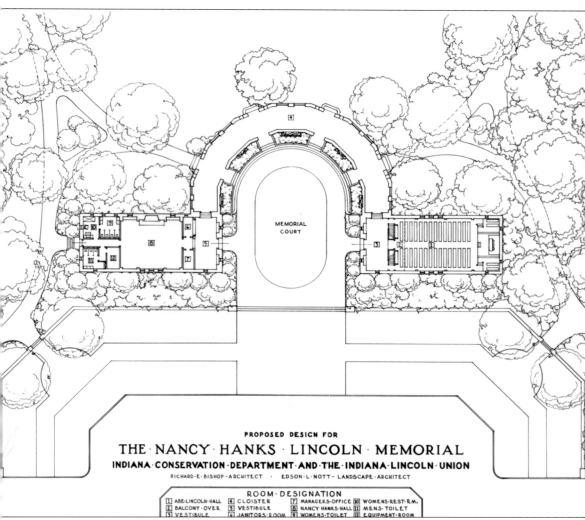

PROPOSED DESIGN FOR

THE · NANCY · HANKS · LINCOLN · MEMORIAL
INDIANA · CONSERVATION · DEPARTMENT · AND · THE · INDIANA · LINCOLN · UNION
RICHARD · E · BISHOP · ARCHITECT · EDSON · L · NOTT · LANDSCAPE · ARCHITECT

ROOM · DESIGNATION

[1] ABE · LINCOLN · HALL	[4] CLOISTER	[7] MANAGERS · OFFICE [10] WOMENS · REST · RM.
[2] BALCONY · OVER	[5] VESTIBULE	[8] NANCY · HANKS · HALL [11] MENS · TOILET
[3] VESTIBULE	[6] JANITORS · ROOM	[9] WOMENS · TOILET [12] EQUIPMENT · ROOM

The second phase of the memorial's development included the construction of the memorial building. Designed by National Park Service architect Richard E. Bishop, the building was to consist of two memorial halls joined by a semicircular cloister with a central memorial court. Bishop described his vision by saying, "Whatever is built should be a forthright expression of honesty, simplicity and dignity, qualities we associate with Lincoln and his mother. There should be no false construction or design. Materials should be native and largely hand worked." (Courtesy of Lincoln Boyhood National Memorial Historic Photograph Collection.)

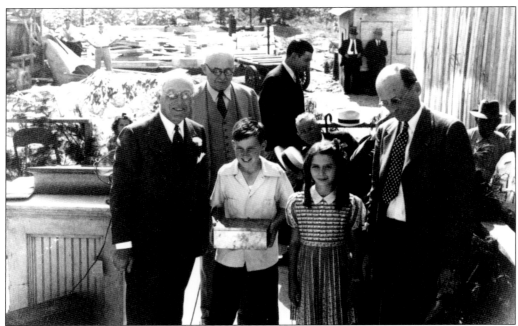

Construction of the memorial building began with the placing of the cornerstone on May 21, 1941. The children in these photographs are Joe Hevron and Pat Yellig Koch. They represented the thousands of schoolchildren who had contributed to funds for the development of the memorial. From left to right, the three men facing the camera in the photograph above are J. I. Holcomb, a member of the Lincoln Union executive committee; Col. Richard Leiber, director of the state department of conservation; and Frank Wallace, acting commissioner of state parks. (Courtesy of Lincoln Boyhood National Memorial Historic Photograph Collection.)

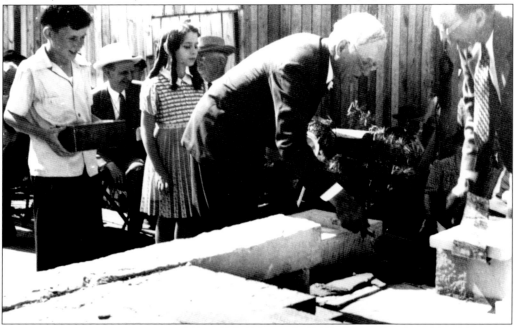

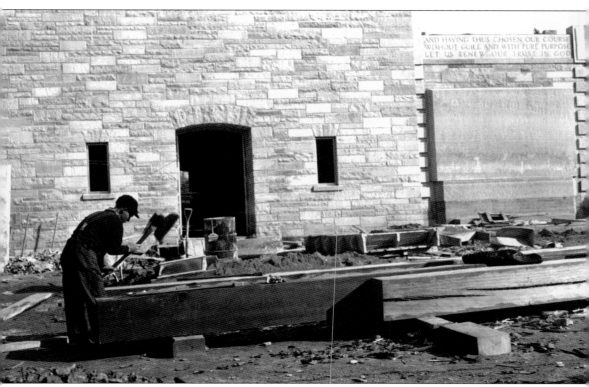

Acquiring the tulip poplar timbers for trusses and beams for the two memorial halls was a formidable challenge. Timber cutting began in December 1940 and continued until the spring of 1941. After being cut, the timbers were kiln dried and then transported to the work site where they were squared to approximately the dimensions required and finished by hand with tools like the broad ax and adze. (Courtesy of O. V. Brown collection.)

Limestone for the building's exterior was provided by the Sare Hoadley Stone Company of Bloomington. The architectural style of the building was intentionally kept as simple as possible. Details of the design were to be reminiscent of early-19th-century buildings in Indiana. Such historic buildings as the Corydon State Capitol and the Spring Mill, built about the time Indiana became a state, were studied and served as prototypes. (Courtesy of O. V. Brown collection.)

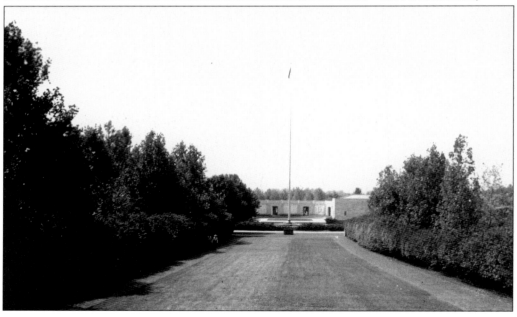

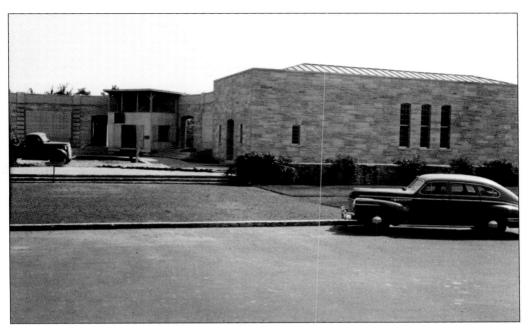

The exterior walls are of Indiana limestone, cut and finished by hand. The stone contractor experimented with many different types of finishes until a suitable style was determined. (Courtesy of O. V. Brown collection.)

Construction on the building began in May 1941 and was completed in 1943. On February 12, 1943, the annual Nancy Hanks Lincoln memorial service was held in the new building for the first time. This occasion marked the substantial completion of the structure, though the sculpture was not finished until the following June, and the landscape work was finished in the early part of 1944. (Courtesy of O. V. Brown collection)

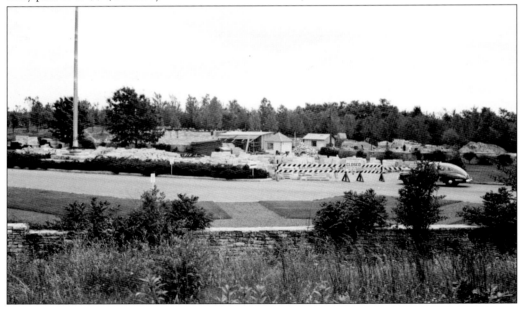

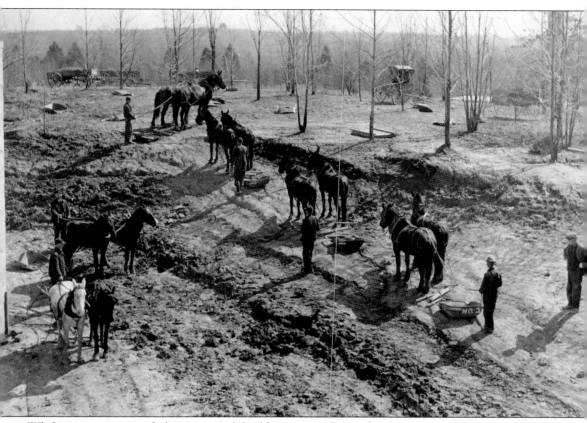

While construction of the memorial building was taking place, some modifications were also made to the surrounding landscape. In this photograph, teams of horses are used to pull equipment used to move dirt and to regrade the contour of the land. (Courtesy of Courtesy of Lincoln Boyhood National Memorial Historic Photograph Collection.)

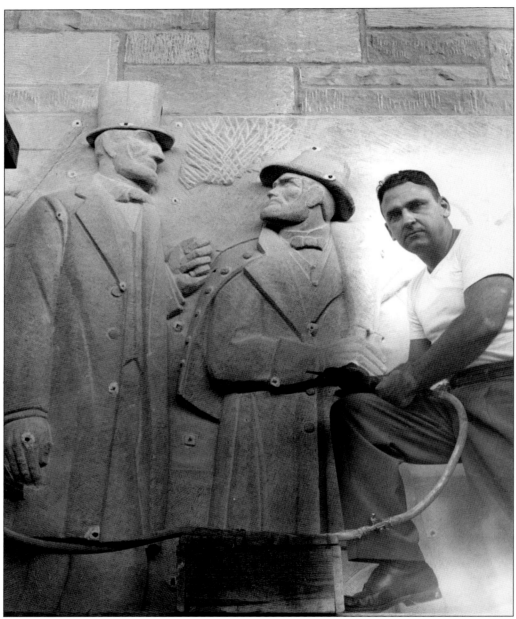

As part of the plan for the cloister, Richard E. Bishop included five sculptured panels separated by four large openings. Four of the panels represented Abraham Lincoln's life in Kentucky, Indiana, Illinois, and Washington, and the fifth represented the deceased president's significance to all Americans. Above the panels and the doorways, passages from Lincoln's speeches were carved in stone. In 1941, Elmer H. Daniels, pictured here, was hired to carve the images. (Courtesy of Lincoln Boyhood National Memorial Historic Photograph Collection.)

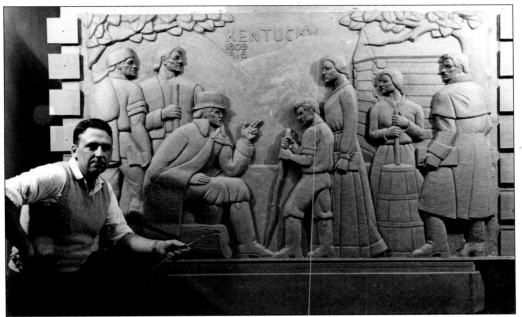

Elmer H. Daniels set up a studio in Jasper in September 1941 and began preparing pencil sketches. These were followed by 16-by-27-inch clay models. When an oversight committee approved of these, he prepared half-scale clay models of each panel from which plaster casts were made. (Courtesy of Lincoln Boyhood National Memorial Historic Photograph Collection.)

Five limestone panels weighing 10 tons and measuring eight feet tall by 13-and-a-half feet wide were quarried near Bloomington. These were to become the palette upon which Daniels created his sculptures. (Courtesy of Lincoln Boyhood National Memorial Historic Photograph Collection.)

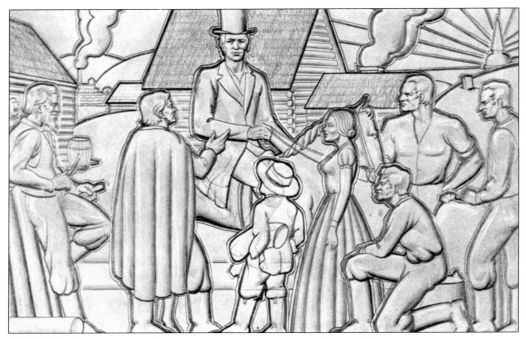

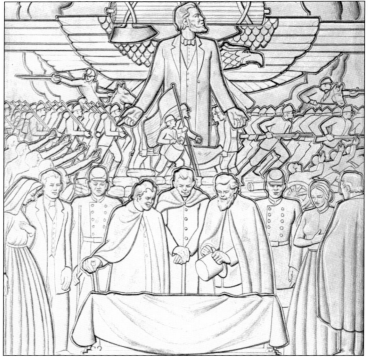

Elmer H. Daniels set up a studio in Jasper in September 1941 and began preparing pencil sketches. These sketches were discussed and debated at great length until each sketch was approved. As these photos show, the content of some of the proposed designs differed greatly from what was eventually carved into the stone. (Courtesy of Lincoln Boyhood National Memorial Historic Photograph Collection.)

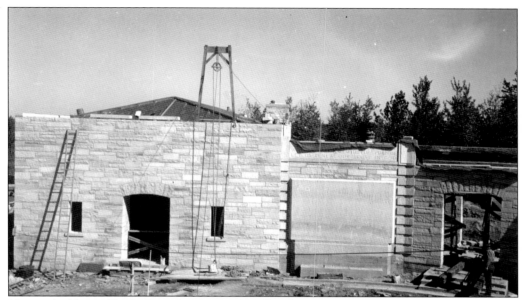

Here is the Nancy Hanks Lincoln Memorial Hall under construction; note the stone panel prior to carving. This panel became the one depicting Abraham Lincoln in Kentucky. (Courtesy of Lincoln Boyhood National Memorial Historic Photograph Collection.)

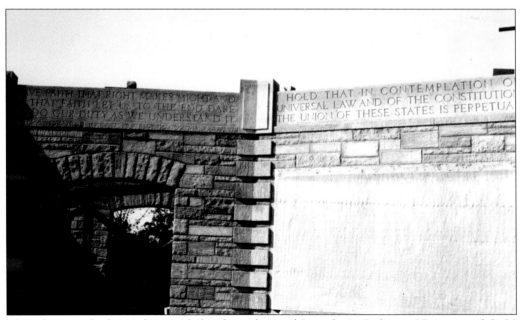

This photograph shows the panel that later depicted Lincoln in Indiana. (Courtesy of O. V. Brown collection.)

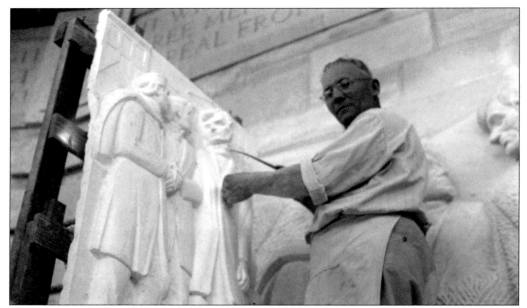

The work of stone carving required one year. Carving was started in late May 1942 and was substantially finished by May 1943. The sculpture was formally approved and accepted by the sculpture committee on July 1, 1943. In addition to Elmer H. Daniels, stone carvers Harry Liva, Joseph Slinkard, and Jesse Corbin, all of Bedford, also worked on the project. (Courtesy of O. V. Brown collection.)

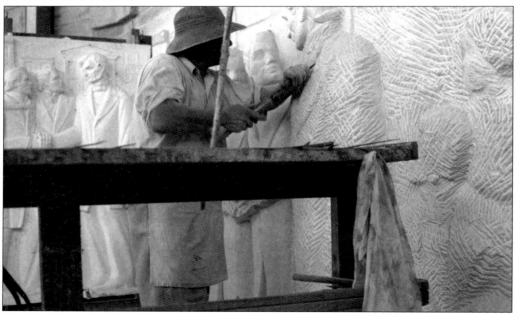

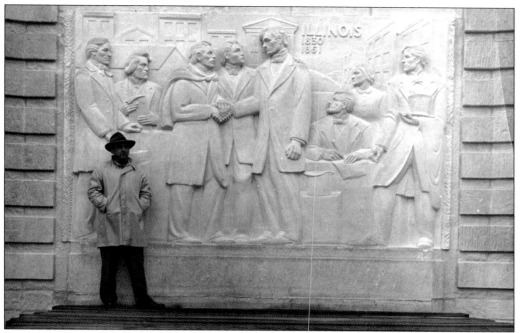

Daniels is pictured in front of the completed Illinois panel. He summed up his role in the project by saying, "I may get a bigger job some day, but I doubt if I will ever have a more significant one." (Courtesy of Lincoln Boyhood National Memorial Historic Photograph Collection.)

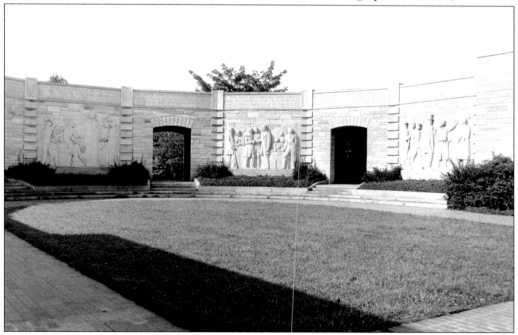

With completion of the memorial building, the development of the Nancy Hanks Lincoln Memorial by the State of Indiana was essentially complete. (Courtesy of Lincoln Boyhood National Memorial Historic Photograph Collection.)

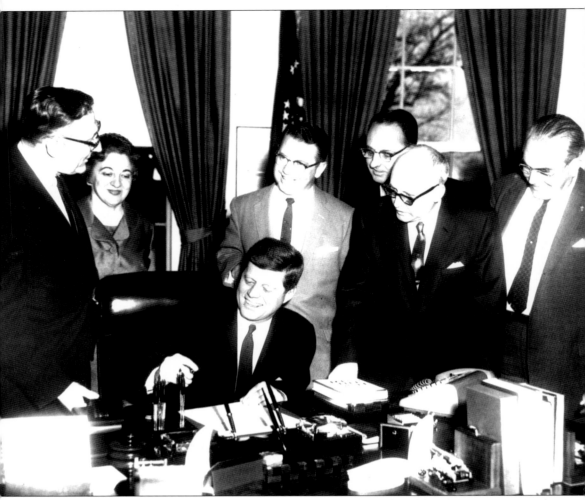

In the 1950s, Indiana Congressman Winfield K. Denton introduced legislation proposing the establishment of a national park unit at Lincoln City. When the state endorsed the proposal and offered to donate the 200 acres containing the cabin site, the grave site, and the memorial building, the legislation passed easily. Pres. John F. Kennedy signed the act authorizing the establishment of the Lincoln Boyhood National Memorial on February 19, 1962. (Courtesy of Lincoln Boyhood National Memorial Historic Photograph Collection.)

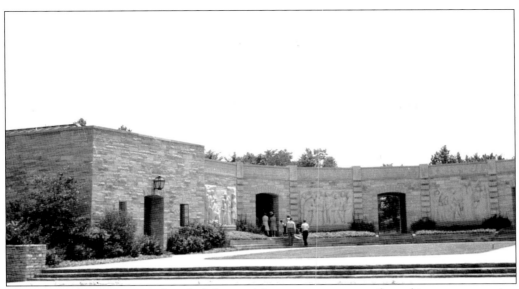

The National Park Service identified the need for more space soon after taking over operation of the park. At first, it was proposed that a separate building be built near the grave site, but Supt. Robert Burns aggressively opposed the proposal and maintained that the integrity of the grave site must be preserved. Conceding his point, National Park Service officials dropped the idea of a separate building and decided to adapt the existing memorial building to meet its needs. The configuration of the courtyard was changed as well, as can be seen in these two photographs. On August 21, 1966, the new addition was formally dedicated. (Courtesy of Lincoln Boyhood National Memorial Historic Photograph Collection.)

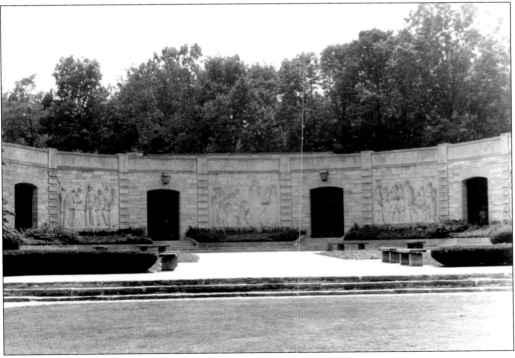

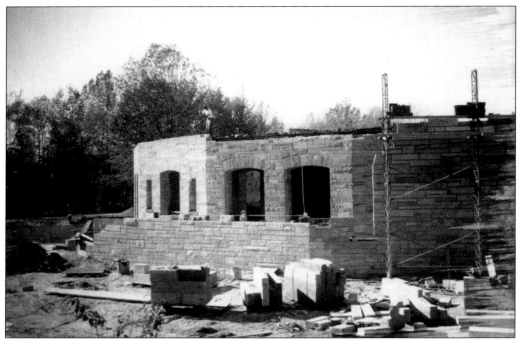

In this photograph, construction is underway on the addition to the memorial building in 1965. (Courtesy of Lincoln Boyhood National Memorial Historic Photograph Collection.)

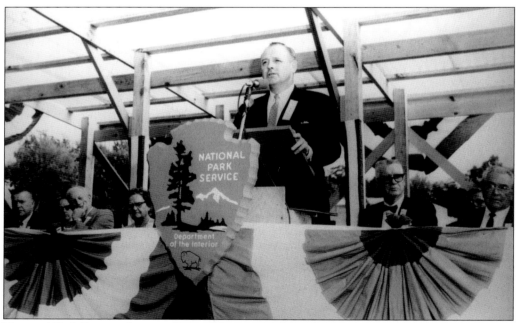

National Park Service director George Hartzog speaks at the August 21, 1966, dedication of the addition to the memorial building. Also pictured to the left of Hartzog are northeast regional director Lemuel Garrison and Congressman Winfield Denton. (Courtesy of Lincoln Boyhood National Memorial Historic Photograph Collection.)

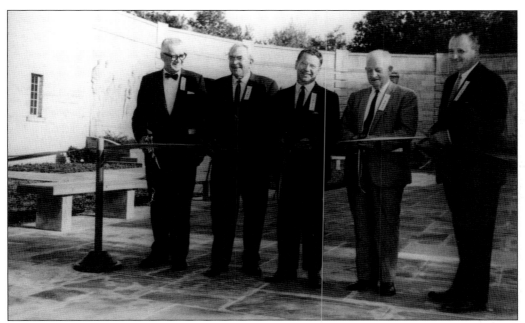

Here is the ribbon-cutting ceremony at the dedication of the memorial building addition on August 21, 1966. Standing from left to right are Garrison, Denton, Sen. Vance Hartke, Birch Bayh Sr., and Hartzog. (Courtesy of Lincoln Boyhood National Memorial Historic Photograph Collection.)

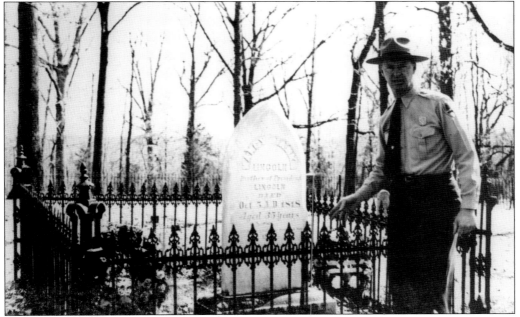

Lincoln Boyhood National Memorial's first National Park Service superintendent, Robert Burns, is pictured at the grave site in 1964. Burns hired the first National Park Service staff for the site and worked with local media to publicize Indiana's first national park. (Courtesy of Lincoln Boyhood National Memorial Historic Photograph Collection.)

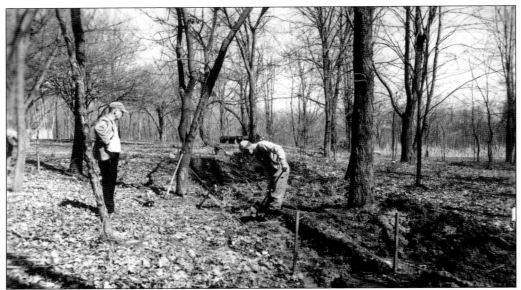

A major addition to the Lincoln Boyhood National Memorial came about in 1968 when the Lincoln Living Historical Farm was created. Because there was not enough documentation to accurately reconstruct the Lincoln farm, it was decided to re-create a farm that was representative of the 1820s time period. Archeological testing of the site in the fall of 1967 revealed no remnants of the historic Lincoln farm. (Courtesy of Lincoln Boyhood National Memorial Historic Photograph Collection.)

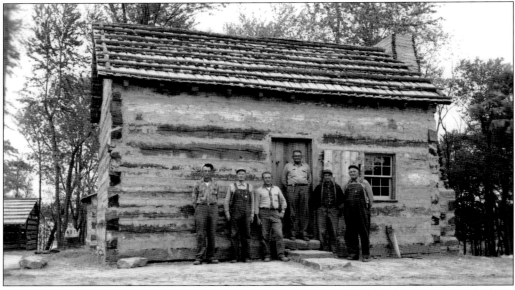

The construction crew for the building of the farm consisted of 10 local men, some of whom were skilled in log construction. Three of them were carpenters and bricklayers or stone masons, and these men served as leads. Tractors operators and general laborers were also used. Pictured from left to right are Abner Crews, Robert Longabaugh, Mason Bryant, Elmer Stein, Fred Smith, and Otis Tribbie. (Courtesy of Lincoln Boyhood National Memorial Historic Photograph Collection.)

In February 1968, clearing of the site began. Progress on the project was hastened by the decision to use logs from existing structures in Spencer County that were dismantled, transported to the site, and then reassembled as the farm buildings, though not necessarily in their original configuration. In all, three structures were used to build the existing cabin, smokehouse, chicken coop, and barn. They were the Reisz barn, from just west of Chrisney; the Bryant house, from near Gentryville; and the Butler house, from between Grandview and Rockport, which was supposedly 125 years old. Pictured here are the Bryant house (above) in Gentryville and the Butler house in Rockport. (Courtesy of Lincoln Boyhood National Memorial Historic Photograph Collection.)

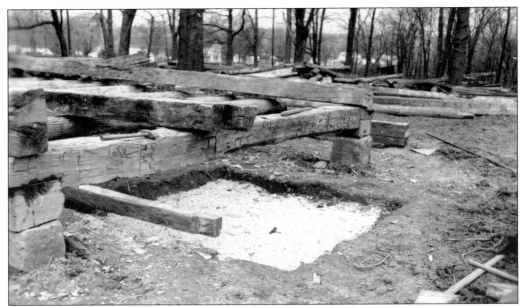

On March 11, 1968, the footing for the cabin fireplace was begun. An excavation was made, gravel was put down, and heavy stone, some of which had been taken from the rubbish heap from the construction of the new addition to the visitor center, was placed in the bottom. As much as it was possible to do, the work of cutting, shaping, and fitting the logs was done using traditional hand tools, including the cutting of the front cabin door opening with a crosscut saw. (Courtesy of Lincoln Boyhood National Memorial Historic Photograph Collection.)

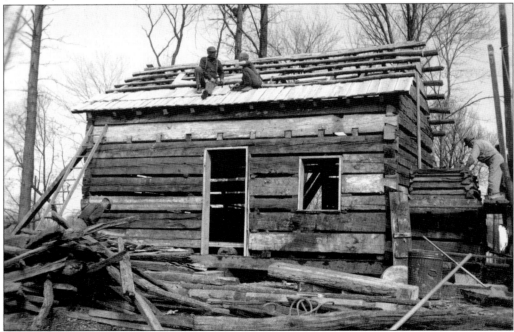

Roofing of the house with rived wood shingles takes place, while at right the "stick" chimney goes up. (Courtesy of Lincoln Boyhood National Memorial Historic Photograph Collection.)

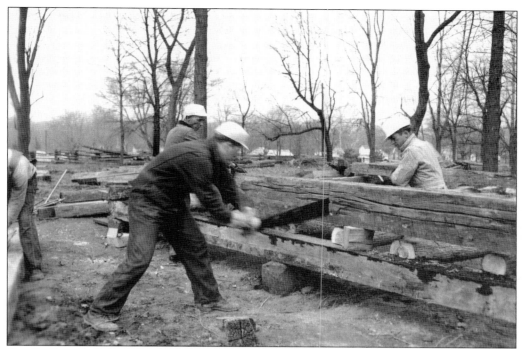

Orville Day, Russell Ficker, and Mason Bryant are using crosscut saw to make the front door opening. (Courtesy of Lincoln Boyhood National Memorial Historic Photograph Collection.)

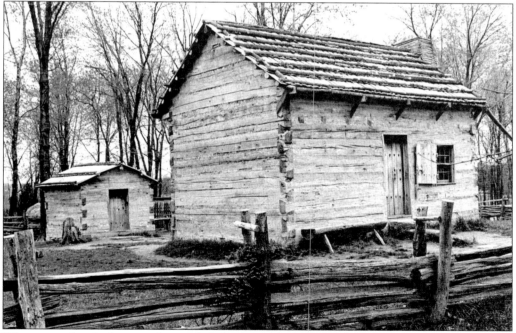

When completed, the complex included a hewn log cabin, a hewn log barn with a shed, a smokehouse, a corncrib, a chicken house, and a workshop, all enclosed by split rail fences. (Courtesy of Lincoln Boyhood National Memorial Historic Photograph Collection.)

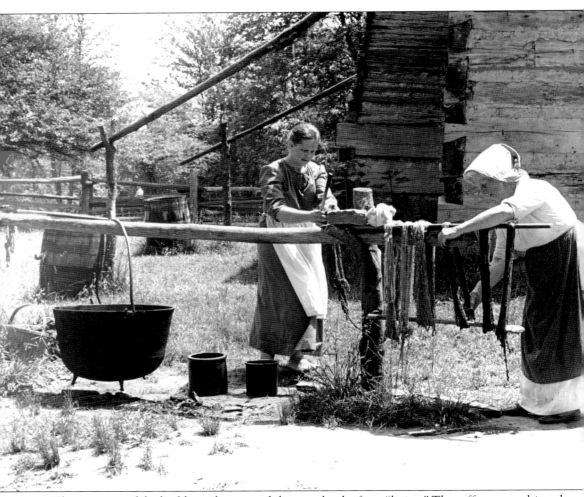

The presence of the buildings, however, did not make the farm "living." That effect was achieved by the addition of interpreters in pioneer clothing who "worked" the farm using historically authentic tools and methods. Early interpretation was intentionally unstructured so as to more closely depict a daily routine of life. That pattern has continued, largely unchanged. (Courtesy of Lincoln Boyhood National Memorial Historic Photograph Collection.)

The farm was still under construction when Sen. Robert F. Kennedy and his family visited the park while in the area during the 1968 presidential primary campaign. Kennedy ate food prepared by the farmers and placed a bouquet on Nancy Hanks Lincoln's grave site. A few weeks later, Kennedy was assassinated in Los Angeles. (Courtesy of Lincoln Boyhood National Memorial Historic Photograph Collection.)

ACROSS AMERICA, PEOPLE ARE DISCOVERING SOMETHING WONDERFUL. *THEIR HERITAGE.*

Arcadia Publishing is the leading local history publisher in the United States. With more than 3,000 titles in print and hundreds of new titles released every year, Arcadia has extensive specialized experience chronicling the history of communities and celebrating America's hidden stories, bringing to life the people, places, and events from the past. To discover the history of other communities across the nation, please visit:

www.arcadiapublishing.com

Customized search tools allow you to find regional history books about the town where you grew up, the cities where your friends and family live, the town where your parents met, or even that retirement spot you've been dreaming about.

they embarked on the mass systematic murder of all Jews under their dominion, a policy known as the Final Solution.

Undoubtedly, among the leaders of the Nazi regime, the rank and file, and collaborators, many completely adopted the Nazi ideology and believed that by murdering Jews they were rescuing mankind from a deadly enemy. It is clear, however, from well-researched scholarly studies that not all the people involved in killing Jews truly believed in all aspects of the Nazi racial vision. A range of other factors, including the desire to achieve personal advancement in Nazi society, greed, peer pressure, and a heartless brutality that blossomed under conditions of total war, contributed to making otherwise ordinary men, in extraordinary circumstances, into mass murderers. At different places and at different times, once the policy of murder was coalescing, local logistical factors, like the lack of space for housing Jews in a proposed ghetto or lack of available food supplies, could set off a specific large-scale murder *Aktion*.

The murder of the Jews could not have happened without the support, both active and passive, of Nazi-dominated society as a whole. Throughout most of the German-controlled territories, people were generally aware of the murder of the Jews and benefited from the distribution of Jewish property. Many people supported the murder wholeheartedly, whereas others were less enthusiastic about it. Outright organized opposition to the murder was virtually non-existent, and only a small minority of individuals took risks in order to help their Jewish neighbors.

A common thread among all murderers and a large segment of society under Nazi domination was an antisemitic worldview that held that Jews are outside the circle of normative social responsibility; in other words, Jewish life was, to say the least, expendable.

been established, and Holocaust education has been instituted in many schools in order to ensure that, despite the efforts of deniers, no such phenomenon will ever happen again. A well-known Holocaust denier, David Irving, sued the historian Deborah Lipstadt for libel for calling him a denier. In the year 2000, the British court that tried the case found that Irving had indeed engaged in the denial of the Holocaust. This was a major blow to all those who profess that the Holocaust never happened.

Especially in the wake of the Six Day War, in June 1967, Holocaust denial began to gain ground in the Arab and Muslim world. Today Holocaust denial is a mainstream belief among many people in those countries.

How was the murder of the Jews humanly possible?

There are many facets to this question, and almost any answer ultimately leaves people who believe in the sanctity of life both baffled and troubled.

At the heart of the Nazi project to wipe out the Jewish people was their racial and antisemitic view of the world. The Nazis sought to reshape the world in accordance with their worldview. Influenced profoundly by Social Darwinism and a belief that throughout human history the strong have prevailed over the weak, they determined that Germans were a people with superior racial qualities and should rule over inferior races. In this regard, after the outbreak of World War II, they engaged in a number of projects that can be best described as racial restructuring in order to achieve their version of utopia. They defined people according to supposedly scientific racial categories, treating them as pawns and moving them around the face of Europe, usually in total disregard of their natural human rights. The Nazis considered the Jews to be their archenemy on racial grounds, an enemy whose "influence" on the rest of mankind had to be stopped. Murder was always a possibility, given Nazi ideology, but, as a policy, it evolved over time. Thereby, the Nazis tried a variety of solutions to the so-called "Jewish problem" before

order to conceal their murderous activities from the world. During the last two years of the war, Sonderkommando units, put to work in a secret program called *Aktion* 1005, were charged with digging up mass graves and burning the corpses. Again, the Nazis' purpose was to hide all evidence of their atrocities.

In the present day, more than sixty years later, there are still some people who either completely reject the notion that the Holocaust happened, or say that the Holocaust was not as widespread as it actually was. "Revisionist historians" and other pseudo-scholars are active in much of the world. In 1978, a "denier group" in California established the Institute for Historical Review. This group, which claims to be scholarly, publishes the *Journal of Historical Review* and holds international conferences.

Deniers often say that the Holocaust did not affect as many people as it really did. A French academic named Paul Rassinier, one of the original founders of the revisionist school, stated that only 500,000 to one million Jews died during World War II, mostly due to bad physical conditions and gradually – not systematically at the hands of the Nazis. Rassinier also claimed to have found the millions of Jews who had disappeared from Europe. He maintains that the large number of North African Jews who moved to Israel both before and after it became a state were not always native North Africans. Rather, they were Jews who had fled Europe before and during the war.

Deniers claim that the Holocaust diaries, testimonies, and photographs are not credible and are full of lies. Some deniers say that the Nazis could not have physically cremated so many people so quickly, nor could Zyklon B gas have been feasibly used on a regular basis in one place. With the advent of the Internet, Holocaust deniers have used this medium to spread their messages of hate. Many websites, established by them or by related groups, such as white supremacists, offer their skewed version of events.

Important steps have been taken to combat this misinformation. In some countries Holocaust denial has been made illegal, and those who disseminate it are punished. Many Holocaust museums have

and, some time later, in the British zone as well. The Soviets, though, persistently refused to recognize the Jews as a distinct group and did not establish special camps for them.

The population in the DP camps in Germany, Austria, and Italy kept growing, mainly because Jewish refugees from Eastern Europe continued to arrive. At the end of 1946, as a result of the mass flight of Jews from Poland (in the wake of the Kielce pogrom), there were about 15,000 Jews in the British occupation zone; 140,000 in the American occupation zone (mostly in Bavaria); and 1,500 in the French zone. In all, there were about 700 active DP camps; among the best known were Landsberg, Pocking, Feldafing, and Bergen-Belsen. Notwithstanding the survivors' many problems, an intense and active lifestyle emerged in these camps, including an educational and vocational system, cultural creativity, journalism, and even political life.

Most Jews in DP camps in Central Europe left the camps by 1950. Many emigrated to Israel; others emigrated to the United States, Canada, Australia, and other localities; and some remained in Germany.

What is "Holocaust denial"?

"Holocaust denial" is a general term covering antisemitic claims that the mass extermination of the Jews by the Nazis never happened; that the number of Jewish losses has been greatly exaggerated; or that the Holocaust was not systematic nor a result of an official policy. Clearly absurd claims of this kind have been made by Nazis, neo-Nazis, pseudo-historians called "revisionists," and the uneducated and uninformed who do not want or cannot believe that such a huge atrocity could actually have occurred.

There was an attempt at Holocaust denial even before World War II ended. Despite the obvious evidence at hand, the Nazis involved in the Final Solution – the extermination of European Jewry – used euphemistic language, including the terms "Final Solution" and "special treatment," rather than gassing, annihilation, and killing, in

In a few instances, highly placed Germans used their position to aid Jews. The most famous of these rescuers is Oskar Schindler, the German businessman who rescued over a thousand Jews from the Płaszów camp by employing them in his factory.

Diplomats and civil servants have also been recognized as "Righteous Among the Nations." Some of the better known are Aristides de Sousa Mendes (Portugal), Chiune-Sempo Sugihara (Japan), and Paul Grüninger (Switzerland). All of them risked their careers in order to help Jews. But the most famous diplomat who rescued Jews is Raoul Wallenberg of Sweden, who helped save tens of thousands of Hungarian Jews. Despite his diplomatic immunity, he was arrested by the Soviets after the conquest of Budapest and apparently died in the Soviet camp system.

By 2005, nearly 21,000 men and women had received the honor and title of "Righteous Among the Nations." The many instances of rescue that had been carried out by those designated as "Righteous Among the Nations" show that rescue was indeed possible, despite the dangerous circumstances. The recipients of the title not only saved Jewish lives but also helped restore our faith in humanity.

What were the displaced persons (DP) camps, and how many Jews resided in them after the war?

Immediately after the liberation, there were 50,000–75,000 Jews in the western part of occupied Germany. These Jews were survivors of the Holocaust from all over Europe; most had been liberated on German soil. In the first few weeks following the war, hundreds of DP camps were provisionally set up in this area for people who did not want to return to their countries of residence, among them many Jews.

In August 1945, the Harrison Committee (appointed by President Truman to investigate the plight of the displaced persons) reported to the American army on the desperate condition of the Jews in the DP camps. As a result of the report, special camps with improved conditions were set up for Jews in the American occupation zone

these joint efforts. Nevertheless, nearly three-quarters of Hungarian Jewry was murdered during the Holocaust.

In France, a number of groups, including the MJS (Mouvement de la Jeunesse Sioniste), Armée Juif, the Jewish Scouts, and the Circuit Garel, under George Garel, did their best to keep Jews out of the hands of the authorities. In particular, they managed to hide Jews throughout the French countryside and smuggle Jews to Spain and Switzerland. Largely due to the cooperation these Jewish rescuers received from Gentiles, some of their efforts succeeded.

In general, it must be acknowledged that, during the Holocaust, Jews lacked the power to rescue other Jews in large numbers without the help of forces from outside the Jewish community. Such help was given all too infrequently in order to prevent the murder of six million Jews.

Who are the "Righteous Among the Nations"?

"Righteous Among the Nations" is the most prestigious title awarded by the State of Israel to non-Jews. It is bestowed by Yad Vashem to honor non-Jews who risked their lives to rescue Jews during the Holocaust for no personal gain. The actions of each candidate for the title are reviewed by a special committee at Yad Vashem.

In many cases it was ordinary people who saved Jewish lives during the Holocaust. They chose, against all odds, to hide one or more Jews in their home or yard. Often the rescuer would build a bunker for the fugitive, who would stay there for weeks, months, or years, hardly ever seeing the sun. Food was very scarce during the war, and the rescuer would share the few morsels he had with the Jews he was hiding from the Nazis.

There are also cases of groups of people, rather than individuals, who rescued Jews. In the Netherlands, Norway, Belgium, and France, underground resistance groups helped Jews, mainly by finding them hiding places. In Denmark, ordinary Danes transported 7,200 of the country's 8,000 Jews to Sweden in a fishing-boat rescue operation.

while focusing on saving lives. The existence of family camps was a distinctly Jewish phenomenon during World War II.

Are there instances during the Holocaust where Jews under Nazi domination rescued other Jews?

In almost every survivor testimony or memoir it is apparent that the survivor received help from another Jew at some point, which contributed to his survival. The phenomenon of spontaneous help given by individual Jews to other Jews is an important aspect of rescue during the Holocaust.

On a larger scale, there are many examples from the Holocaust years of Jews trying to rescue other Jews. In Slovakia, for example, a body called the "Working Group," led by Rabbi Michael Dov Weismandel and the head of the Slovak Women's Zionist Organization, Gisi Fleischmann, engaged in a wide variety of tactics to safeguard Jews from Slovakia and other parts of Europe from deportation. Among other activities, they negotiated with members of the Slovak government and the SS to stop the deportations, and they financed escapes from Slovakia to neighboring Hungary. Despite their strenuous efforts, however, the vast majority of Slovak Jewry was murdered during the Holocaust, and the efforts to rescue Jews outside of Slovakia were largely unsuccessful.

In Hungary, the Relief and Rescue Committee, led by Israel Kasztner and Otto Komoly, aided refugees from other countries who reached Hungary before the German occupation in March 1944. Generally, they provided them with false papers, safe houses, and basic necessities. After the Germans occupied Hungary, members of the Relief and Rescue Committee continued to engage in rescue activities, including negotiating with the SS. Along with the Zionist youth underground, they worked with various diplomats from neutral countries and international organizations to protect Jews from Nazi deportations and the rampages of the Hungarian fascist Arrow Cross. In the autumn of 1944 and early winter of 1945, tens of thousands of Jews in the capital city of Budapest were saved by

They had to fend for themselves until such units were organized and took hold. Once partisan units existed, however, finding one that would accept Jews was far from simple. Despite such hurdles Jewish partisan activity in Eastern Europe swelled to considerable proportions. Scholars believe that up to 30,000 Jews were part of partisan units in the forests, where they carried out daring raids and rescue operations.

There was much Jewish partisan activity throughout occupied Soviet territory. Owing to local conditions, Jewish partisan activity in Poland was much smaller in scale. Jews also became partisans in Slovakia, where more than 1,500 participated in the Slovak national uprising. In Yugoslavia, Bulgaria, and Greece, Jews were accepted into partisan units as equals; however – and perhaps because of that acceptance – there were no separate Jewish partisan units in those countries.

Jewish and non-Jewish partisans differed in several ways. Non-Jewish partisans generally had ready access to weapons before they became partisans, whereas Jews did not. Non-Jewish partisans joined the fight either as nationalists who wanted to rid their countries of all foreigners (both Nazis and Jews included), or as communists and socialists, who wanted to combat Fascism. They left their families at home in a relatively safe environment, generally expecting to return to them after the war. The Jewish partisan was not fighting only for revenge or for an instrumental goal like the liberation of the conquered land, but for the most basic right of all – the right to life. Jewish partisans believed that they would never see home or family again, since most family members had been murdered already. Whereas non-Jewish partisans had much popular support, Jewish partisans were considered to be strangers and had a very slight chance of actually surviving in the forest.

Especially in Belorussia, the Jewish units that were formed included many non-combatants – women, children, and elderly people. The largest of these "family camps" was under the leadership of Tuvia Bielski, with some 1,200 people. These units justified their existence as partisan groups by fighting as much as was necessary,

usually timed to coincide with the dates chosen by the Nazis for deportations to extermination camps. In some cases the uprisings were spontaneous.

The most famous ghetto revolt was the Warsaw Ghetto Uprising. The Nazis entered the ghetto on April 19, 1943, in order to resume the deportations of the Jews to the extermination camps. The Jews, led by members of the Jewish Fighting Organization (ŻOB) and Jewish Military Union (ŻZW) within the ghetto, revolted and bravely held off the Germans for four weeks. Dozens of survivors managed to escape to the partisans.

Armed revolts took place in many other ghettos as well. For example, in Krakow, the Jewish resistance felt that they had no chance by fighting inside the ghetto, so they moved the battle to the "Aryan" side of the city and staged attacks against the Germans there. In Vilna there was disagreement over strategy. Some members of the clandestine fighting organization (FPO) wanted to fight in the ghetto itself, whereas others wanted to join the partisans in the nearby forests; they did so with partial success. When the ghetto revolt tottered immediately after breaking out, the remaining fighters fled to the partisans. In Kovno the underground members tried to reach the partisans. In Bialystok, as the uprising faltered, a planned escape to the partisans was foiled, and the fighters were killed.

All reason opposed physical resistance within the camps: the Jews there had no weapons; they were at the mercy of their guards; they were starving, exhausted, and sick; and they knew that if one person resisted, many others would be punished. And yet revolts took place in a number of camps, including Treblinka, Sobibor, and Auschwitz-Birkenau. In the latter, Sonderkommando members (inmates who worked in the crematoria) succeeded in killing several SS men and set fire to a crematorium.

Jews who fled from the ghettos to the forests, mountains, and swamps of Eastern Europe became partisans. However, they faced many obstacles in being accepted into the partisan ranks. First, escaping from the ghetto itself posed a great challenge. Moreover, many Jews fled from ghettos before there was any kind of organized partisan movement in the occupied Soviet territories.

report (the "Auschwitz Protocols") that informed the Western world of the killing apparatus in Auschwitz-Birkenau.

In countries – especially in Central and Western Europe – where large-scale rescue was a possibility, Jews sought to save the lives of other Jews, sometimes combining rescue activity with armed acts against the Nazis and their henchmen. This was the case in Slovakia, the Netherlands, France, and Belgium. In Hungary, at the time of the German occupation, Jews working alongside diplomats from neutral countries mounted a large-scale rescue operation in Budapest. Jewish organizations outside of Nazi-dominated Europe, most with representatives in Geneva, did their utmost to send material aid and life-saving documents to their brethren. They also made great efforts to tell the world about the unfolding slaughter.

Individuals and small groups of Jews also resisted the Nazis and their cohorts in many ways, ranging from hopeless acts of violent resistance to flight and hiding, to simply maintaining their dignity at the time of their murder. Many Jews made desperate attempts to save their children by handing them over to Gentiles who were willing to hide them.

What was the nature of Jewish armed resistance?

Despite the almost impossible conditions, there were many cases of Jewish armed struggle during the Holocaust. The Jews in the different ghettos and camps had little contact with one another and no outside support, were physically debilitated, were equipped with few weapons and little training in armed warfare, and were facing the might and wrath of the German war machine. Most of the fighters also knew that they had no real chance of beating their oppressors, yet they fought as hard as they could. These Jews resisted for resistance's sake.

Armed underground organizations were formed in about 100 ghettos in Poland, Lithuania, Belorussia, and the Ukraine. Their aim was to stage armed uprisings or break out of the ghetto by force in order to join the partisans on the outside. Resistance actions were

How did Jews resist the Nazis' murderous assault?

In the context of the Nazi policy of the systematic mass murder of all Jews under their control, Jewish resistance to their assault took on many forms. The very acts of trying to stay alive and to maintain at least a remnant of human dignity constituted resistance to the Nazi effort to dehumanize and ultimately annihilate the Jews. Jews on the individual, familial, and community levels strove to sustain themselves both physically and emotionally in the face of the Nazi murder machine.

In many ghettos the Jewish Councils (Judenräte) and various underground communal organizations did their utmost to distribute food and medicines and supply other essential needs to the suffering masses. In many places they organized cultural, educational, and religious activities, which were expressions of the still-vital human spirit of the ghetto inhabitants. The act of providing work took on great importance in many places, both for its practical day-to-day aspects and because, in several ghettos, proving the value of Jewish labor evolved into a strategy for safeguarding as many as possible from the Nazis. In some localities attempts were made to document the ever deepening suffering under the Nazis. In an organized fashion and sometimes on their own, Jews acquired false documents that identified them as Gentiles and used them to hide and even to cross international borders.

As Jews became aware of the fact that the Nazis intended to murder them, armed underground organizations came into being. In dozens of ghettos, these groups prepared for armed resistance against the Nazis, either within the confines of the ghettos or by joining the partisans in the surrounding forests, swamps, or mountains. However, for a variety of reasons, not all of the planned armed resistance against the Nazis was actually carried out.

In several Nazi camps – despite their brutal regimes – Jews also engaged in armed uprisings. Jews escaped from many camps, including Auschwitz-Birkenau. Two sets of escapees from that camp, in the spring of 1944, brought with them the first detailed

that the Allies did not marshal the same energy and determination to rescue the Jews as the Nazis did to murder them.

What were the Jewish Councils (*Judenräte*)?

In every country the Germans controlled during the war, they established a Jewish leadership organization commonly known as a Judenrat (Jewish Council) or an Ältestenrat (Council of Elders). Most states allied with the Germans, such as Slovakia, established similar institutions. The objective was to have a tool by which to control the Jews, isolate them from the outside world, and implement various decrees. In general, the authorities tried to pack the Councils with recognized pre-war Jewish leaders and respected public figures. The Councils were tragically torn between their desire to meet the Jews' needs and the harsh demands of the authorities.

Jewish Councils attempted to adopt various policies they thought would help the Jews. These ranged from active support for underground groups and armed resistance to nearly total cooperation with the authorities in carrying out their policies, in the hope that this would prevent worse measures than those already applied. With the nearing of the mass deportations and the sense among many Jewish leaders that deportations would be murderous, the issue of obeying or disobeying Nazi commands assumed a much greater significance. The chairman of the Warsaw Judenrat, Adam Czerniakow, committed suicide rather than give in to Nazi demands that he provide them with Jews for deportation. In Lodz, the chairman of the Judenrat, Mordechai Chaim Rumkowski, chose to continue obeying Nazi demands. Hoping to save at least part of the ghetto population – primarily workers whom he believed had a better chance of being spared – he provided lists of Jews for the Nazis and even pleaded with mothers to give up their small children. In contrast to the situation in Lodz, in the small ghetto of Tuczyn, the Judenrat planned and attempted armed resistance and mass escape – though with little success.

Recently liberated prisoners, Dachau concentration camp,
Spring 1945

Jewish Soldiers in World War II*

State	Number of soldiers	Passed away (incl. fallen in battle)	Decorated
U.S.A	550,000	28,000	36,352
Soviet Union	500,000	200,000	160,772
Poland	122,000	31,126	n/a
Great Britain	62,000	1,500	819
Palestine	40,000	688	n/a
France	35,000	n/a	700
Canada	17,000	429	200
South Africa	10,000	357	100
Czechoslovakia	5,500	n/a	43
Australia	3,900	140	60
Greece	3,000	613	n/a
Yugoslavia	2,500	n/a	n/a

* In addition there were 25,000–30,000 Jewish partisans and underground fighters.

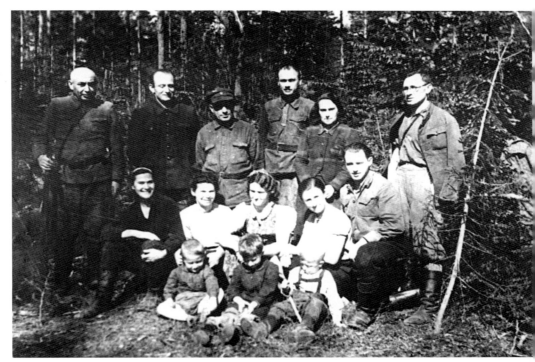

Jewish partisan "family camp" under the leadership
of Tuvia Bielski, Belorussia

Crematoria 3, used to incinerate the bodies of victims at Birkenau

Selektion of Hungarian Jews on the ramp at Birkenau, June 1944

Map showing the route used by gas vans during the asphyxiation of Jews, Chelmno, Poland

Gas van used to murder Jews, Chelmno, Poland

Land	Zahl
A. Altreich	131.800
Ostmark	43.700
Ostgebiete	420.000
Generalgouvernement	2.284.000
Bialystok	400.000
Protektorat Böhmen und Mähren	74.200
Estland — judenfrei —	
Lettland	3.500
Litauen	34.000
Belgien	43.000
Dänemark	5.600
Frankreich / Besetztes Gebiet	165.000
Unbesetztes Gebiet	700.000
Griechenland	69.600
Niederlande	160.800
Norwegen	1.300
B. Bulgarien	48.000
England	330.000
Finnland	2.300
Irland	4.000
Italien einschl. Sardinien	58.000
Albanien	200
Kroatien	40.000
Portugal	3.000
Rumänien einschl. Bessarabien	342.000
Schweden	8.000
Schweiz	18.000
Serbien	10.000
Slowakei	88.000
Spanien	6.000
Türkei (europ. Teil)	55.500
Ungarn	742.800
UdSSR	5.000.000
Ukraine 2.994.684	
Weißrußland ausschl. Bialystok 446.484	
Zusammen: über	**11.000.000**

Excerpt from the protocol of the Wansee Conference, held on January 20, 1942, where senior Nazi functionaries coordinated the already ongoing mass murder of the Jews.
The excerpt shows Nazi estimates of Jewish populations by country, planned for total elimination.

Execution of Jews by German Army (Wehrmacht) units,
Serbia, Autumn 1941

© Établissement Cinématographique et Photographique des Armées, Paris, France

Mass executions carried out by German units, Kraigonev,
Soviet Union, Summer 1941
© National Archives, Washington, D.C., USA

Women selling Jewish badges, Warsaw ghetto

The Chlodna Street bridge
spanning two parts of the
Warsaw ghetto was outside
the ghetto confines, and thus
forbidden to Jews

A section of the Warsaw ghetto wall
showing the sealed ghetto on one side and
the Aryan side on the other

Child labor, Lodz ghetto
© Jewish Museum, Frankfurt

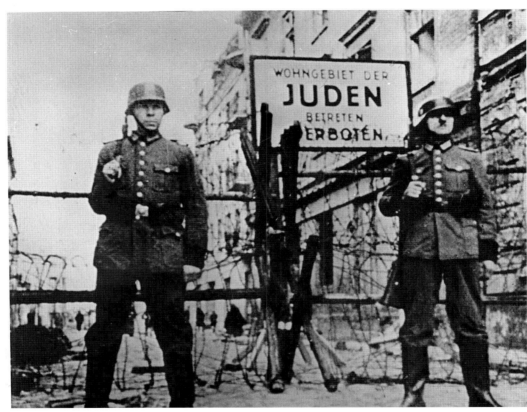

Gate to the Lodz ghetto guarded by a German soldier. The sign reads:
"Jewish Residential Area. No Entry."

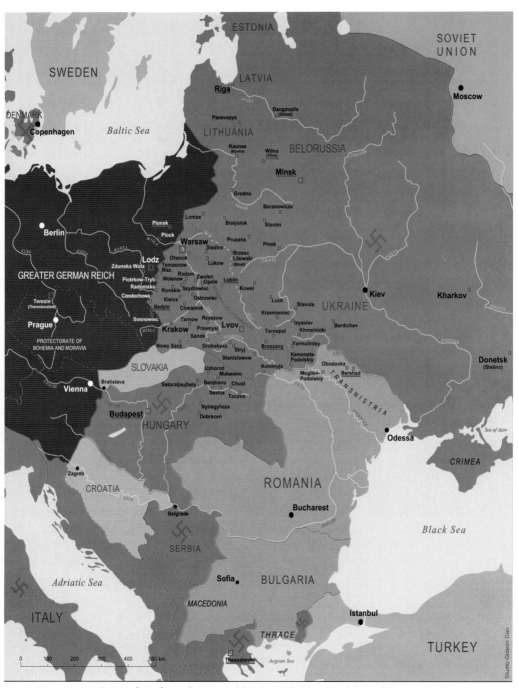

Map showing ghettos with over 10,000 Jewish residents

WILL THE EVIAN CONFERENCE GUIDE HIM TO FREEDOM?

Cartoon depicting the lack of options for Jews wishing to leave Europe on the eve of the Evian Conference, July 1938

DEUTSCHES REICH

REISEPASS
Nr. 34878

NAME DES PASSINHABERS

BEGLEITET VON SEINER EHEFRAU

UND VON KINDERN

STAATSANGEHÖRIGKEIT:

DEUTSCHES REICH

Passport with the letter "J" stamped on it, required from 1938 onwards in all passports belonging to Jews living in the German Reich

Burning synagogue, Baden Baden, Germany,
Kristallnacht, November 9–10, 1938

On December 17, 1942, the Allies issued a proclamation condemning the "extermination" of the Jewish people in Europe and declared that they would punish the perpetrators. Nevertheless, it remains unclear to what extent and when Allied and neutral leaders understood the full import of the information. The utter shock of senior Allied commanders who liberated the camps at the end of the war may indicate that they had not comprehended the actual situation, despite the information available.

Why didn't the Allies bomb Auschwitz-Birkenau?

The first detailed information about Auschwitz reached the Allies in June 1944, in a report from two escaped prisoners forwarded by Jewish underground activists in Slovakia. The information included a request to bomb the camp and the rail lines leading to it from Hungary, as masses of Hungarian Jews were then being deported to the camp. The Allies had command of the skies by that time, and air bases in Italy brought the Allied forces in the West within range of parts of Poland. From the spring to the autumn of 1944, Allied aircraft flew over the camp several times on a mission to photograph German industrial plants a few kilometers away. In the late summer these plants were bombed, but the extermination camp of Auschwitz-Birkenau was never bombed.

The Allies explained their decision not to bomb the camp in several ways. They said it was technically impossible for them to reach the camp. The fact that they bombed other targets very nearby indicates that this was not true. They argued that such a bombardment would not slow down the murder operation and would divert forces from decisive battles and endanger the airmen. The only way to rescue Jews, they said, was by winning the war. Their main arguments, then, were "rescue through victory" and "no diversion from the war effort." The Allies also did not want it to appear that they were fighting the war for the sake of the Jews.

Whether a bombing mission to the extermination camp would have succeeded or failed is an open question. However, it is clear

supervised the burning of the victims' bodies in the extermination camps. These operations became more and more important as the Nazi leaders began to consider that Germany might lose the war. From June 1943 onward, Sonderkommando 1005 returned to murder sites in the occupied areas of the Soviet Union dating from as early as June 1941, and tried to erase the traces of mass graves by burning the remains in huge pyres. Sometimes Jewish slave laborers performed this gruesome task. Although the Nazis did not succeed in wiping out all traces of the murder, their attempt to do so has made it much harder to determine the exact details and statistical magnitude of the crimes that were committed.

When did the world learn about the Holocaust? How did information reach the free world?

A distinction should be made between reports on specific mass-murder incidents and reports on genocide. Information regarding mass murders of Jews began to reach the free world soon after these actions began in the Soviet Union in late June 1941, and the volume of such reports increased with time. The early sources of information included German police reports intercepted by British intelligence; local eyewitnesses and escaped Jews reporting to underground, Soviet, or neutral sources; and Hungarian soldiers on home leave, whose observations were reported by neutral sources. During 1942, reports of a Nazi plan to murder all the Jews – including details on methods, numbers, and locations – reached Allied and neutral leaders from many sources, such as the underground Jewish Socialist Bund party in the Warsaw ghetto in May, and again in November; information emanating from Jewish organizations in Geneva, such as Gerhard Riegner's cable from Switzerland in August; the eyewitness account of Polish underground courier Jan Karski in November; and the eyewitness accounts of sixty-nine Polish Jews who reached Palestine in a civilian prisoner exchange between Germany and Britain in November 1942.

protected the Jews in its traditional territories, but those of the annexed areas of Macedonia and Thrace were deported by the Bulgarians to their deaths.

Puppet states, like Croatia, either brutally murdered their own Jews or, like Slovakia, turned them over to the Germans. As long as France remained divided between an occupied northern zone and unoccupied southern zone, in the latter, semi-sovereign Vichy France collaborated in the deportation of non-French Jews. By and large the Vichy authorities refrained from deporting Jews who held French citizenship. In the northern occupied zone, and after the occupation of the southern zone, the Germans acted against the Jews as they did in other areas under their direct control. The Jews of Denmark lived safely as long as a semblance of Danish independence was maintained; only when the Germans began encroaching on this independence did it become necessary to save the Danish Jews by smuggling them over to Sweden. To the great credit of the Danish people, they managed to save almost all of the Jews residing in their country.

How did the Nazis try to hide their atrocities?

The first method the Nazis used to camouflage the murder of the Jews was the use of euphemisms in many of their documents – for example, "special treatment" instead of murder, and "evacuation" instead of deportations. Even the term "Final Solution" is a code word for the extermination policy. Those who participated in the murder operations were sworn to secrecy. Jews were told various lies about where they were being taken when they were ordered to prepare for deportation. Generally, they were told they were going to a "better place," where they would have to work but would be able to live.

From June 1942 onward, a special operation, *Aktion* 1005, was initiated in order to destroy the physical evidence of the murder. Under SS officer Paul Blobel, a special unit called Sonderkommando 1005

murdered anyone who faltered or tried to escape. This mass murder of hundreds of thousands of inmates continued until the day the Germans surrendered.

What role did German-dominated governments play in the murder of Jews?

To answer this question, we must take into account many factors. Two of the most salient are the nature of the relationship of a given state to Nazi Germany and the way that state related to the Jews in its midst. More independence from Nazi Germany generally meant that Jews had a greater chance of survival, since these states were somewhat less inclined to pursue the Nazi goal of murdering all the Jews. In several countries the authorities differentiated between long-standing Jewish citizens and Jews who were not citizens or who lived in newly acquired territories. They usually felt no obligation to protect these Jews, and, at times, they even actively fostered their murder.

Conversely, the Jews of countries ruled directly or almost directly by Germany during most of the war generally had only the slimmest chances of survival, because in these places there were no major obstacles to the Nazi implementation of their murderous plans.

As long as Italy remained a full-fledged ally of Germany (until September 1943), the Jews there were persecuted but not subjected to murder. In Italian-occupied territories the military was reluctant to hand over the Jews to the Germans. Romanian military forces murdered great numbers of Jews in territories acquired after World War I and at the start of World War II, but, for the most part, the government did not murder Jews from its core territories. The Hungarian government did not accede to Nazi pressure to deport the masses of Hungarian Jewry until the Germans occupied Hungary in March 1944. During the occupation, however, Hungarian forces played a major role in the deportation. The Bulgarian regime

The first camp specifically established as an extermination camp was at Chelmno (Kulmhof), Poland. It began to function on December 8, 1941, when Jews from the surrounding area were brought there. Gas vans were used for the murder. Eventually, approximately 330,000 people, mostly Jews, were murdered there.

Early in 1942, the Nazis began to murder Jews in three extermination camps in the framework of "Operation (*Aktion*) Reinhard": Belzec, Sobibor, and Treblinka. Most of the Jews from Poland were murdered in these camps in 1942 and 1943. In all, about 1.7 million Jews were murdered in the Reinhard camps. Majdanek was both a concentration-labor camp and a killing center. Unlike the Operation Reinhard camps, most of the inmates in Majdanek were not Jews.

The most infamous of the extermination camps was established at Auschwitz, which eventually grew into a large complex of labor camps and sub-camps. The extermination center began to function in the spring of 1942, after larger gas chambers were built in nearby Birkenau (Auschwitz II). Many Jews were murdered immediately upon arrival in Auschwitz; others were taken for forced labor, and when they could no longer work, were dispatched to Birkenau to be gassed. Eventually, about one million Jews and roughly 100,000 Poles, Roma, Soviet prisoners of war, and people of various other nationalities were murdered there.

What were the death marches?

As the Third Reich tottered and the Eastern Front collapsed, SS head Heinrich Himmler ordered that no camp inmates be taken alive by the Allies. At the end of 1944, the Germans began evacuating hundreds of camps in Poland and East Prussia. In April 1945, the evacuation extended to the inmates of the concentration camps in Germany and Austria. In the midst of a severe winter, camp inmates were taken mostly by foot on murderous forced marches that lasted for weeks. Their survival depended on evading the hazards along the way and the brutality of their overseers, who

(*Kristallnacht*), people were no longer imprisoned primarily because of their perceived actions. They began to be imprisoned for reasons of race. As the Nazis conquered more and more territory, they expanded the camp system greatly and used it as a tool in their plan for reordering European society along racial lines. Others who were considered troublesome by the regime on social grounds – including homosexuals, Jehovah's Witnesses, common criminals, men who had fought in the International Brigade in the Spanish Civil War, and even fans of jazz music – were also incarcerated in the camps.

Forced labor was always a component of the concentration-camp system, and, as time went on, this component became more and more central to it. In fact, the Nazis did not call all of their camps "concentration camps"; some were designated as labor or hard-labor camps, others as transit camps, and others as exchange camps. As a result of the inhuman labor conditions, the cruelty of the camp staff, and the horrific physical conditions, many prisoners died in the camps, especially during the war. With the onset of the Final Solution, six extermination camps were also established in which primarily Jewish prisoners were systematically murdered. In Croatia, the Ustasa regime, allied with the Nazis, established a very large concentration and extermination camp at Jasenovac, where primarily Serbs, and also local Jews, were killed.

What were the extermination camps? When did they start to function, and what was their purpose?

Extermination camps were set up to be sites of industrial mass murder. Millions of people, almost exclusively Jews, were brought to the extermination camps, usually by train. There was a staff responsible for carrying out the systematic slaughter by means of a well-honed machinery of death. The private property of the victims, including their gold teeth and hair, were collected and used in various ways by the authorities. The bodies of the victims were incinerated either in crematoria or in pits.

Who built the gas chambers? What kind of gas was used to kill Jews there, and who provided it?

In the extermination camps built under "Operation Reinhard" – Belzec, Sobibor, and Treblinka – the gas first used to murder people was carbon monoxide, either generated by gasoline engines or released from carbon-monoxide cylinders. In Majdanek a variety of different types of gases were used. Experiments in the use of Zyklon B, a form of hydrogen cyanide or prussic acid, began in Auschwitz in September 1941. The gas pellets were supplied by DEGESCH (a German cooperative that manufactured pesticides), which was controlled by I.G. Farben. Tesch and Stabenow Co. of Hamburg also supplied gas pellets. The improved gas chamber and crematoria facilities at Auschwitz-Birkenau were built by J. A. Topf und Söhne of Erfurt, Germany.

What were the concentration camps? When did they start to function, and what was their purpose?

Immediately after they came to power, the Nazis set up camps in which they imprisoned those whom they considered opponents to their regime (communists, socialists, labor leaders, and others who "threatened" their regime) and treated them with great brutality. These camps were designed to break the opposition and inspire fear among the population in order to ensure that any further opposition would not arise. The first concentration camp was established at Dachau, on March 23, 1933, just two months after Hitler became chancellor of Germany. Dachau became the training ground for the SS guards. Its first commandant was Theodor Eicke, who set many precedents for brutality that were subsequently followed throughout the expanding camp system. Among the major camps established in Greater Germany were Buchenwald, Mauthausen, Neuengamme, Ravensbrück, and Sachsenhausen.

At the time of the annexation of Austria and, more so, during the pogrom against the Jews of Germany in November 1938

Tens of thousands of Jews who tried to escape from incarceration were painstakingly hunted down, one by one, by the SS and other armed German formations.

Other government authorities and German civilians were involved in the murder process. Throughout Eastern Europe, ghettos were generally run by civilian German administrations that included lawyers, engineers, physicians, and other officials.

German industrialists exploited millions of people for slave labor, and the death rate of Jewish laborers, who were at the bottom of the social ladder in the camps and factories, was exceptionally high. The deportation of Jews to the camps and among the camps could not have happened without the concerted effort of the German railway system, for example. Moreover, in all stages of the murder, many non-German civilians voluntarily participated in the killing operations. At no stage was there a shortage of individuals willing to participate in the murder of Jews.

What were the gas vans? When and where were they used?

Gas vans were trucks used to murder Jews and others by asphyxiation. At first the carbon monoxide generated by the combustion of gasoline by the trucks' engines was channeled into sealed chambers. The first experiment using gas vans was carried out on mentally ill children in Kochanowka, near Lodz, in 1940. Later, in September 1941, Soviet prisoners of war were murdered in Sachsenhausen by channeling the fumes into the sealed compartment of the truck itself. Two months later mobile gas vans were put into use in the Soviet Union as part of the murder of Jews spearheaded by the Einsatzgruppen. When the Chelmno extermination camp was established in December 1941, three gas vans were used there as the instruments of death. Gas vans were used in other areas as well. For example, Jews – mostly women and children – were murdered in gas vans in the Sajmiste camp near Belgrade in Serbia, early in 1942. All told, gas vans were used in the murder of approximately 700,000 people, half of them in Chelmno.

four main units and sub-units, their primary task was to destroy what they regarded as the ideological infrastructure of the Soviet Union: political commissars, members of the Communist party, and, above all, Jews. The overwhelming majority of the commanders of these units had graduate degrees and were deeply committed to building the Nazi utopia; i.e., a racially and ideologically pure society without Jews.

The Einsatzgruppen advanced into the Soviet Union along with the German army. Wherever they stopped, they collected and shot in cold blood as many Jews as they could find (first Jewish males, and soon thereafter Jewish women and children as well). They wrote detailed daily reports on most of their activities, and copies of these documents still exist. According to their own incomplete reports, they killed at least 900,000 Jews and were assisted by other units in the murder of up to six hundred thousand more.

Which German units took part in the murder of the Jews?

Most segments of German society played a role in the murder of the Jews either directly or indirectly, and the Wannsee Conference, where the Final Solution was coordinated, was attended by representatives of all the main government offices and agencies. The SS was at the forefront of the murder, often cooperating with other entities. These included SS brigades, police formations, units of the German armed forces, units of non-Germans who had joined the German forces, and, on occasion, unlikely groups such as construction crews and musicians. About one and a half million Jews were shot by the Einsatzgruppen and their accomplices. Millions of Jews from all over Europe were murdered in extermination camps run by the SS. The entire Jewish community of Serbia was annihilated in a joint operation of the regular German army and the SS. In Romanian-controlled territory, the German 11th Army was deeply involved in the murder, along with Einsatzgruppe D, Romanian military units and civilians, and local Ukrainian militias. Hundreds of thousands died in concentration and labor camps run by the SS, or in ghettos.

How did the Jews cope with the conditions in the ghettos?

Although the lives of the Jews were firmly under the control of the German authorities, they did whatever they could to try to keep their bodies and souls together. They used all legal methods and resorted to "illegal" means as well in their attempts to cope with the severe conditions imposed on their lives in the ghettos. Jewish councils arranged for housing, distributed food, and provided social welfare, childcare, refugee assistance, and other services – stretching their very meager resources even beyond the limits of their capabilities. In some ghettos autonomous social-welfare organizations were created to deal with the same types of needs, and political parties and youth movements organized clandestinely to provide their members with supplementary aid and moral support. Families and friends tried to help their own as much as possible.

Many Jews in many ghettos, individually and collectively, came to realize that the Nazis had cornered them in a trap: if they obeyed the Nazis' rules, they stood to die prematurely of starvation or disease. If they were caught breaking the rules by smuggling food, supplies, and information, they faced certain death. The Nazi policy of collective punishment meant that many innocent people could pay for the act of an individual, especially his closest family members. This policy weighed heavily upon the Jews. Nevertheless, in many instances, Jews chose to become "outlaws" in their struggle to survive.

What were the Einsatzgruppen, and what was their role in the murder of the Jews?

Einsatzgruppen means "task forces." The SS set up such units before they entered Austria, Czechoslovakia, Poland, and the Soviet Union. The task of the Einsatzgruppen in Poland was to terrorize the local population and murder anyone whom the SS deemed undesirable. The most infamous Einsatzgruppen were formed before the invasion of the Soviet Union in June 1941. Divided into

23

failed Vilna ghetto uprising. The last few thousand Jews were sent to camps in Estonia on September 23, 1943. The Bialystok ghetto, which originally contained 50,000 Jews, was liquidated on August 16, 1943; during the liquidation the Jewish underground responded with armed resistance to the Germans.

What conditions prevailed in the ghettos?

In Poland, before they even entered the ghettos, most Jews had already been impoverished as a result of the decrees that had been passed against them by the ruling authorities. In the occupied areas of the Soviet Union, ghettos were generally established after the Jews had experienced a wave of mass murder. In the ghettos themselves, the Nazis confiscated nearly all of the Jews' remaining belongings and denied them access to even the most basic needs of daily life. Usually ghettos were established in the poor areas of the cities and towns. The physical area to which the Jews were confined was crowded, and non-Jews were barred from entering the "Jewish living area." Many ghettos were surrounded by walls or fences in order to enforce the Jews' isolation and separation from their neighbors and the outside world. The ghettos were meant to serve as temporary, tightly controlled collection points, where the Jews' labor potential would be exploited until a future German policy led to their removal.

Jews in most ghettos were kept under horrendous conditions. Severe overcrowding, lack of hygiene, extreme starvation, and denial of basic medicines led to widespread epidemics in many ghettos. The harsh conditions and long hours of forced labor weakened the Jews further. In Warsaw, the largest of the ghettos, approximately 85,000 Jews (about 20 percent of the ghetto population) died as a result of the conditions even before the Nazis began to deport them to the death camps. Similar death rates were evident in other ghettos, and even where conditions were somewhat better, the suffering was immense.

of this policy. Early in December, a meeting was scheduled at Wannsee under Heydrich to coordinate the ongoing murder of the Jews. As a result of the Japanese attack on Pearl Harbor, however, it was postponed until January 20, 1942. These events strongly suggest that the Final Solution coalesced sometime in the second half of 1941, and that Hitler, Göring, Himmler, Heydrich, and other Nazi leaders were integral to the decision-making process that led to the mass murder of the Jews.

What were the largest ghettos, how many Jews were concentrated in them, and when were they liquidated?

The largest ghetto was in Warsaw, which held up to 445,000 Jews. After massive deportations to Treblinka in the summer of 1942, and two uprisings in January and April 1943, the ghetto was liquidated in May 1943. The Lodz ghetto contained over 160,000 Jews at its peak. This ghetto was liquidated gradually: in a first wave of deportations to Chelmno between January and May of 1942; in many subsequent deportations, primarily to Chelmno and Auschwitz-Birkenau; and in the final liquidation on August 30, 1944. The Lwow ghetto contained about 110,000 Jews when established in November 1941; its last few thousand inhabitants were removed in June 1943, after the rest had been deported to their deaths in Belzec and Janowska. The Minsk ghetto held 100,000 Jews from this city, the surrounding towns and villages, and from the Reich. The Minsk ghetto was liquidated on October 21, 1943, after most of its Jewish inhabitants had been shot at Maly Trostinets and Tuchinka. In the summer of 1941, the 57,000 Jews of Vilna were first subjected to a wave of mass murder before a ghetto was established. Eventually two ghettos were set up: one for the weak, and one for the strong. The ghetto with the weaker Jews was emptied out, and its inhabitants shot at Ponar; some of the inhabitants of the second ghetto met a similar fate. This wave of murder ended in December 1941. The remaining Jews, approximately 20,000, lived in the ghetto until the

which called for the murder of all Jews, developed during the war itself.

At the time of the German conquest of Poland in the autumn of 1939, the Nazis crossed the line from earlier forms of discrimination to mass murder. Sporadic mass killings in conquered areas in which most Polish Jews lived resulted in the deaths of thousands in the last months of 1939. With the invasion of the Soviet Union on June 22, 1941, wider-ranging murderous operations against the Jews were implemented. At first German armed formations – chief among them special units of the SS known as the Einsatzgruppen – along with local volunteers began shooting Jewish males, as well as Communist political officers, in a mass and systematic fashion.

On July 31, 1941, the "No. 2" man in the SS, Reinhard Heydrich, was made responsible by Hitler's deputy Hermann Göring for the "Final Solution to the Jewish Question in Europe." In mid-August, when the head of the SS, Heinrich Himmler, visited the newly occupied Soviet areas, the Germans extended the killing to Jewish women and children. Soon thereafter experiments began on the use of Zyklon B gas as a means for mass murder. These experiments were conducted in Auschwitz on Soviet prisoners of war.

The deportation of the Jews from the Reich began in mid-October, 1941, and an edict passed just a few days later prohibited any further Jewish emigration from the Reich. Also in October, sites were chosen for the earliest extermination camps. In early December, the first extermination camp, Chelmno, went into operation. There, Jews began to be murdered by gas in mobile vans. In the meantime tens of thousands of Jews had been murdered by different Nazi formations and Nazi allies in Serbia, Romania, and the Romanian-held territory known as Transnistria. The murder of the Jews, therefore, converged from many angles.

At a meeting between Hitler and his inner circle on December 12, the murder of the Jews of the Soviet Union and fresh murder operations against the Jews of Germany were discussed. From this meeting it is clear that Hitler was intimately involved in the evolution

To which countries did the Jews of the Reich emigrate before the outbreak of the war?

In the first years of the Nazi regime, most German Jews who emigrated went to neighboring European countries and to British mandatory Palestine. However, the picture changed considerably after 1936, and especially in 1938. During this period, as immigration of refugees to Palestine and most of the countries of Europe became increasingly difficult, and the circumstances of Jews in Germany deteriorated, Jews became more willing to consider more remote places, especially South America. In addition, as the plight of Austrian Jewry became more desperate after the Nazi annexation of March 1938 and the *Kristallnacht* pogrom in November, which struck the Jews of the entire Reich, the United States and Great Britain somewhat relaxed their restrictive practices.

In their frantic efforts to break out of the Nazi trap, the Jewish refugees from Germany and Austria went wherever they could. Some traveled as far as Shanghai, one of the few places that accepted immigrants freely. Others tried to reach Palestine clandestinely in order to circumvent British restrictions on Jewish immigration.

It is estimated that about 366,000 Jews emigrated from Greater Germany in 1933–1939. Their destinations were primarily the United States, Palestine, Latin America, Shanghai, and various West European countries.

When and how did the Nazis decide to murder the Jews under their control?

The exact date of the Nazi policy decision to murder all the Jews is not entirely clear. No written order from Hitler to this effect has been found, although there are many documents that attest to the planning and execution of such a policy. Currently there is a consensus among historians that, before the outbreak of the war, the Nazis did not have a definite plan to murder the Jews of Europe. Rather, the policy that came to be known as the "Final Solution,"

By the mid-1930s, the Jewish organizations increasingly emphasized activities that fostered emigration. They disseminated information about various countries of destination, and they offered language and vocational classes. This wide range of activities continued until the advent of the pogrom of November 1938. After the pogrom the Nazis circumscribed these activities, and the Jewish organizations were able to continue them only on a much narrower basis.

Why couldn't more Jews leave Europe before the war began?

The most straightforward answer is that they simply had nowhere to go. For the Jews of Europe, as noted in Chaim Weizmann's famous remark in December 1936, "There are now two sorts of countries in the world, those that want to expel the Jews and those that don't want to admit them."

The restrictive immigration practices of the major overseas countries vis-à-vis Jewish refugees reflected a global climate of economic protectionism tinged with xenophobia and outright antisemitism. An international conference on refugees held at Evian, France, in July 1938, initiated by President Franklin D. Roosevelt, proved to be a fiasco. Except for the Dominican Republic, none of the representatives of the thirty-two countries present offered prospective Jewish refugees from Germany and Austria any hope whatsoever.

Another explanation is that the intermittent and uneven application of the antisemitic pressure during the Nazi regime's first years sent confusing signals to the Jewish victims, quelling their sense of danger, and allowing them to believe that the worst had already passed. In the wake of the annexation of Austria in March 1938 and the new Nazi policy of forced emigration, many Jews rushed to leave. This exodus intensified after the November pogrom. By that time Jews were willing to emigrate to any place they could.

majority of German Jewry, the Central Association of German Citizens of the Jewish Faith. "No one can deprive us of our homeland and fatherland." On the other side of the ideological divide, the German Zionists, who were more pessimistic about the viability of a German-Jewish synthesis, seemed better attuned to the new times. Even they, however, could not fathom the full extent of the Nazi threat to Jewish existence.

Jews tended to assume that the revolutionary ardor of the Nazi regime would spend itself after the first few months in office and that its bite would not prove to be half as dangerous as its bark. In a way, the first to be aware of the danger were those Jews who were active in the Socialist and Communist movements and, for this reason, were doubly exposed to political and racial persecution.

After the initial shock, German Jewry began to reorganize in response to their new circumstances. Already in April 1933, the Central Committee for Help and Reconstruction was established, which coordinated the wide-ranging welfare activities of the beleaguered Jewish community. On September 17, 1933, the National Representation of the German Jews came into being and assumed responsibility for overall political representation.

As a small minority living under a violent authoritarian regime, German Jewry were unable to mount any political opposition against the Nazis. Their hope that the status of the Jews in Germany could be settled in a tolerable fashion through negotiations carried out between the Jewish leadership and the regime proved futile. Thus, what remained was for the Jewish leadership to focus on the internal life of the Jewish community. An important by-product of this focus was a deepening of Jewish consciousness and a strengthening of inner bonds of Jewish solidarity under the persecution.

As the isolation of the Jews increased, the Jewish organizations focused on social-welfare work and aid to the needy. They established a Jewish educational system for children who had been ousted from the German schools. They fostered adult education and founded the Kulturbund, an organization in which Jewish artists could express themselves.

Dachau, Sachsenhausen, and Buchenwald. They were subjected to brutal mistreatment, and an estimated 2,000–2,500 died. Most of the survivors were allowed to return home over the next three months after signing a statement obliging them to emigrate from Germany.

At a conference of top Nazi officials convened by Reich Marshall Göring in the offices of the Air Transport Ministry on November 12, 1938, a decision was made to fine the Jews an "indemnity," or "atonement," of one billion Reichsmarks for the damages following the pogrom that had been perpetrated against them. In the ensuing weeks and months, a veritable torrent of discriminatory decrees and repressive measures – outlined during the Air Transport Ministry conference – poured down upon the hapless Jews of Germany and Austria, stripping them of their livelihood and the last vestiges of their legal rights. The Jews were turned into social pariahs and were now fair game to all. "I would not like to be a Jew in Germany," commented Göring.

How did the Jews in Nazi Germany respond to their persecution before the war?

German Jewry, the first victims of the Nazi regime, represented one of the oldest established Jewish communities in Europe. Until 1933, German Jews had been widely regarded as a virtual model of the success of Emancipation and of the creative interaction between the Jews and their non-Jewish environment. Most German Jews considered themselves no less German than any of their Christian neighbors. Some 12,000 of them had died on the battlefields of World War I, fighting for the interests and honor of their beloved country.

During the first days of the Nazi regime, it was difficult for them to grasp that anyone could strip them of their German rights and identity, that they could be turned into pariahs in their own land. "Germany remains Germany," stated a leading article in the newspaper published by the organization that represented the

tightening and loosening of the antisemitic pressure. Spurts of intense antisemitic activity were buffered by prolonged periods of deceptive stabilization. By and large, the pre-war antisemitic campaign crested at three junctures: (1) The economic boycott of April 1, 1933, and the ensuing wave of racial legislation aimed at Jewish employees in the public services and the various professions; (2) the Nuremberg Laws of September 15, 1935, which ended Jewish emancipation in Germany and defined "Jewishness" in racial terms; and (3) the state-organized pogrom on the night of November 9–10, 1938, referred to as *Kristallnacht.*

What was *Kristallnacht?*

On the night of November 9–10, 1938, Nazi storm troopers carried out a concerted campaign of murder, arson, and looting against the Jewish population in Germany, Austria, and the newly annexed Sudeten area of Czechoslovakia. By the time they were finished, they left a trail of some 1,000 destroyed synagogues, 7,500 vandalized shops and businesses, and ninety-one murdered Jews.

The Nazis claimed that the events of that infamous night – *Kristallnacht,* or "Night of the Broken Glass," after the shards of glass that littered the streets and the pavements of the German towns – had been a "spontaneous outburst of the people's anger" in response to the assassination of Ernst vom Rath, the third secretary in the German embassy in Paris. Vom Rath, who died of his wounds on November 9, had been shot down in Paris two days earlier by Herschel Grynszpan, a seventeen-year-old German-born Jew of Polish extraction. Grynszpan was acting in exasperation over the fate of his family, who had been among the 17,000 Polish Jews living in Germany deported by the Gestapo overnight to no-man's-land near the Polish border.

In the immediate aftermath of the pogrom, the Gestapo and the SS, who had stood aside during the night, went into action and arrested roughly 30,000 Jewish men, aged sixteen to sixty-five. Most of them were sent to concentration camps such as

15

the last democratic elections, held on November 6, 1932, the Nazi party, though the strongest, actually declined from the 37.3 percent of the total vote that it had achieved in the previous elections, on July 31, 1932, to 33.1 percent. Hitler attained power when President Hindenburg appointed him chancellor on January 30, 1933.

Once in control, Hitler and his accomplices lost no time in broadening their power base and dismantling the democratic constitution piece by piece. A crucial landmark was the so-called Law of Empowerment, which authorized the government to enact laws without recourse either to the parliament or the president. The autonomy of the individual German states (*Länder*) was abolished in a bylaw passed on March 31, 1933. The Nazi seizure of power was completed, in a sense, with the Law Against the Establishment of New Parties of July 14, 1933. Consequently, the Nazi party became the only legal political party in Germany.

How did the Nazis treat the Jews during the first years after they came to power?

The pre-war persecution of Jews in Germany took place under very different circumstances from that of the Nazis' extermination campaign during World War II. The operative aim of the Nazi policy during the first years was not yet the physical annihilation of the Jews but rather their social and economic displacement and their removal from German soil. In pursuing these goals, the regime was still subject to internal and external constraints, which restrained the brutality of its antisemitic measures. Most of the anti-Jewish campaign was carried out in the full glare of the world media. Its typical manifestations were discriminatory racial legislation, economic deprivation, public defamation, administrative harassment, and social ostracism rather than physical torture and murder. Nevertheless, all this was characterized by widespread and ever-growing violence.

A distinctive feature of Nazi policy before the war was the confusing interplay between repression and normalcy, the constant

social problem to be treated in accordance with the Nazi racial restructuring of their society. Beginning in 1942, the Nazis persecuted and murdered nomadic Roma in some places, and in others they singled out non-nomadic Roma as their victims. Between 90,000 and 150,000 Roma were murdered in the course of the German genocide perpetrated against them during World War II in the occupied countries and in Auschwitz-Birkenau.

A range of peoples in Europe, especially those who spoke Slavic languages, was deemed racially inferior by the Nazis. Yet it was not racial ideology alone that determined how the Nazis treated particular ethnic groups; *realpolitik* also came into play. Despite their supposed inferiority, the Slovaks, Croatians, Bulgarians, and some Ukrainians were allies of the Nazis. However, some two million Russian prisoners of war were murdered by means of intentional neglect, hard labor, starvation, and shooting, because of the Nazis' racism and loathing of Communism. Stemming primarily from their plans to reorganize Europe on racial and political grounds, the Nazis sought to destroy the existence of the Poles as a nation. The Nazi plans, however, did not target at the Poles for annihilation. Polish children who "looked German" were to be raised as Germans; the intellectuals and leaders were to be murdered in order to prevent rebellion; and the rest were to be enslaved.

When and how did the Nazis come to power?

Hitler did not come to power through a coup d'etat against a democratically elected government but through the democratic process. Largely as a result of the continuing social, economic, and political crisis that had struck Germany, especially after 1929, and Hitler's skill at addressing various segments of the society with the words they wanted most to hear, he and his party gained more votes than any other in the various elections held in 1932 and 1933 in Germany. However, Hitler was never elected by a clear-cut majority of the German electorate, nor was he ever given a clear mandate to become the dictatorial ruler of Germany. Actually, in

and murder every single person of an ethnic group as defined not by them, but by the perpetrators; not just in the country where this genocidal motivation arose, not just on the continent its planners first wished to control, but ultimately everywhere on earth, and for purely ideological reasons."

The Holocaust happened in a world similar to ours. The ideas and processes that led to it, its perpetration and responses to it, clearly bear on all mankind. The Holocaust stands as a warning about man's capacity, despite the trappings of civilization, to commit wholesale murder in the name of an ideology.

Who were other victims of Nazism? How was their fate similar to and different from the fate of the Jews?

There were many other people and peoples who fell victim to the Nazi regime for political, social, or racial reasons. Left-wing Germans were among the first to be persecuted because of their political activities; they included communists, socialists, and labor leaders. Many died in concentration camps, but most were released after their spirit was broken. In October 1939, Hitler ordered the start of a "euthanasia program" designed to kill persons who were born with mental or physical disabilities. According to Nazi ideology, these people were "unworthy of life." Some 100,000 children and adults – mostly Germans held primarily in six facilities, under medical supervision – were murdered in 1939–1941 throughout the Reich. The operation was officially terminated in August 1941, following protests by the churches. When the euthanasia institutions were closed, their medical and operational personnel were sent to Poland; there they were engaged in establishing and commanding the extermination camps for Jews.

Other Germans were incarcerated for being "asocials" – homosexuals, criminals, or nonconformists. These people, although treated brutally, were never slated for utter annihilation, as were the Jews.

The Nazi ideology viewed the Roma (Gypsy) peoples as a

of our past, own up to responsibility for crimes committed, and prevent future holocausts, genocides, ethnic cleansings, and terror from claiming innocent victims.

What is the Holocaust?

The Holocaust was the attempt by the Nazis to murder all the Jews. During World War II, with the help of many collaborators from different nations, they succeeded in killing approximately six million Jews from all over Europe. As Nazi discrimination against the Jews began with Hitler's accession to power in January 1933, many historians mark this as the start of the Holocaust era.

The systematic mass murder of the Jews began soon after the German invasion of the Soviet Union in June 1941; it evolved from shootings to murder by gas. By the end of the war, the area of Europe under Nazi domination was almost totally devoid of Jews.

Genocide is a legal term denoting the destruction of the essential foundations of the lives of national groups. It may include – but does not necessarily include – the physical annihilation of the group. The Holocaust is an expression – arguably, the most extreme expression – of genocide.

The Hebrew term for the Holocaust is Shoah, which is used more and more frequently in other languages as well.

Why is the Holocaust so important to us? Is the Holocaust a singular event in history?

Professor Yehuda Bauer of Yad Vashem and the Task Force for International Cooperation on Holocaust Education has said: "There is something unprecedented, frightening about the Holocaust of the Jewish people: for the first time in the bloodstained history of the human race, a decision developed, in a modern state in the midst of a civilized continent, to track down, register, mark, isolate from their surroundings, dispossess, humiliate, concentrate, transport

distort it, or even deny it – all of which applies to the Holocaust much too frequently. Ignorance is also a contributing factor to allowing people to be more receptive to those who seek to escape society's responsibility for having carried out the crime. Such people diminish the Holocaust's significance through unbalanced comparisons to other events. Others call for relegating the memory of the Holocaust to the dustbin of history, claiming it is not relevant to their lives.

For many, however, the Holocaust has emerged as a paradigm for man's capacity to commit evil. During the first decades after the end of World War II, it was not acceptable in the West, either in public discourse or in polite company to use the antisemitic rhetoric or other ideas that had bred the Holocaust. In recent years, however, such restraints have fallen away. Antisemitism has re-emerged and has moved beyond mere words to acts of violence. Many people have reduced the complex and deep-rooted conflict between Israel and the Palestinians to a new and skewed version of the Holocaust. Israel is regularly portrayed as a Nazi state and the Palestinians as its victims. This kind of glib comparison does nothing to clarify either the source or the course of that protracted conflict; it succeeds only in feeding a new perverted antisemitism in which a whole nation is tarred with the brush of great evil.

The Holocaust stands as a warning to mankind, yet that warning has not been of sufficient strength to prevent other genocides or genocide-like events from taking place in the last sixty years. For some people, the Holocaust is not a warning at all, but, rather, a model to be imitated. Thus, millions have fallen victim to genocidal murder in Cambodia, Bosnia, Rwanda, and, most recently, Darfur. Radical Islam has also become genocidal in its rhetoric and intent, and terrorists who have carried out attacks in its name have shown an eerie Nazi-like disregard for the sanctity of human life.

It is with all this in mind that we have produced this pamphlet with basic information about the Holocaust. Ignorance can be battled only with knowledge, and only with knowledge is there some chance of attaining wisdom. May all men and women acquire the wisdom necessary to appreciate the need to preserve the memory

Introduction

It is now sixty years since the end of the most horrific war in history. World War II was unlike any that preceded it. It sucked almost the entire globe into its vast dimensions and wrought untold death and destruction in its terrible wake. Tens of millions of soldiers and civilians died either as a direct or indirect result of the six years during which the war raged. It was a bitter struggle between the Axis armies – primarily Nazi Germany and Japan – and the armies of the Allied forces, primarily Great Britain, the Soviet Union, and the United States. World War II was a total war, and innovative weapons of destruction were used to deadly effect. Civilians not only suffered from collateral damage, they became the targets of military operations and murder actions intentionally directed against them.

Across the face of Europe and North Africa, however, one civilian group in particular was targeted for mass, systematic, and complete destruction. The Nazis named this policy, which sought to wipe out all the Jews, "the Final Solution of the Jewish Question." While this policy was not fully accomplished, the Nazis, along with many collaborators, did succeed in murdering some six million Jews in what has come to be known as the Holocaust.

Sixty years after the collapse of the Third Reich, the memory of the Holocaust has evolved paradoxically. Museums, memorials, days of remembrance, and school lesson plans abound. The Holocaust is frequently mentioned in the media, and terms associated with it and the Nazi period are commonly applied in discussions of current events. There is so much use and misuse of the Holocaust that some Europeans are suffering from what can best be termed "Holocaust fatigue." This, despite the fact that a great many Europeans, while living in the very places where the murder of the Jews was planned and carried out, really know very little about the Holocaust, its antecedents and repercussions.

Ignorance about the Holocaust facilitates a breeding ground for several interrelated and disturbing phenomena. When people know little about an event, it is easy to trivialize it, manipulate it,

Who built the gas chambers? What kind of gas was used to
kill Jews there, and who provided it? 26

What were the concentration camps? When did they start to
function, and what was their purpose? 26

What were the extermination camps? When did they start to
function, and what was their purpose? 27

What were the death marches? ... 28

What role did German-dominated governments play in the
murder of Jews? ... 29

How did the Nazis try to hide their atrocities? 30

When did the world learn about the Holocaust? How did
information reach the free world? .. 31

Why didn't the Allies bomb Auschwitz-Birkenau? 32

What were the Jewish Councils (Judenräte)? 33

How did Jews resist the Nazis' murderous assault? 34

What was the nature of Jewish armed resistance? 35

Are there instances during the Holocaust where Jews under
Nazi domination rescued other Jews? 38

Who are the "Righteous Among the Nations?" 39

What were the displaced persons (DP) camps, and how
many Jews resided in them after the war? 40

What is "Holocaust denial"? .. 41

How was the murder of the Jews humanly possible? 43

Contents

Introduction ... 9

What is the Holocaust? .. 11

Why is the Holocaust so important to us? Is the Holocaust
 a singular event in history? 11

Who were other victims of Nazism? How was their fate
 similar to and different from the fate of the Jews? 12

When and how did the Nazis come to power? 13

How did the Nazis treat the Jews during the first years after
 they came to power? ... 14

What was *Kristallnacht*? .. 15

How did the Jews in Nazi Germany respond to their
 persecution before the war? 16

Why couldn't more Jews leave Europe before the war
 began? ... 18

To which countries did the Jews of the Reich emigrate
 before the outbreak of the war? 19

When and how did the Nazis decide to murder the Jews
 under their control? ... 19

What were the largest ghettos, how many Jews were
 concentrated in them, and when were they liquidated? 21

What conditions prevailed in the ghettos? 22

How did the Jews cope with the conditions in the ghettos? 23

What were the Einsatzgruppen, and what was their role in
 the murder of the Jews? 23

Which German units took part in the murder of the Jews? 24

What were the gas vans? When and where were they used? 25

Remember only that I was innocent
and, just like you, mortal on that day,
I, too, had had a face marked by rage, by pity and joy,
quite simply, a human face!

Benjamin Fondane, *Exodus*
Murdered at Auschwitz, 1944

Contributors and Consultants:	Dr. Daniel Frankel
	Ephraim Kay
	Dr. Yaacov Lozowick
	Avraham Milgram
	Dr. Guy Miron
	Dr. Robert Rozett
	Dr. David Silberklang
	Dr. Shmuel Spector

Language Editor:	Leah Aharonov
Assistant Editor:	Avital Saf
Cover Design:	Stephanie & Ruti Design

On the Cover: Deportation of Jews to Kutno ghetto, Poland, June 1940

Danacode 268-424

ISBN: 965-308-253-1

Printed in Israel 2005

By Keterpress Enterprises, Jerusalem

THE HOLOCAUST
FREQUENTLY ASKED QUESTIONS

Edited by
Avraham Milgram and Robert Rozett

Yad Vashem
The Holocaust Martyrs' and
Heroes' Remembrance Authority

The Knesset
The Israeli Parliamentary Association for
Holocaust Remembrance and Aid to survivors

Jerusalem 2005

This pamphlet was published
on the initiative and with the generous support
of David Svirsky

THE HOLOCAUST
FREQUENTLY ASKED QUESTIONS

Prissy Culobaci

CUBAN COFFEE. TWO-PINT MUG. NINE SUGARS.

HE LOVES YOU AND HE WANTS YOU TO VOTE--HE'S NEVER HAD A BLOWJOB AND HE DOESN'T OWN A TAPE RECORDER--HE LOVES YOU AND HE WANTS YOU TO VOTE--

OH, FUCK... NOT FIRST THING IN THE MORNING...

TV: GO TO SPKF POLITICAL CHANNEL.

WELL, WE HAVEN'T HEARD FROM YOU IN TWO MONTHS, ASIDE FROM YOUR COLUMNS.

WHICH IS HOW I WANTED IT, THANKS.

uh-huh. NEW APARTMENT OKAY?

FINE. THE SECURITY SYSTEM INTERROGATES FRESH AIR BEFORE IT LETS IT IN.

BOB HELLER SEEKS TO RIDE INTO OFFICE UPON A WAVE OF MUTILATION.

HIS FLORIDA CAMPAIGN FOR THE CANDIDACY RESTED ENTIRELY UPON CULTURAL AND ECONOMIC DIVIDES, THE EXPLOITATION OF TENSIONS AND THE VESTIGES OF PREJUDICE.

HIS APPEARANCE IN SANFORD LOOKED LIKE A NUREMBERG RALLY.

SO... YOU'RE DOING OKAY, THEN?

ASIDE FROM ALL THE PICTURES OF THE FUCKING SMILER THAT ASSAULT ME TWENTY-FOUR/SEVEN...

THAT KIND OF BRINGS ME TO A, YOU KNOW, QUESTION, SPIDER...

THAT'S A BIT STRONG, VITA...

NO, IT'S NOT. WHAT THE HELL DOES "AMERICA FOR AMERICANS" MEAN, ANYWAY?

THIS COUNTRY WAS CREATED BY THE ADVENTURERS AND DREAMERS OF SEVERAL OLD NATIONS. AMERICA IS THE DUTCH, AND THE GERMAN, AND THE SPANISH, AND EVEN THE ENGLISH.

OUR POLICE WERE IRISH, OUR FARMERS--

EXTRACT OF QUEEN ANT (UPPER)

--OUR CRIMES, AFRICAN AND NATIVE...

PLEASE BE FACETIOUS ON YOUR OWN TIME, ROBERT. I'M ANSWERING YOUR QUESTION SO YOU'RE ON MY DIME.

HEH.

WHAT?

NOTHING. QUESTION.

WHEN ARE YOU GOING TO START COVERING THE GODDAMN ELECTION, SPIDER?

SPIDER, THE CITY CAUCUS HAS COME AND GONE. THE OPPOSITION PARTY CONVENTION IS HERE IN TOWN. THE RULING PARTY CON HAS BEEN AND GONE.

WHAT'S YOUR POINT?

TALK TO YOU LATER, ROYCE.

CLICK

14

HELLER WANTS [TO WI]N BY CREATING AN [U]NEQUAL DIVIDE AND [A]PPEALING TO THE [WORST INSTINCTS OF THE LARGER DEMOGRAPHIC.

SENATOR CALLAHAN WANTED NO PART OF SUCH A CONTEST. WE RESERVE OUR BETTER ENERGIES FOR THE CONVENTION.

WHERE YOU NEED TO OBTAIN SOMETHING LIKE FIVE HUNDRED DELEGATES FOR CALLA-HAN TO GET THE NOMINATION TO CANDIDACY.

THIS IN A CONVENTION MORE TORN THAN ANY IN LIVING MEMORY.

THE PLAYERS IN THE APPROACHING BATTLE BEGIN TO RESEMBLE COURTLY CONSPIRATORS IN SOME SHAKESPEAREAN TRAGEDY--

TOGGLE OVER TO RELATED FEEDSITE.

BABEL
SPKE
PC

OPPOSITION PARTY CONVENTION; THE RUNNERS; BASIC STATS; VOICE-CONTROLLED PROGRESSION.

CUSTOM BREAKFAST ONE.

THE MAKER'S BASE MATTER BLOCK IS ALMOST EXPENDED. PLEASE REPLACE OR BEGIN UTILIZING THE GARBAGE CONVERTER.

AH, SHIT.

AND BEFORE YOU HANG UP ON ME AGAIN--GET INTO THE OFFICE THIS AFTERNOON--I HAVE YOUR NEW ASSISTANT HERE.

¡CLICK!

PROCEED. AUDIO.

SENATOR GARY CALLAHAN, D-CAL. THIRTY-NINE YEARS OLD, MARRIED, TWO CHILDREN--

FUCK THIS. SHUT UP.

Damn it.

19

My new apartment overlooks Chase Square. A very rich part of town, very media, very safe. And, of course, barely ten minutes' walk from one of the worst sinkholes in the City.

Because it's always like that, isn't it?

20

BUSINESS?

BUSINESS, MISTER?

GOOD MORNING. I'D LIKE TO ASK YOU A QUESTION ABOUT SENATOR GARY--

I write a column for The Word newspaper called "I Hate It Here."

The joy of being in this City has worn off. I sense, vaguely, that I'm finally as beaten as everybody else.

I sense everything vaguely, these days.

SHOPPING?

OUT OF MY FACE, KID. I'M NOT IN THE MOOD FOR PUSHER'S-BOY GAMES.

I LOOK LIKE A BOY TO YOU, FUCKO?

22

WHAT'S THE *SCORE* THIS TIME, KRISTIN? IS THIS AN ELECTION OR ANOTHER STRAW MAN FOR THE BEAST?

CALLAHAN, THE SMILER. HE'S THE ONE TO WATCH. LISTEN, DID YOU VOTE FOR LONGMARCH EIGHT YEARS AGO?

SURE.

WHY?

BECAUSE HE WAS THE ONLY ONE IN A POSITION TO STOP THE BEAST TAKING POWER.

AND THE SMILER CAN STOP THE BEAST GETTING BACK IN. AND HE'S THE ONLY ONE IN THAT POSITION.

BUT HIS CAMPAIGN'S IN TROUBLE, HIS PARTY'S ON THE VERGE OF CANNIBALISM, AND THERE ARE SPOILERS AND BASTARDS ON THE HORIZON.

AGNEW

IT'S GOING TO BE WORTH COVERING. YOU SAW THE BEAST GO IN-- THIS MAY BE THE ONLY CHANCE FOR THE NEXT EIGHT YEARS TO SEE HIM GO OUT.

THANKS, KRISTIN.

BY THE WAY: I WANT SOMETHING THAT'LL GIVE ME THE STAMINA OF A YOUNG WEREWOLF, THE VISION OF A SHAMAN, THE THOUGHTS OF A SERIAL KILLER AND THE GENTLENESS OF A HUNGRY VAMPIRE BAT.

DOABLE...

WARREN ELLIS writes and DARICK ROBERTSON pencils

year of the bastard 2: BADMOUTH

RODNEY RAMOS Clem Robins Nathan Eyring Cliff Chiang Stuart Moore
inker letterer color & seps ass't editor editor

TRANSMETROPOLITAN created by WARREN ELLIS & DARICK ROBERTSON

HERE TO SEE ROYCE.

YES ABSOLUTELY IN YOU GO DON'T HIT ME

ROYCE. YOUR CHALLENGE WAS IGNORANT AND FILTHY, BUT I ACCEPT IT ANYWAY, ON CONDITION THAT I GET A RAISE AND AN EXPENSE ACCOUNT FOR WEAPONRY AND THE USE OF YOUR WIFE.

SURE.

mitchell royce city editor

THAT EASY? EVEN THE WIFE BIT?

WHY NOT? SHE LEFT ME LAST YEAR. YOU CAN FIND HER, YOU'RE WELCOME TO HER. CARRY A WHIP AND A CHAIR.

I AM DEFEATED.

THROUGH JUDICIOUS MEDICATION I HAVE THE BRAIN PATTERNS OF LIZZIE BORDEN AND THE STEAMING GENITALS OF GENGHIS KHAN, BUT I AM UNDONE.

THE DRUGS ARE SHIT.

WHO'S THIS?

THIS IS YELENA ROSSINI.

SHE'S YOUR NEW ASSISTANT.

LIKE FUCK SHE IS--

SHE IS ALSO MY NIECE, SO BEHAVE YOURSELF AND PLAY NICE, OR I'LL KNOW.

NIECE?

YOU-- YOU--

ALL RIGHT. YOU MEET M[?] OUTSIDE MEANY HALL TOMORROW AT 8 am. BRIN[?] RECORDING GEAR AND BIG KITBAG FOR MY PROFESSIONAL EQUIPMENT.

32

THE NEXT DAY:

WE LOVE THE SENATOR! HE'S A PRESIDENT IN WAITING! WE ALL LIVE IN NORTH TIP! WE ALL LOVE THE SENATOR THERE!

SPKF LIVE

ladies who lunch for

IS THIS LIVE? CAN WE SAY HELLO TO JOAQUIM, THE CHEF AT DAHMER'S WHERE WE HAVE LUNCH EVERY DAY?

callahan

HIIIIIII, JOAQUIM!

MEANY HALL

ELECT CALLAHAN!

I KNOW YOU, DON'T I?

YOU *BASTARD.* THAT POOR FLOWER SELLER MUST'VE BEEN *SIXTY*--

OH, IT SPEAKS. I THOUGHT THE CRACKED GENES AND STUMP OF A FAMILY TREE THAT IS ROYCE'S BROOD HAD PRODUCED A MUTE.

BASTARD.

LISTEN. THAT "POOR WOMAN" IS A VETERAN SECRET SERVICE MAN CALLED ADOLF WHO ROUTINELY OVERCHARGES IN HIS SIDELINE OF NARCOTICS DEALING. HE DESERVED IT. AND I HELPED HIS COVER.

CARCINOMA

NOW, WHAT'S YOUR NAME?

YELENA ROSSINI.

GOOD. WHAT'S IN THAT BAG?

IN THIS VERY HEAVY AND UNCOMFORTABLE BAG I'M CARRYING FOR YOU? RECORDING GEAR FROM THE WORD STORES, AS YOU ASKED FOR.

DAMNIT, I WANTED THE KIT-BAG TO CARRY MY DRUGS IN.

SHUT UP. YOU'RE HORRIBLE. I HATE YOU.

I'M GOING TO SHIT IN YOUR LUNGS FOR THIS, ROYCE.

40

MOTHER OF TWELVE BASTARDS, WOULD YOU LOOK AT THIS...

I'M HERE TO SEE DR. SEVERN FOR AN INTERVIEW... I'M WITH *THE WORD*?

EEEEHHHH...

...FOLLOW ME.

HERE TO HELP YOU

GOT A NAME THERE?

EEEEHHHH...

...WELL, THERE'S A STORY IN THAT.

Y'SEE THAT STAGE THERE? BUNCHA YEARS BACK, I DESIGNED THAT, BUILT IT M'SELF. BUT DO THEY CALL ME BILL THE STAGE-BUILDER? NAAA...

Y'SEE THESE DOORS? IT WAS SIXTEEN YEARS AGO I FIXED THEM UP, BUT DO THEY CALL ME BILL THE HANDYMAN? NAAAA...

WROTE THESE FLOOR GUIDES, BUT DO THEY CALL ME BILL THE GUIDE? NAAAA...

HEY! BILL CHIMPFUCKER!

EEEEHHHH...

HERE

HERE Y'GO.

BRIEFING 1

42

MR. JERUSALEM. GLAD YOU COULD MAKE IT.

I'M VITA SEVERN, POLITICAL DIRECTOR FOR THE SENATOR'S CAMPAIGN--

I KNOW. I CAUGHT YOU ON TV. THAT'S WHY I WANTED TO INTERVIEW YOU.

--AND IF YOU'LL LET ME FINISH, PLEASE MEET ALAN SCHACT, POLITICAL CONSULTANT TO THE SENATOR ...AND SENATOR CALLAHAN HIMSELF.

er...

ALAN SCHACT. A PLEASURE TO MEET YOU. ALWAYS ENJOYED YOUR COLUMN. WE'RE ALL VERY EXCITED ABOUT THE MESSAGE YOUR NEW COLUMNS WILL--

WHY DO YOU NEED A CONSULTANT AS WELL AS A DIRECTOR?

WE DON'T.

NOW, VITA-- YOU KNOW WHAT I SAID ABOUT US ALL BEING ON THE SAME MESSAGE...

I DON'T CARE WHAT YOU SAID. YOU'RE AN EMPLOYEE, SCHACT--

PLEASE, YITA--A UNITED FRONT BEFORE THE PRESS, PLEASE, HAHAHA...

DOES HE MOVE?

THE LIGHTS BEGIN TO TWINKLE FROM THE ROCKS:

THE LONG DAY WANES: THE SLOW MOON CLIMBS: THE DEEP

MOANS ROUND WITH MANY VOICES, COME, MY FRIENDS,

'TIS NOT TOO LATE TO SEEK A NEWER WORLD.

"ULYSSES." TENNYSON. MY FAVORITE POEM.

A NEW WORLD. NEW OPPOSITION. NEW CAMPAIGN. NEW POLITICS.

NEW PRESIDENT.

GARY CALLAHAN. NICE TO MEET YOU.

AAH! IT MOVED!

YE-ES...

JUST WANTED TO SIT IN ON THE INTERVIEW. LET YOU KNOW HOW IMPORTANT WE FEEL HONEST DEALINGS WITH THE PRESS ARE.

AND VITA'S IMPORTANT TO US, YOU KNOW. NEED TO KNOW SHE'S GOING TO BE TREATED FAIRLY.

ACTUALLY, I WANT TO KNOW WHY DR. SEVERN CARRIES A GUN.

RECORDING

YOU CARRY A GUN, VITA? I DIDN'T KNOW THAT.

WELL, SENATOR, YOU KNOW I DON'T ALWAYS FEEL SAFE... IT IS CONSTITUTIONAL...

IT IS OFF-MESSAGE THOUGH, ISN'T IT, VITA?

HOW'S THAT, MR. SCHACT?

ALAN. ALAN. AS GARY'S SAID TIME AND TIME AGAIN--

CALL HIM SENATOR CALLAHAN--

THAT'S NOT THE KIND OF CAMPAIGN THIS IS--WE'RE TO BE APPROACHABLE, VITA--

His smile dies.

Inch by inch, he abandons the room, his bickering fixers trying so hard to make each other bleed without looking bad for the press. He goes inside himself, sets his mind in motion.

When the smile dies, he is utterly alone.

He's not all there. Head full of bad wiring and a hidden bleakness... there's hate in there.

This is what I needed... to get up close and see if he's really got the brain damage to fight the Beast.

The smile. The Smiler. The obviously broken personality, when you get up close.

47

ULYSSES.

WASN'T THAT BOBBY KENNEDY'S FAVORITE POEM?

WHO?

I THINK WE'LL RESCHEDULE THE INTERVIEW FOR ANOTHER TIME, DR. SEVERN. THIS IS A BRIEFING ROOM. I'M SURE YOU'RE ALL VERY BUSY...

THAT WON'T BE NECESS--

PLEASURE MEETING YOU ALL. MAYBE WE'LL TALK AGAIN.

LACKEY--MY EQUIPMENT.

THAT WAS IT? UNCLE MITCHELL'S GOING TO ROAST YOUR NASTY ASS--

THAT WAS JUST THE BEGINNING. I MUST FIND A BATHROOM IMMEDIATELY.

48

"ALL RIGHT, VITA, ALL RIGHT. BUT YOU GET THAT INTERVIEW RESCHEDULED LIKE HE SAID.

YOU BE NICE TO HIM. YOU PURR. YOU SUCK HIS DICK IF YOU THINK IT'LL HELP. WE NEED THAT COLUMN ON OUR SIDE."

"FOR GOD'S SAKE, SENATOR..."

"SPIDER JERUSALEM SPEAKS TO A VAST AUDIENCE OF LOSERS, WANNABES, WHITE TRASH, HATE ADDICTS, CHILDREN, AND NERVE DAMAGE CASES.

"ALL OF WHOM HAVE *VOTES*. THEY ARE THE NEW SCUM, VITA, AND THEY'RE THE BIGGEST VOTING BLOCK IN THIS CITY.

"AND YOU KNOW WHAT THEY SAY--IF YOU CAN TAKE THE CITY, YOU GET THE COUNTRY."

"WE NEED THE POPULAR PRESS, VITA. WE ALL NEED TO BE PUTTING OUT THE SAME MESSAGE. ALAN HERE TAUGHT ME THAT."

"ALL RIGHT. I'LL RESCHEDULE. BUT LISTEN, SENATOR... WE NEED TO BE TALKING ABOUT HELLER AND HIS PHONE CALL."

"DON'T WORRY ABOUT JOE HELLER. WE'LL COME TO TERMS."

I FEEL A *COLUMN* COMING ON.

Gary Callahan is a
genuinely intelligent,
educated man. Not the
wolfen street-fighting
instinctual smarts of
the Beast, but a man
of knowledge and long
thought. He has
honorable people
working for him, and
even the brightest
veteran political
fixers tell me he's
going to be President.

He's also a fake.

A source close to
the Senator has him
describing the millions
disenfranchished by
the Beast as "The New Scum,"
and indicates that the
Senator considers himself
on close moral terms with
the monstrous Joe Heller…

It seems the convention
is merely going to decide
the face of the guy who'll
be fucking us next…

TO BE CONTINUED

BABEL

POLITICAL CHAOS IN THE CITY AS SPIDER JERUSALEM'S "NEW SCUM" COLUMN THROWS THE OPPOSITION PARTY CONVENTION INTO TURMOIL...

am Robert McX Click for Biography

A source close to the Senator has him describing the millions disenfranchised by the Beast as "The New Scum," and indicates that the Senator considers himself on close moral terms with the monstrous Joe Heller...

It seems the convention is merely going to decide the face of the guy who'll be fucking us next...

Spider Jerusalem, "I Hate It Here," from THE WORD.

SPKF LIVE REPORT

WHEN ASKED ABOUT THE COLUMN BY OUR CORRESPONDENT, JERUSALEM LAUGHED, FONDLY BOTTLED HIM IN THE TEMPLE AND INVITED US ALL TO SUCK HIS COCK.

click here to order a bottle of STALIN VODKA

WARREN ELLIS writes & DARICK ROBERTSON pencils

YEAR OF THE BASTARD

Part 3: SMILE

RODNEY RAMOS
inker

NATHAN EYRING
color & seps

CLEM ROBINS
letters

CLIFF CHIANG
ass't ed.

STUART MOORE
editor

TRANSMETROPOLITAN created by WARREN ELLIS & DARICK ROBERTSON

I TOLD THE ONES OUTSIDE-- THE ONES CURRENTLY BLEEDING FROM THE EYES AFTER I GAVE THEM EBOLA HAND-SHAKES, *SO BE ADVISED*--

--I AM A *JOURNALIST.* I DO NOT REVEAL MY SOURCES.

SENATOR CALLAHAN

SO SAID OUTLAW JOURNALIST *SPIDER JERUSALEM,* ONCE MORE THE CITY'S BEST-LOVED DIARIST, IN A PRINT DISTRICT BAR THIS AFTERNOON.

BRAD GOODJAW

the thunderer
FAMOUS COLUMNIST DECLARES SMILER "FAKE"

"Smiler" Senator Callahan Spider Jerusalem

SMILER TUMBLES IN MORNING POLLS
OPPOSITION CANDIDACY A FREE-FOR-AL

WE'RE ON THE STREET WITH YELENA ROSSINI, SPIDER JERUSALEM'S SULKILY LOVELY ASSISTANT. WHAT HAVE YOU GOT THERE, YELENA?

I'M CONOR BAIGENT, STREET LISTENER FOR *PT-OPC?*

WHAT?

POLITICAL TELEVISION-OPPOSITION PARTY CONVENTION.

LIVE?

ISN'T SHE PRETTY? REALLY WHAT THIS CONVENTION NEEDED...

WELL, I'VE GOT SOME STUFF FOR THE OLD... I MEAN, FOR MISTER JERUSALEM.

PT-OPC VIX POP: YELENA ROSSINI

HE MUST BE HAVING A TOUGH TIME. THIS HAS TO BE A STRESSFUL ASSIGNMENT FOR HIM, COVERING THE CONVENTION. LET'S SEE HOW SPIDER JERUSALEM COPES WITH THE STRAINS IMPOSED BY THE TRUTH, FOLKS...

CLICK HERE TO ACCESS YELENA ROSSINI'S BIOGRAPHY

PACKET OF FRESH BABY SEAL EYES.

BRAIN-OF-WELSHMEN PÂTÉ FROM THE LOCAL BLACK OPS DELI.

THIS BOX SAYS "POWDERED CHILDREN," BUT I'M *SURE* THAT'S NOT WHAT IT MEANS.

BABY SEAL EYES

BLACK OPS DEL

56

AND FORTY PICTURES OF GERTRUDE STEIN AND ALICE B. TOKLAS NAKED AND FEEDING EACH OTHER ASPARAGUS.

HE SAYS IT HELPS HIS CONCENTRATION.

YOU WANT TO KNOW ABOUT VOTING.

I'M HERE TO TELL YOU ABOUT VOTING.

IMAGINE YOU'RE LOCKED IN A HUGE UNDERGROUND NIGHTCLUB FILLED WITH SINNERS, WHORES, FREAKS AND UNNAMEABLE THINGS THAT RAPE PIT BULLS FOR FUN.

AND YOU AIN'T ALLOWED OUT UNTIL YOU ALL VOTE ON WHAT YOU'RE GOING TO DO TONIGHT.

YOU LIKE TO PUT YOUR FEET UP AND WATCH "REPUBLICAN PARTY RESERVATION."

THEY LIKE TO HAVE SEX WITH NORMAL PEOPLE USING KNIVES, GUNS, AND BRAND-NEW SEXUAL ORGANS THAT YOU DID NOT KNOW EXISTED.

SO YOU VOTE FOR TELEVISION, AND EVERYONE ELSE, AS FAR AS YOUR EYE CAN SEE, VOTES TO FUCK YOU WITH SWITCHBLADES.

THAT'S VOTING.

YOU'RE WELCOME.

Noticed how quiet Civic Center's been this week? Our fair City, of course, is run by The Beast's party. And you know how it's run? Schools fail to teach. Children in care are left unprotected from pedophile social workers. Millions wasted on pointless internal inquiries. Homeless families have been housed in asbestos-filled apartment blocks, an operation which an independent human rights agency found to be "politically motivated." And, of course, while they were in the middle of some serious gerrymandering, there was the internal report that stated "enforcing planning laws in our target wards would ensure that the right type of homes are provided with the right sort of voters"..

MY NAME'S YELENA ROSSINI, AND I'M SPIDER JERUSALEM'S ASSISTANT.

I'M TWENTY-FOUR YEARS OLD. I WAS BORN IN THE CITY, I'M AN OLD HEATH ROAD GIRL.

I SPEAK SEVEN LANGUAGES, HAVE JUST GRADUATED FROM THE HILLIS BUSINESS SCHOOL IN NORTH TIP...

...AND, YES, I'VE BEEN WORKING FOR SPIDER JERUSALEM FOR ABOUT A WEEK. IT'S REALLY BEEN QUITE INTERESTING.

JUST LOOKING BEHIND THE SCENES OF POLITICS HAS BEEN FUN. MY DAD HELPED FUND THE LONGMARCH CAMPAIGN, BUT I WAS TOO YOUNG TO PAY ANY ATTENTION.

NO, MR. JERUSALEM DOESN'T KNOW ABOUT THAT. HE'S NEVER ASKED.

HOW DO I GET ALONG WITH HIM?

WELL, HE HASN'T ACTUALLY REMEMBERED MY NAME YET.

AND ONE TIME HE STOPPED IN THE MIDDLE OF A CONVERSATION AND SAID, "WHO ARE YOU AND WHAT ARE YOU DOING IN MY HOUSE?"

AND YESTERDAY HE SPENT TWO HOURS THINKING HE WAS IN AN AVIARY SOME-WHERE IN POLAND.

ONE TIME HE CALLED ME "CHANNON."

Sudden expectant silence; they take a breath and hold it in their throats, as if they're about to come. On stage, posing "greeters" flash their paid-for smiles at a small figure...

Here we go. So goddamn potent that even show-girls twice his height just have to have a taste.

Around me, that breath is still held...

...and explodes out in a sudden roar of approval and love. He's still a working stiff at heart... Christ...

Bob Heller has a really punchable face.

63

General notes:

Two days in the whirlwind have left me shipwrecked and abandoned. Even the stuff I've been shooting in order to, Holmes-like, keep my interest in the world alive is failing me now. I've played the game like a good little whore, snarled and cursed on cue, done the work and banged out the columns.

I'll let myself sleep soon, and hope to hell the world doesn't seem so goddamn fractured when I wake up. Having said that, I also hope I wake to find half this city committed suicide in my honor...

PTOO

HA!

THIS IS YOUR DOOR SPEAKING. YOU HAVE A CALLER.

IF YOU'D COME OUT IN FAVOR OF HIM...

I CAN'T ENDORSE A CANDIDATE...

CHRIST, YOU'RE A HACK, NOT A PRIEST. WHAT'LL IT HURT?

OR ARE YOU *REALLY* THE VOICE OF THE CITY? WILL THEY *ALL* DO AS YOU SAY, OUT THERE?

OOH, FISHER PRICE PSYCHOLOGY. PLAY MY POOR HACK'S EGO LIKE A PIANO-- YES, I'LL ENDORSE YOUR PET LIZARD FOR PRESIDENT *NOW*...

SHITFORBRAINS JUNKIE DOGFUCKER-- I DON'T KNOW WHY I THOUGHT THIS WAS A GOOD IDEA--

YOU CHANGED YOUR HAIR.

WHAT?

YOU CHANGED YOUR HAIR. TELL ME WHY.

THAT HAIRCUT WAS ALL CULTURAL BUTTONPUSHING, SEMIOTIC TERRORISM. SCHACT'S IDEA.

MADE ME LOOK TOUGH AND SMART, BUT ALSO THE UNDERDOG, FIGHTING AN EVIL EMPIRE AS BEST I CAN...

AWFUL GODDAMN THING.

71

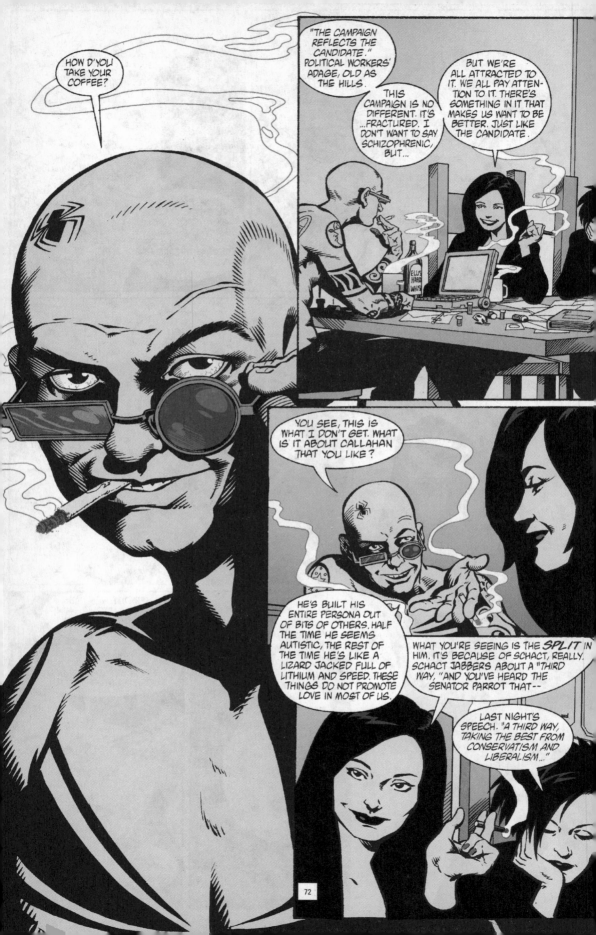

HOW D'YOU TAKE YOUR COFFEE?

"THE CAMPAIGN REFLECTS THE CANDIDATE." POLITICAL WORKERS' ADAGE, OLD AS THE HILLS.

THIS CAMPAIGN IS NO DIFFERENT. IT'S ...FRACTURED. I DON'T WANT TO SAY SCHIZOPHRENIC, BUT...

BUT WE'RE ALL ATTRACTED TO IT. WE ALL PAY ATTENTION TO IT. THERE'S SOMETHING IN IT THAT MAKES US WANT TO BE BETTER. JUST LIKE THE CANDIDATE.

YOU SEE, THIS IS WHAT I DON'T GET. WHAT IS IT ABOUT CALLAHAN THAT YOU LIKE?

HE'S BUILT HIS ENTIRE PERSONA OUT OF BITS OF OTHERS. HALF THE TIME HE SEEMS AUTISTIC, THE REST OF THE TIME HE'S LIKE A LIZARD JACKED FULL OF LITHIUM AND SPEED. THESE THINGS DO NOT PROMOTE LOVE IN MOST OF US.

WHAT YOU'RE SEEING IS THE *SPLIT* IN HIM. IT'S BECAUSE OF SCHACT, REALLY. SCHACT JABBERS ABOUT A "THIRD WAY," AND YOU'VE HEARD THE SENATOR PARROT THAT--

LAST NIGHT'S SPEECH. "A THIRD WAY, TAKING THE BEST FROM CONSERVATISM AND LIBERALISM..."

72

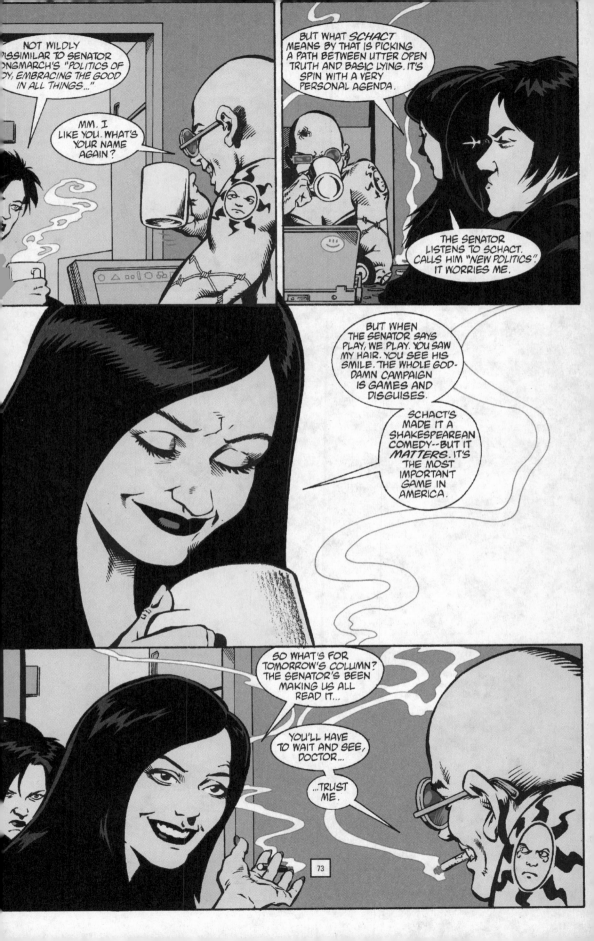

BABEL

SPIDER JERUSALEM MAKES AN ACIDLY BACKHANDED ENDORSEMENT OF CALLAHAN; CONVENTION GOES BERSERK.

explore BABEL roadsite

Dr. Vita Severn is bright, funny, acid, caring, brutal and passionate. She's the only actual human being I've met in politics to date, and the fact that she's also a campaign director would make me laugh if it weren't such a waste.

As far as I can see, her employment by the Smiler is the only sign of actual taste I've seen him show. And she is the only reason to vote for him.

Spider Jerusalem, "I Hate It Here," from THE WORD.

WHEN ASKED ABOUT THE COLUMN BY OUR CORRESPONDENT, JERUSALEM LAUGHED, SHAT IN THE CAMERA AND THREW DOG CARCASSES TO AN ADMIRING AUDIENCE.

AND I'VE ONLY *BEGUN* FUCKING WITH YOU PEOPLE...

TO BE CONTINUED

HATE IT HERE
The New Columns of SPIDER JERUSALEM

GODDAMN WHOREHOPPER.

GODDAMN COLUMN.

GODDAMN MODERN PRINTING. SAY YOU'RE PUBLISHING A BOOK ONE DAY, WRITE THE MARKETING COPY THE DAY AFTER, PUBLISH THE FUCKER THE DAY AFTER *THAT*.

GODDAMN *GODDAMN*.

JUST THINK OF THE MONEY, BOY. THINK OF ALL THE DOLPHIN STEAKS, GUNS AND SOMA-HOLIDAYS IT'LL BUY, AND PLOW ON...

WHAT'S GOING ON? WHAT IS THIS SHIT?

THIS IS ALL SOME ELABORATE PLAN TO DRIVE ME INSANE SO THAT ROYCE AND THE WHOREHOPPER AND WHATSERNAME CAN SPLIT THE ROYALTIES AND STEAL MY CAT!

ADMIT IT, YOU SCHEMING DOGFUCKER...I'VE GOT YOU RED-HANDED, YOU LEE HARVEY OSWALD SONOFABITCH--

PLEEEEEASE... LOOOOOOOK...

YOU'RE TRYING TO DRIVE ME *MAD*, AREN'T YOU?

IN THE NAME OF FUCK.

SPIDER JERUSALEM'S

I HATE IT HERE!

Promotional Giveaway Today Only
Spider Shades!

79

...Everything's getting a little... disconnected...

RETURN OF THE VIKING WARSHIPS

NO...NO, MISTER JERUSALEM WILL NOT ADVERTISE CEREALS. I DON'T CARE HOW GOOD YOUR PITCH IS--I DON'T *CARE* IF IT HAS BITS OF KOALA BEARS IN IT--

--NO, I HAVE EXPRESS ORDERS TO SEND TRAINED DEATHWATCH BEETLES TO GNAW ALL THE MEAT OFF YOUR PELVIS IF YOU CALL AGAIN. GOODBYE.

TELL ME SOMETHING.

SHOOT.

I'VE BEEN HERE WHAT, A WEEK NOW? SOMETHING LIKE THAT... TIME SEEMS TO MOVE DIFFERENTLY SINCE I STARTED WORKING FOR YOU...

REALLY WANT TO KNOW: HY ARE YOU POUNDING ALL IIS CRAP INTO YOURSELF? HEN EVERYTHING'S GOING SO *WELL*?

TO KEEP ME HERE.

TO KEEP ME INTERESTED.

WHAT'S NOT TO BE INTERESTED IN? YOUR LIFE LOOKS PRETTY DAMN GOOD FROM HERE.

I'M NOT HERE ANYMORE.

I'M *THERE*.

mitchell royce
city editor

HELLO, YELENA...

FIVE HUNDRED PIECES OF PAPER SIGNED BY SPIDER JERUSALEM, AS REQUESTED.

SIT DOWN, SIT DOWN...HOW MANY DID HE ACTUALLY SIGN?

THIRTY-TWO BEFORE DROPPING INTO A SHALLOW COMA AND GENTLY PISSING HIMSELF. I HAD THE MAKER REPLICATE THE REST.

YOU NEVER TOLD ME WHAT THEY WERE FOR.

WE'RE GOING TO SELL COPIES OF THE ISSUE IN *THE WORD* WITH THE FIRST "I HATE IT HERE" IN IT, WITH THESE AUTOGRAPHS TIPPED IN. FIVE HUNDRED BUCKS EACH, WOULD YOU BELIEVE...

YEAH. I HAVE A QUESTION.

WHY IS JERUSALEM CRAMMING EVERY DAMN ORIFICE AND PORE WITH DRUGS? I JUST DON'T GET IT, AND HE'S INCAPABLE OF A STRAIGHT ANSWER...

YEAH. WE'RE BACK AT THAT STAGE ALREADY, AREN'T WE?

82

IF THAT GOD-DAMN MONSTROSITY GOT APPROVED, THEN THE FIX IS IN.

NEWS AT THE TOP OF THE HOUR FROM 24:7, AS SPONSORED BY LONG PIG--FOOD WITH THE HUMAN TOUCH...

THE NAKED SCREAMING FIGURE SEEN RUNNING ACROSS THE WHITE HOUSE LAWN LAST NIGHT, WAVING BROKEN MANACLES AND SHAKING HEAVY CHAINS, WAS APPARENTLY NOT THE VICE PRESIDENT.

WHITE HOUSE AUTHORITIES ARE DISMISSING A HUNDRED EYEWITNESS REPORTS TO THE CONTRARY AS "HYSTERIA AND SWAMP GAS."

PRRR

HAVE GONE TO COMMIT SUICIDE. INTEND TO RETURN FROM GRAVE FRIDAY. FEED CAT.

The V

Back on the street: back where I was born, where parts of me will always be. The parts that were chopped off and buried with cardamom pods by that strange little cat-eyed girl from Ashmolean Point. Another lesson in media activism and riding the monoculture; using it for all it's worth.

I've been postered and ten-second-ad-spotted to death in the last twenty-four hours. That's aside from the TV and feedsite stuff I've done for money, and the extra heat on the column.

Lots of people know my face. I'm deliberately walking through Redchurch on my way to my final destination; Redchurch being what Gary Callahan would call my natural constituency.

Whores, pushers, filmmakers, musicians, dancers, deviants, polysexual transhumans, alkies, junkies, editors, The New Scum, *voters*...and, even more crucially, *feedsite listeners.*

The feedsite listener falls into step and true-to-form, asks in his supple TV voice, "What's happening, Spider?" And all I say is, "We're going *this* way." And that's it, I've *got* him.

I recognize a journalist from The Thunderer checking me out and wandering along, and a pair of camera eyes from the Tavanier specialty news channels staggering out of an edge game club, all scarred, sticky and orgasm-eyed...

And you can see it in all of them: "Spider Jerusalem's a nut, and everyone knows that, he's a crazy man, let's go see what the crazy man's doing." That's the Spider-image sold and sent. Trust t fuckhead. Loathsome, lifeless, robotic little shits. Follow the money, follow the famous guy.

Well, today, I make you all see what I want you to see. You bastards want to make me the news, fine – *here's* your goddamn news.

We peel off the street into the connective alleyway, and a few of them work out where I'm going. They get nervous. Within a few minutes, their shiver of knowledge has travelled the group around, and the party atmosphere dies by regretful, betrayed degrees.

AND HERE WE ARE!

The bit of Redchurch no one ever goes to. The bit they'd never have gone to, if they hadn't been blindly following me.

Welcome to the Cluny Square community estate, I said to them. Also known as the Redchurch Housing Projects, depending on whose paperwork you read. Built and filled precisely one month after the Beast took power. One month after the city fell into the hands of the Party In Government. This estate was designed specifically for families in poverty, meaning families who traditionally voted for the party now in Opposition.

WHERE THE HELL HAVE YOU BEEN?

DOES IT MATTER?

YES! I JUST FOUND OUT THEY'RE *SELECTING* TOMORROW! IT ALL *HAPPENS* TOMORROW! THEY CHOOSE THE CANDIDATE, THE CANDIDATE CHOOSES HIS VICE PRESIDENTIAL CANDIDATE--

IT'S ALL OVER. IT'S ALL HAPPENED ALREADY. THE FIX IS IN.

JUST LIKE IT WAS WHEN THEY SELECTED LONGMARCH. ASK YOUR DADDY.

I...DIDN'T THINK YOU HEARD ME WHEN I TOLD YOU ABOUT THAT.

I HEAR ALL.

TO BE CONTINUED

WARREN ELLIS writes and DARICK ROBERTSON pencils

YEAR OF THE BASTARD
5: LOVE

RODNEY RAMOS- inker / finished art p.7-8, 12, 14-16, 18-21
CLEM ROBINS- letterer NATHAN EYRING- color and separations
CLIFF CHIANG- ass't editor STUART MOORE- editor

TRANSMETROPOLITAN created by WARREN ELLIS and DARICK ROBERTSON

The fix is in. It remains only to see what it's been traded for. To get to this stage, anyone wanting to be Candidate has had to learn to enjoy the special flavor of pressure-group dick. The question is: will the Smiler stagger on stage with lungs half-full of steaming lobbyist semen? Or will he merely be licking his lips?

I so badly want to kill everyone in this room. Even the children.

Especially the children.

SQUEAKY'S PORK BAR

Fresh Kills NIGHTLY!

O APPARENTLY I FUCKED MY EDITOR'S NIECE.

HER NAME'S YELENA ROSSINI. ANGLO-RUSSIAN-ITALIAN. OLD HEATH ROAD. HER FAMILY ARE SO OLD MONEY THEY'RE PREHISTORIC-RICHE.

I FUCKED MY EDITOR'S NIECE AND SHE SAYS NOTHING HAPPENED.

BUT I KNOW IT DID.

BECAUSE I'M CLEVER.

AND BECAUSE I LEFT MY SHADES ON.

AND MY SHADES' DEFENSE SYSTEM THOUGHT ALL THE FALLING DOWN AND ROLLING AROUND AND STUFF WAS AN ASSAULT.

AND WHAT DOES IT DO WHEN THERE'S AN ASSAULT? I'M GLAD YOU ASKED.

IT TAKES PICTURES.

It takes a little less than twelve hours before my own words sink into my own useless goddamn head. *I had sex with my editor's niece.*

By four o'clock, I've discounted suicide in favor of killing everyone else in the entire world instead.

WE'RE OUTSIDE GREEN-BROOK TOWER, SENATOR CALLAHAN'S BASE OF OPERATIONS IN THE CITY...

...WAITING FOR THE SIGN THAT HE'S CHOSEN HIS VICE-PRESIDENTIAL CANDIDATE... HE ONLY HAS UNTIL FOUR P.M. TODAY TO CHOOSE, AND IT'S, WHAT, THREE FIFTY-EIGHT NOW...

...THREE FIFTY-NINE...

THERE IT IS! SEE IT? THE CHIMNEY? THAT SMOKE INDICATES THAT THE SELECTION HAS BEEN MADE...

SHAMELESSLY THIEVED FROM THE SELECTION TRADITION FOR POPES.

I'VE HEARD OF THEM.

SENATOR CALLAHAN WILL BE OUT IN A FEW MINUTES, WE UNDER-STAND--

116

IVE

I WILL BE JOINED ON THE OPPOSITION CAMPAIGN TICKET BY A GOOD MAN, AN HONEST AND BRAVE MAN WHO IS DEDICATED TO OUR CAUSE AND OUR MESSAGE.

I WILL BE JOINED BY REPRESENTATIVE JOSHUA SHREIBER FREEH.

WELCOME ABOARD THE WINNING TICKET, JOSH.

GLAD TO BE ABOARD, GARY.

NEVER HEARD OF HIM.

SO?

OR DOES HE?

THAT'S IT, IT'S SO OBVIOUS, MY BRAIN MUST BE GOING CRUSTY...

HE'S GOT TO BE ONE OF HELLER'S CREATURES.

SO HE'LL DO CALLAHAN NO GOOD. THERE'S NO POINTS IN HAVING HIM ON THE TICKET. HE DOESN'T BRING ANYTHING TO IT.

THAT MUST BE HIS WORTH. CALLAHAN TAKES ON THIS, THIS, THIS WHATEVERHEIS, AND GETS FLORIDA AND STUPID EVIL JOE FUCKFACE SPORTSBAR AND THE UNDERGROUND NEO-NAZI SUBHUMAN VOTE.

THAT BASTARD! HE BENT OVER FOR HELLER'S VOTING BLOC.

I DON'T BELIEVE IT!

AND LOOK-- NO VITA SEVERN.

POOR BITCH MUST BE THINKING ABOUT SWALLOWING A GRENADE RIGHT NOW.

WHAT NOW?

WHAT NOW?

THERE'S A BAG OF ANTI-CANCER TRAIT IN THE BATHROOM. TAKE SOME. CIGARETTES ON THE TABLE. START SMOKING.

BUT I--

DAMNIT, YOU'RE MY ASSISTANT, AREN'T YOU?

THEN GET THE BAG. YOU START SMOKING TODAY. ALL OF MY ASSISTANTS SMOKE.

...YES.

GET MOVING! THERE'S A JOB TO BE DONE!

Election Selection!

REPRESENTATIVE JOSHUA SHREIBER FREEH HAS COME FROM NOWHERE TO BE SELECTED AS SENATOR GARY CALLAHAN'S RUNNING MATE IN THIS YEAR'S PRESIDENTIAL ELECTION.

VOTED TO THE HOUSE OF REPRESENTATIVES BY THIS CITY ONLY TWO YEARS AGO, PARTICULARLY ACTIVE IN THE LAST YEAR ON DOMESTIC HUMAN RIGHTS, MR. FREEH IS A FRESH FACE IN NATIONAL POLITICS -- AS MR. CALLAHAN SAYS, "JUST WHAT THE DOCTOR ORDERED."

FREE

TOP STOR

WARREN ELLIS writes and DARICK ROBERTSON pencils

YEAR OF THE BASTARD
6: BASTARD

RODNEY RAMOS
Inker

NATHAN EYRING
color & separations

CLEM ROBINS
letterer

CLIFF CHIANG
ass't editor

STUART MOORE
editor

TRANSMETROPOLITAN created by WARREN ELLIS & DARICK ROBERTSON

INITIATE DISCOVERY! FIRE THE MACHINES!

THROW THE SWITCH, IGOR! THROW THE FUCKING SWITCH!

WHAT WE'RE DOING HERE IS CALLED *INVESTIGATIVE JOURNALISM.* TIME WAS, IT'D TAKE MONTHS, YEARS EVEN, TO NAIL YOUR STORY THROUGH INVESTIGATIVE JOURNALISM.

TODAY, IT TAKES A MATTER OF HOURS. YOU KNOW WHY?

NOT BECAUSE WE ARE FANTASTICALLY ADVANCED. *NOT* BECAUSE WE ARE GENERALLY CLEVERER THAN FUCK.

BUT BECAUSE NOBODY *DOES* INVESTIGATIVE JOURNALISM ANYMORE. SO NO ONE *EXPECTS* IT.

WHEN I TELL SOMEONE LIKE VITA I'M GOING DIGGING, SHE THINKS I MEAN I'M CHECKING THE *PRESS RELEASES.*

WE ARE GOING TO GATHER AND SORT VAST AMOUNTS OF INFORMATION -- AND THEN WE'RE GOING TO *DO* THE STORY.

125

126

WE SELL MUCH OF OUR PRODUCT TO LONG PIG, OF COURSE. EASIER MONEY. WE ONLY HAVE TO GROW A BRAINSTEM, YOU SEE? FOR THE AUTONOMIC FUNCTIONS.

BRAIN SIZE DOESN'T AFFECT FLAVOR.

I FOLLOW ALL THAT, MR. CARIES...

...BUT I'M HERE ABOUT A MORE COMPLEX JOB YOU UNDERTOOK A FEW YEARS AGO.

YOU WERE CONTRACTED FOR IT BY A COMPANY CALLED HOUSEPAINTING PROPRIETY, MR. CARIES, BUT THAT WAS A FRONT.

MR. CARIES. LET'S BE LIPFRONT HERE. I ASKED AROUND.

I KNOW WHAT YOU SELL TO, WHAT YOU MIGHT CALL, PERVERTED BUSINESSMEN WHO LIKE THEIR LOVERS MINUS THE USUAL WEIGHT OF GREY MATTER.

AND LET'S BE HONEST: YOU RUN A BASTARD FARM, MR. CARIES. THAT DOESN'T MAKE YOU A MAN OF HIGH REPUTATION.

GIVE ME THE PAPERWORK ON THAT MORE COMPLEX JOB. ALL OF IT. AND MAYBE I'LL GET SELECTIVE AMNESIA TOMORROW.

CHRIST, SPIDER, WHAT DO WE DO?

WE TELL THE TRUTH. AS LOUDLY AS POSSIBLE.

I DON'T SEE HOW WE CAN DO THAT.

WHY THE HELL NOT?

IT'LL KILL THE SMILER'S CANDIDACY.

THAT'S THE IDEA.

IT'LL ALSO COMPROMISE YOUR BIG FRIEND VITA SEVERN. SHE'S GONE ON RECORD AS STATING NEITHER SHE NOR CALLAHAN COULD GIVE A HELLER CREATURE HOUSE ROOM.

THE TRUTH, YELENA. NO MATTER WHAT.

NO MATTER WHO IT HURTS?

I CAN'T LET MYSELF WORRY ABOUT THAT.

QUIT LOOKING AT ME LIKE THAT. YEAH, IT COULD HURT VITA. YEAH, IT COULD ENSURE THAT THE BEAST GETS REELECTED.

BUT I DON'T HAVE A CHOICE.

THIS IS WRONG.

129

EXCUSE ME, WE HAVE TO GET TO THE PRESS CONFERENCE IN THERE--

NOPE.

BUT WE'RE PRESS, AND THAT'S CALLAHAN AND FREEH'S FIRST REAL QUESTION AND ANSWER SESSION IN THERE--

I KNOW WHAT IT IS.

SECURITY BRAUNJEV

I'VE HAD SPECIAL INSTRUCTIONS ABOUT YOU TWO.

NOW FUCK OFF, BEFORE THINGS GET NASTY.

130

I DON'T BELIEVE I JUST STOPPED SOMEONE FROM SHOOTING YOU.

A FEW MONTHS AGO, I'D'VE PAID GOOD MONEY TO SEE IT.

ROYCE NEVER PAID YOU THAT MUCH MONEY.

YELENA ROSSINI, CURRENT ASSISTANT, MEET CHANNON YARROW, PREVIOUS ASSISTANT.

THIS ISN'T A COINCIDENCE.

NO. I KNEW YOU'D BE HERE TO COVER THE Q&A. AND LIFE IN FRED CHRIST'S CHURCH WAS SO CREEPY I WOUND UP DOING A BIT OF JOURNALISM AFTER ALL :

AND... WELL, YOU'LL NEED THIS.

FRED CHRIST PAID FOR THE CONSCIOUSNESS UPGRADE FREEH NEEDED TO BE ABLE TO ACT AS V.P. CANDIDATE.

FRED HAS LOTS OF MONEY THESE DAYS. HE'S BEEN WHORING OUT TRANSIENT GIRLS TO POLITICIANS.

AND HE'S BEEN PROMISE TAX BREAKS FOR HIS CHUR WHEN THE SMILER'S ELECTE

BEING A NUN WASN'T ALL IT WAS CRACKED UP TO BE. AND THE SEX WAS SHIT. BU I SEE YOU DON'T NEED AN ASSISTANT...

FREEH WAS TRADED TO CALLAHAN IN RETURN FOR HELLER'S CONTROL OF FLORIDA.

AND ONCE *FLORIDA* FELL TO CALLAHAN, THE *REST* OF THE CONVENTION VOTED IN HIS FAVOR.

I TELL YOU RIGHT NOW THAT *THE VICE-PRESIDENTIAL CANDIDATE WAS GROW* BY A *FASCIST.*

"JUST WHAT THE DOCTOR ORDERED," IN FACT.

AND IN ORDER FOR HIM TO FUNCTION CORRECTLY AS A V.P., HE REQUIRED A *MASSIVE WETWARE UPGRADE--*

--PAID FOR BY *FRED CHRIST,* WHOSE *CHURCH* FREEH JUST PLUGGED.

MY QUESTION IS:

SENATOR CALLAHAN --D YOU STAND E YOUR RUNNIN MATE?

QUICK, SPIDER-- THEY'RE GOING TO MAKE THE ANNOUNCEMENT--

THIS SHOULD BE GOOD. WHAT'S THE SMILER'S APPROVAL RATING NOW?

89% PRE-JERUSALEM 55% WHEN FREEH'S COVERS ARE PULLED.

38% WHEN CALLAHAN'S SEEN ON-SCREEN VACILLATING WHEN YOU ASK HIM IF HE'LL STAND BY FREEH.

THREE DAYS LATER-- 18%.

LIVE

Vita Severn
Approval Rating
92%

YOUR FRIEND *VITA*, ON THE OTHER HAND, RETAINS A 92% APPROVAL RATING, AND IS SEEN AS THE BEST THING ABOUT CALLAHAN'S CAMPAIGN.

NO SURPRISE THEY'RE LETTING HER MAKE THE ANNOUNCEMENT. SHE'S ALL THEY'VE GOT.